JAMES CARTER

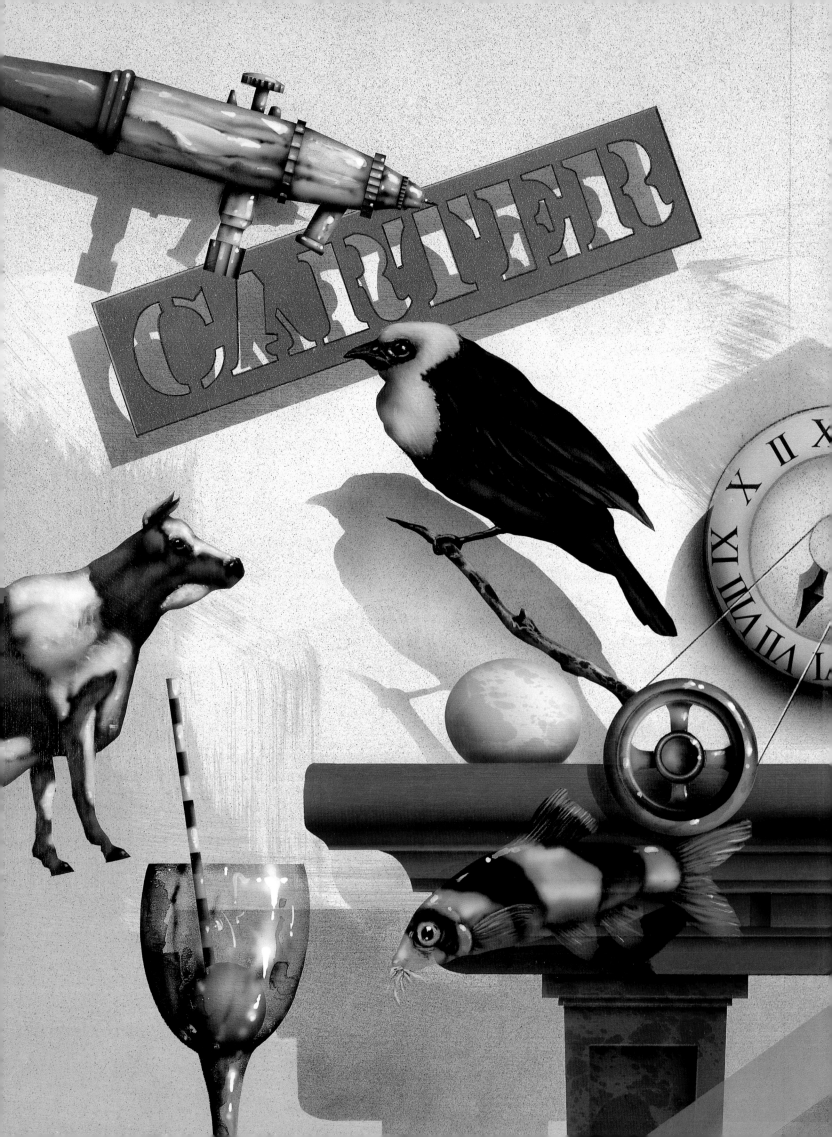

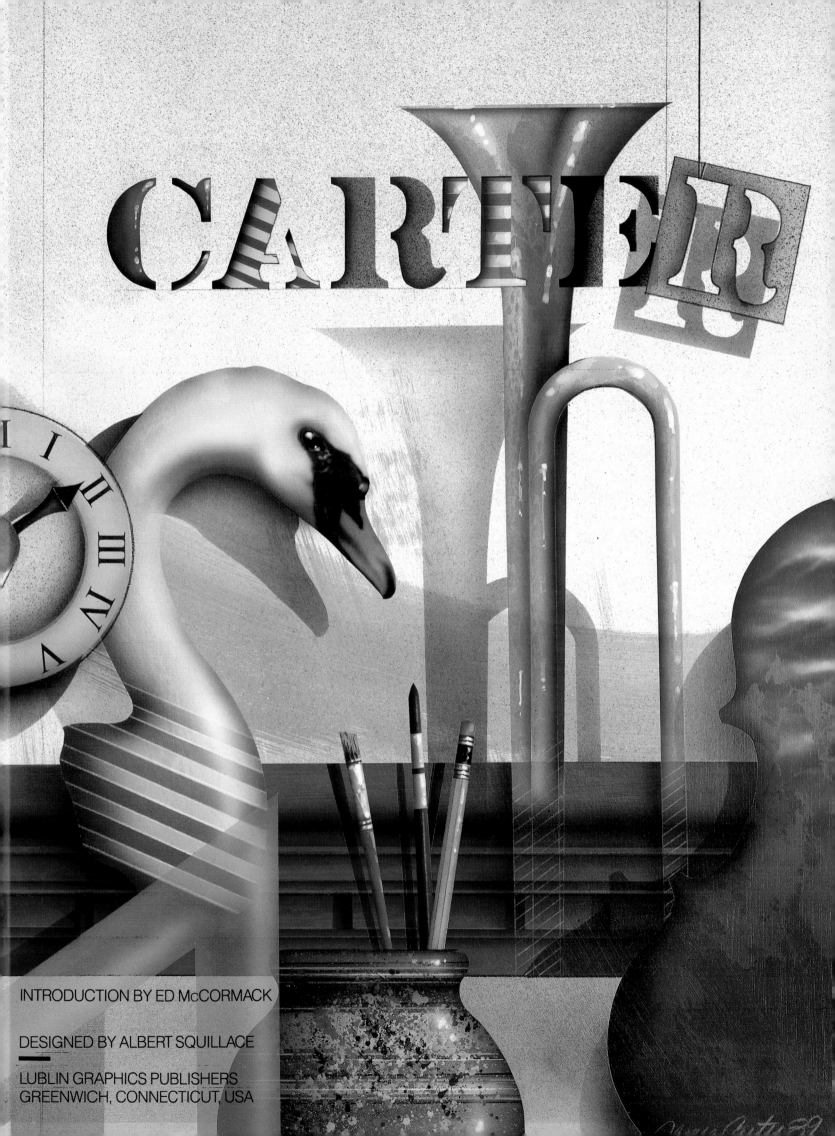

CARTER

INTRODUCTION BY ED McCORMACK

DESIGNED BY ALBERT SQUILLACE

LUBLIN GRAPHICS PUBLISHERS
GREENWICH, CONNECTICUT, USA

DESIGNED BY **ALBERT SQUILLACE**
EDITOR: **MICHELLE LUBLIN CASSANETTI**
ASSISTANT EDITOR: **DONNA DUCHINSKY**
ART DIRECTOR: **TAMMY JORDAN**
PHOTOGRAPHIC CREDITS: **ALBERT SQUILLACE**—PAGES 73–96;
PAGES 158–163
TRACY W. HAMBLEY—PAGES 154–157

PRINTED BY DAI NIPPON IN JAPAN

FIRST EDITION

LIBRARY OF CONGRESS CATALOG CARD NUMBER: 89-084655
ISBN 0-941393-18-6

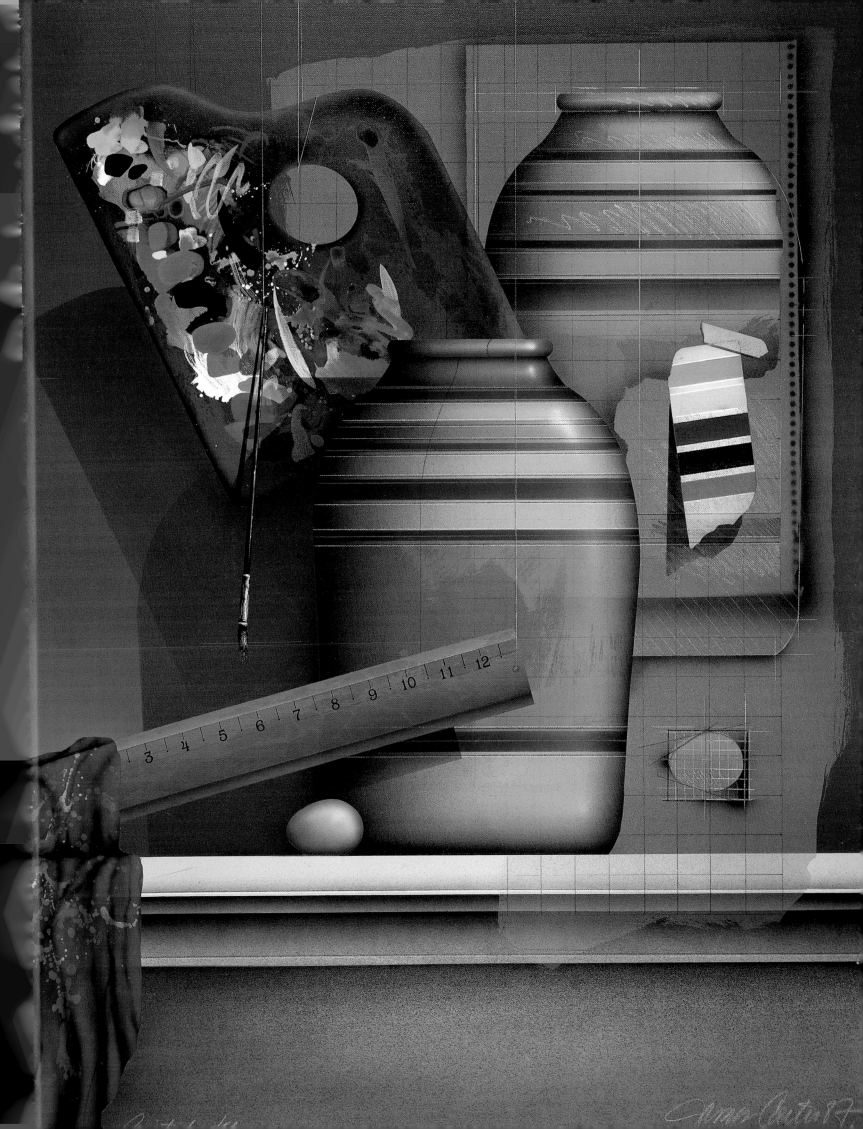

JAMES CARTER, ARCHITECT OF DREAMS BY ED McCORMACK

Recently, when the contemporary painter and printmaker James Carter saw the Kevin Costner film "Field of Dreams," he was deeply struck by the scene showing a baseball diamond surrounded by a high field of corn—for here was an image finally worthy of his own potent blend of Americana and surrealism; of the commonplace and pure unadulterated magic.

As both an artist and a man, Carter comes across as American as baseball and Entenmann's cakes—after painting, two of his abiding passions. Born in 1948 in Port Chester, New York, he is a trim, youthful man with longish hair and a brushy mustache. Like many among the generation that came of age in the late sixties, he can remember sitting in the mud at Woodstock, waiting for the Aquarian Age to dawn, and still reveres certain rock stars of that era. Yet, his hip contemporary sensibility is tempered by an enduring love of tradition that gives his work its unique character. As a child, he would often watch his grandfather, the noted wildlife artist Ridley Carter, painting his meticulous watercolors. Traces of that formative experience remain in the images of animals, both domestic and exotic, that often appear in James Carter's exquisitely refined acrylic and airbrush paintings, as well as his equally detailed serigraphs and lithographs. One early series celebrated endangered species, such as the whale, the buffalo, the black rhino, and the zebra—an animal Carter considers one of nature's most surreal handiworks.

Although his animal images are so realistically rendered that one almost expects them to blink their eyes, the artist asserts that he prefers them to appear "stuffed, as though their natural habitat should be one of those fake nature settings in the Museum of Natural History." In fact, Carter's creatures inhabit even stranger still life settings, where they co-exist with wine glasses, seashells, machine parts, and other incongruous objects with strongly symbolic overtones. Having been displaced by mankind's carelessness and greed, they now seek refuge in metaphysical environments whose blatant artificiality dramatizes their plight.

But perhaps the most affecting animal image in Carter's paintings and prints is that of the ordinary dairy cow. Although not exactly endangered as a species, Carter's cows are elegiac figures, seemingly symbolic of lost American innocence. Closer in spirit to those in the pastoral landscapes of Courbet and Corot than, say, the campy cow-head wallpaper of Andy Warhol, these gentle beasts have a stoic bovine dignity that is genuinely moving, as they attempt to cope with their strange surroundings.

In the major acrylic painting, "The Optimist," for one splendid example, the hapless creature floats in midair before one of the cabinet-like structures that Carter often employs to segment his still life objects (in this case, four glass goblets containing colored eggs and seashells, as well as a brightly patterned compass). Stencilled on the animal's side, like the stamp of a government meat inspector, is the word "Cow." However, a neatly lettered sign, pointing to the animal's genital region, says "Steer," and its gender is made more ambiguous by the visual pun of the precise "bull's-eye" that surrounds its real eye like a comical monocle.

Even greater indignities are inflicted on the dissected cow set against fragments of vivid blue sky and combined with a butcher shop diagram in "Cow Puzzle," while the animal in "Study #1 Beltdrive Moon Jumping Machine" is hooked up to an infernal mechanical contraption that resembles a Rube Goldberg invention for the practical realization of a nursery rhyme. In the latter painting, the visual

6

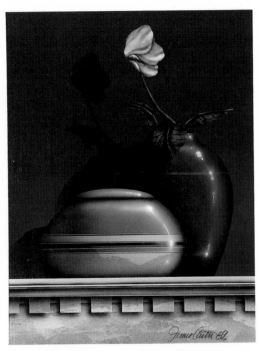

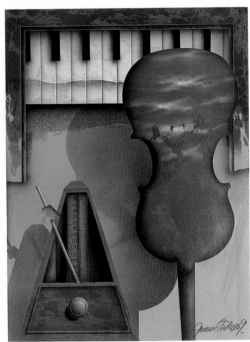

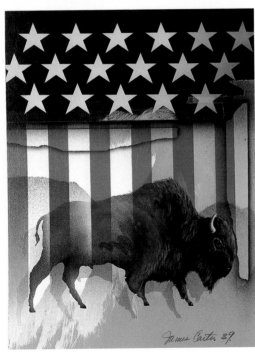

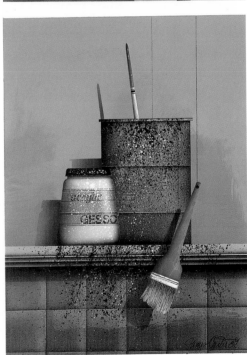

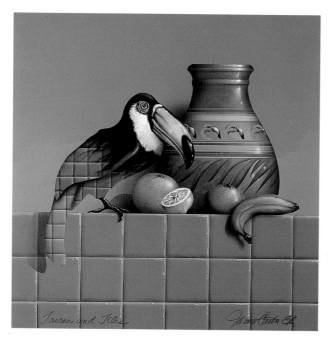

metaphor implicit in the merging of animal and machine suggests the end of the pastoral dream at the onset of the industrial era.

Such imagistic juxtapositions—so thoroughly in the mainstream of contemporary aesthetics, yet haunted by the poignant poetry of the American past—can also be seen in Carter's important series inspired by Western themes. These combine fragments of pottery, feathers, peace pipes, and other American Indian artifacts in spare, sometimes stark, compositions that come close to abstract illusionism, even while suggesting a host of symbolic allusions and meanings. The series reaches its apex of stunning simplicity in "Waterfall," its composition dominated by a broken Hopi jug mysteriously suspended from strings above three blue spheres.

By contrast, "A Fall From Grace (Study #1 The Flexible Dream)" is a more complex painting, particularly notable for its dense imagistic layering.

As its title suggests, this emotionally laden canvas depicts the erosion of Native American culture. The upper-half of the powerfully emblematic composition is dominated by a ghostly animal skull, superimposed over the Stars and Stripes; while below, a large peace pipe floats like a dirigible over shadowy mountain plains.

In their attempts to pin down his highly original, sometimes perplexing imagery, and place it within the context of art history, critics have likened James Carter to a broad range of illustrious predecessors, past and present. For his continuation of a distinctively American still life tradition, he has often been compared to the nineteenth century trompe l'oeil illusionist William Harnett. Others have compared his unique brand of surrealism to the poetic box-constructions of Joseph Cornell. Natural parallels have also been drawn to the pristine contemporary realism of William Bailey, as well as the full frontal "object-ness" of Jasper Johns and Jim Dine. All such comparisons have some basis in truth: Carter does indeed update Harnett's trompe l'oeil technique to create an illusionistic sense of three-dimensional space with "carpentered geometries" (as one critic referred to them) that recall Cornell's boxes. He also admires Bailey's peculiarly American blend of secularism and puritanism (although the ironic post-modernist literalism in his own handling of the object is more philosophically akin to that of Johns and Dine).

Carter also cites the influence of European Dadaism and Surrealism on his work. His enthusiasm for such artists as Max Ernst and René Magritte began at an early age, when his father's business took the family to Berlin for five years and he promptly became immersed in European art, architecture, and history. The lessons he learned from Magritte are especially evident in paintings such as the major acrylic "Un Mare di Passione,"

CONTINUED ON PAGE 146

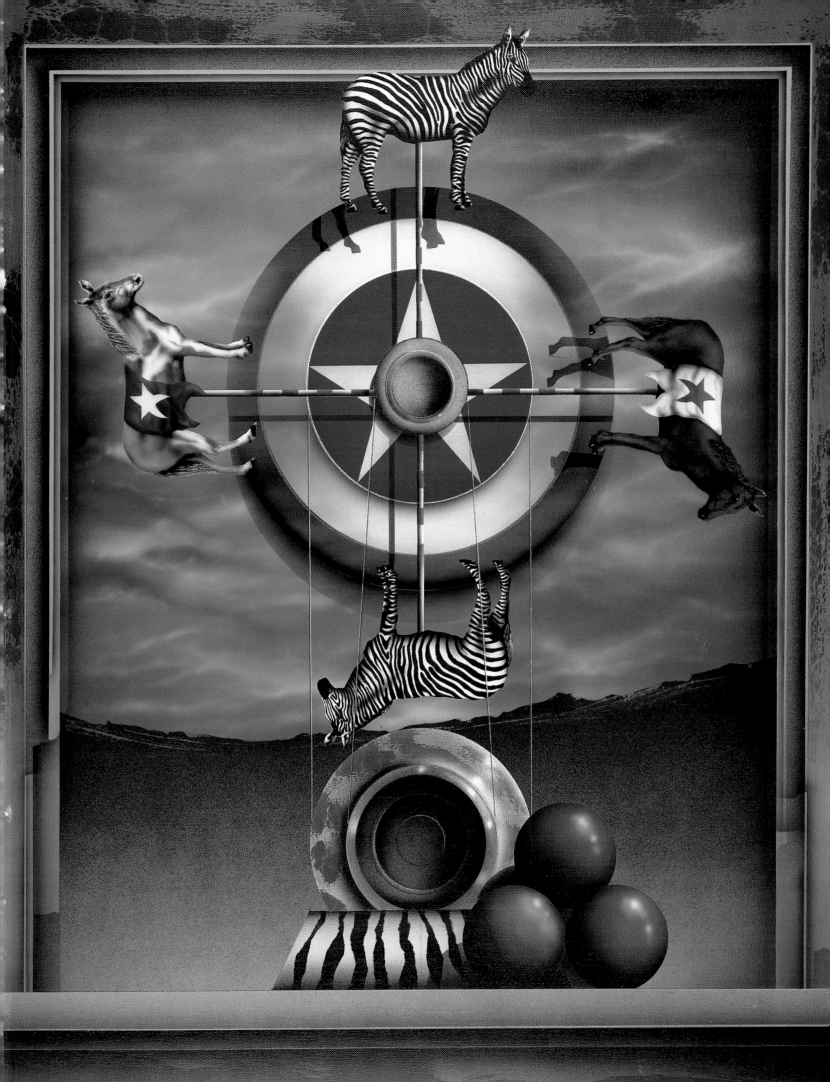

ook, if there's an egg in it and no bird, then it's surreal.

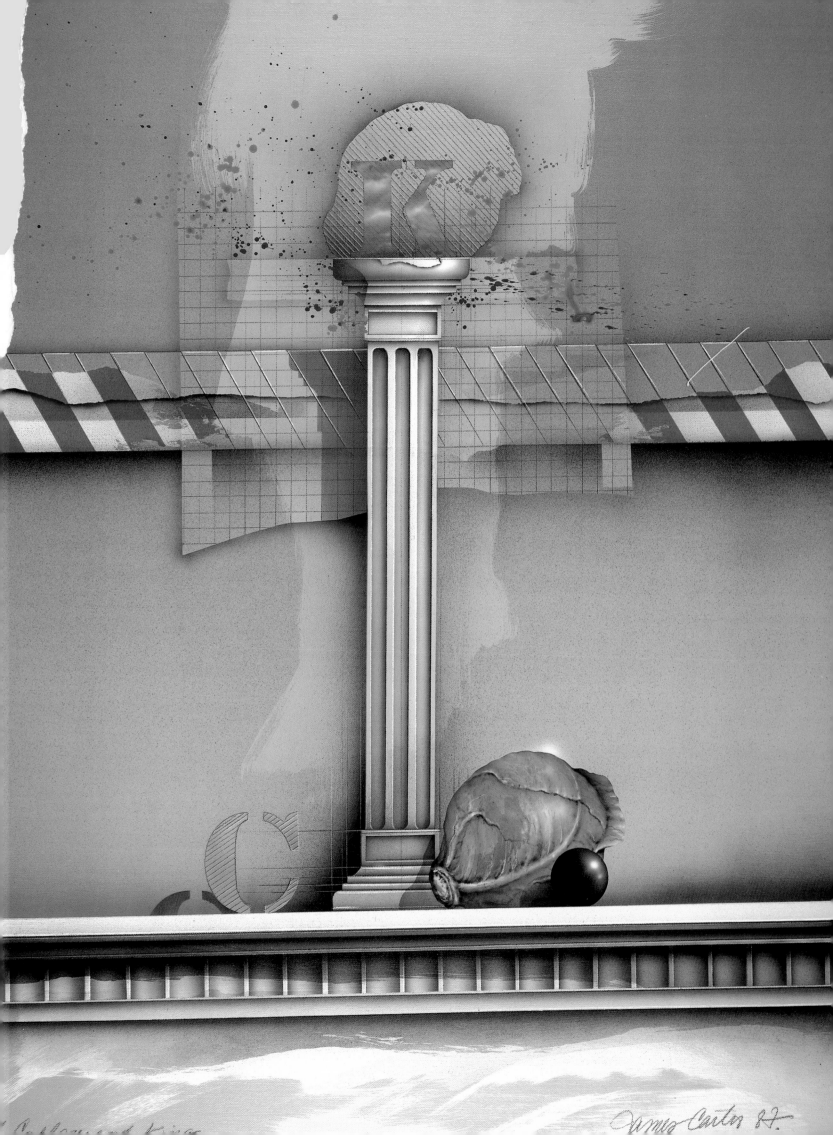

James Carter 87.

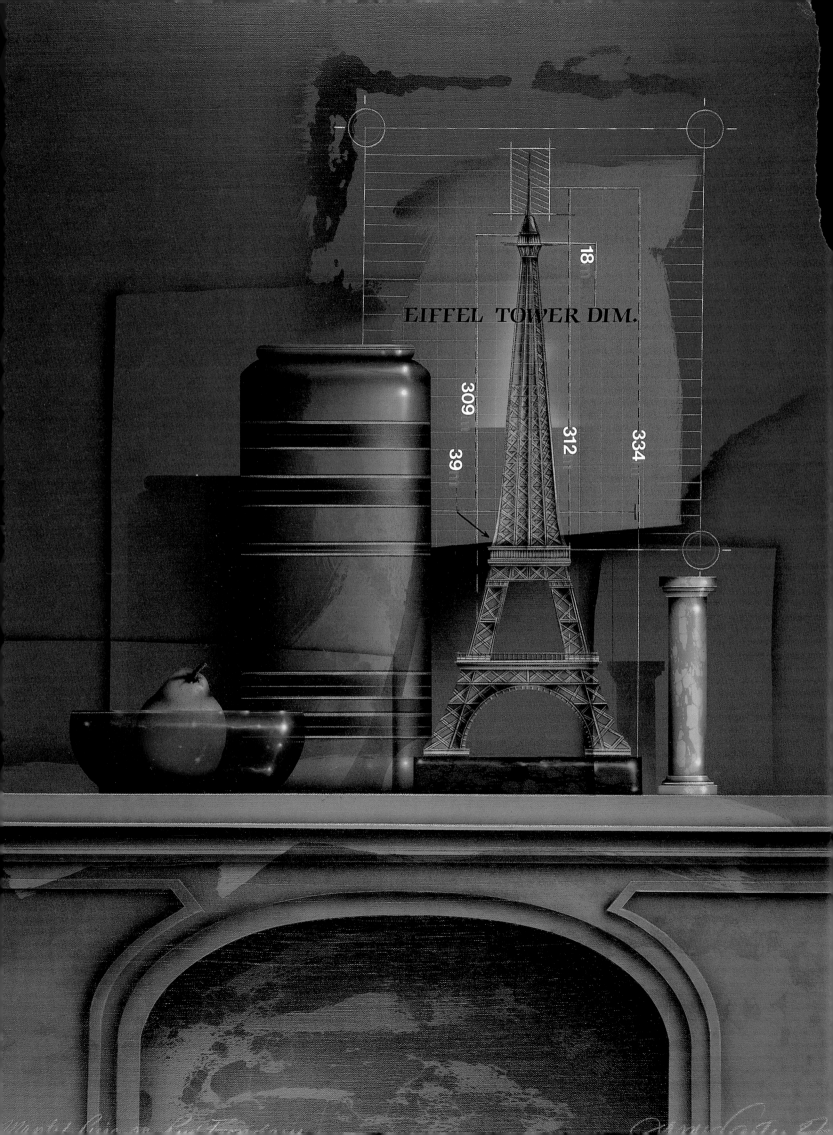

EIFFEL TOWER DIM.

18

309

312

334

39

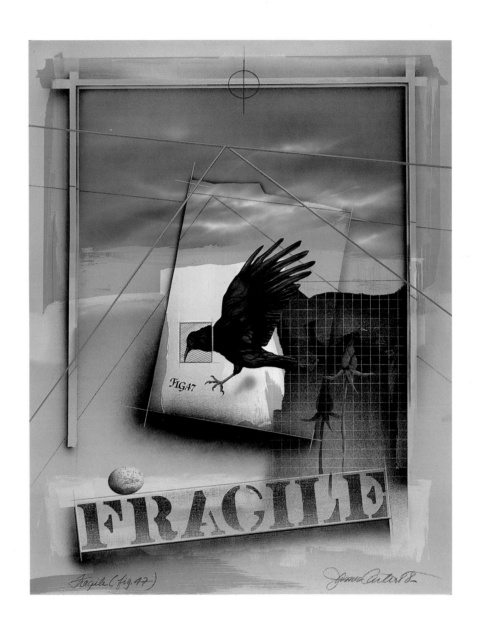

FRAGILE (FIG. 47) ABOVE
MANTEL PIECE ON RUE FONDARY OPPOSITE

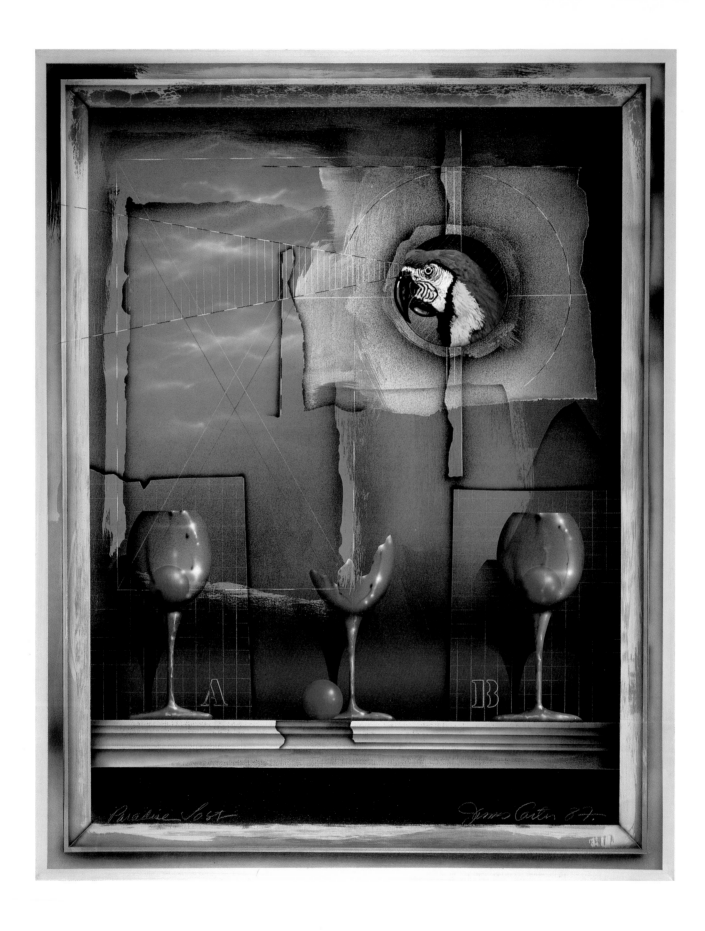

Paradise Lost

James Carter 87.

14

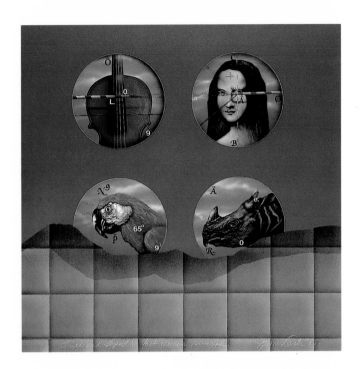

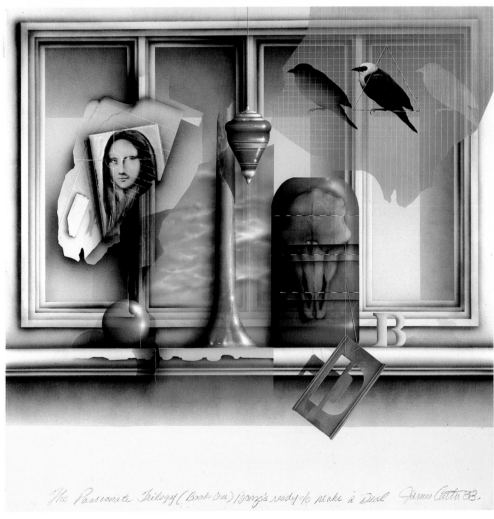

TRUTH AND LEGEND (FACT VERSUS PRINCIPLE) TOP
THE PASSIONATE TRILOGY (BOOK ONE) BONZO'S READY
TO MAKE A DEAL ABOVE
(FULL SIZE DETAIL, PAGES 16 & 17)
PARADISE LOST OPPOSITE

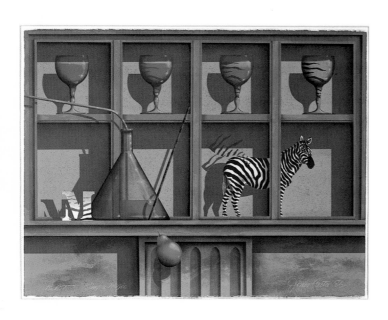

SIMPLE MAGIC ABOVE
GLASS OF RED RIGHT

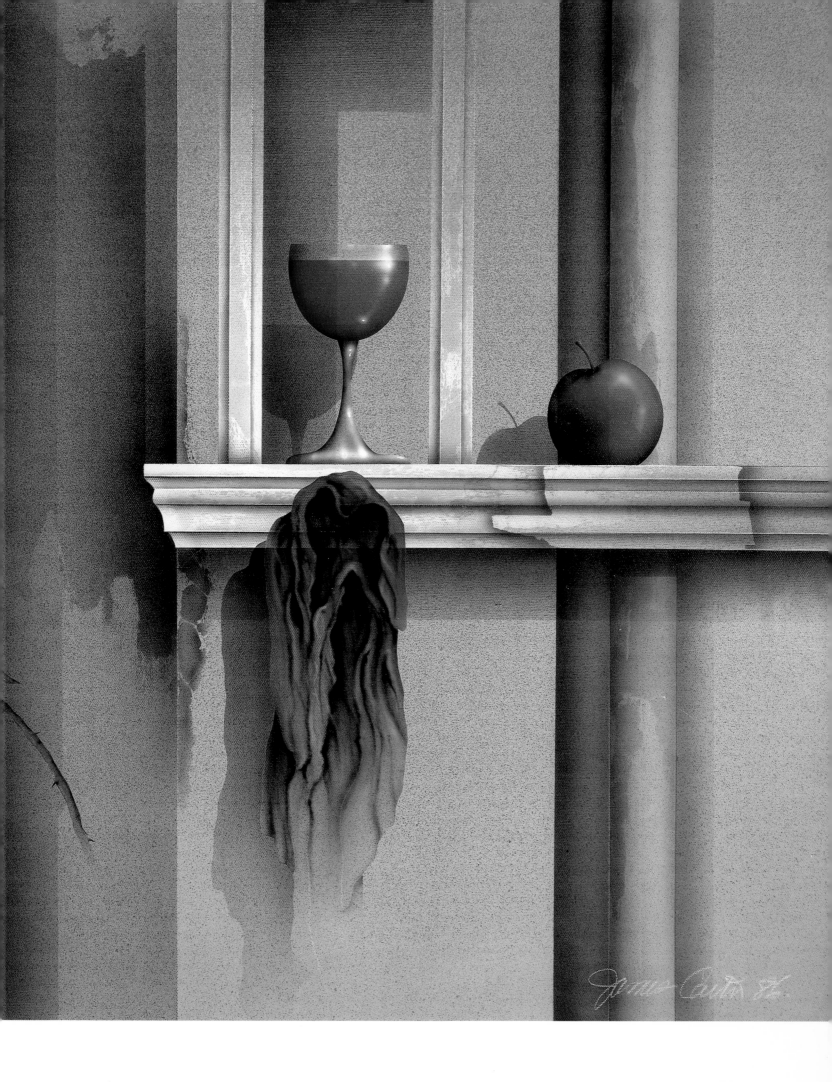

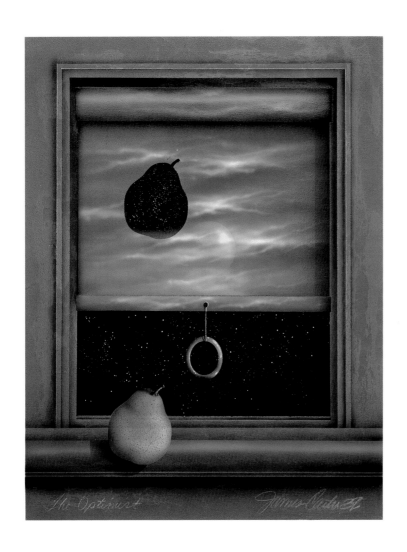

THE OPTIMIST ABOVE
STILL LIFE WITH LEOPARD CLOTH RIGHT

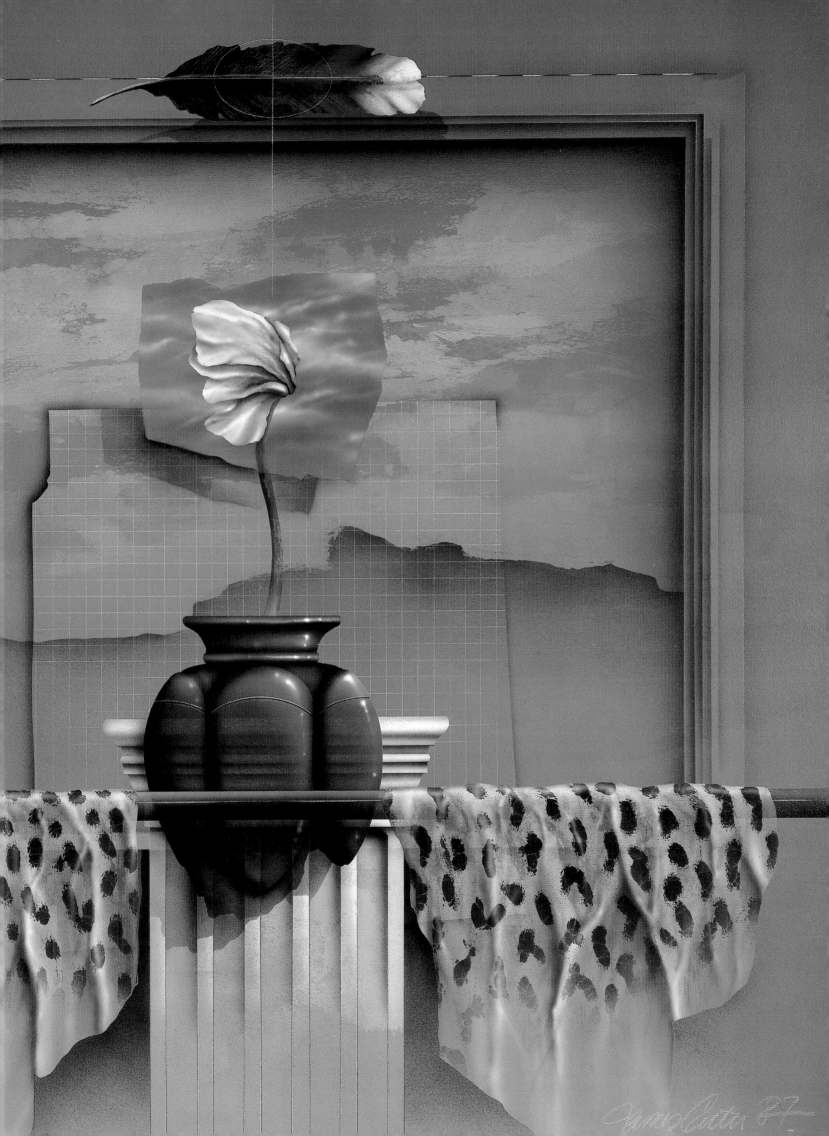

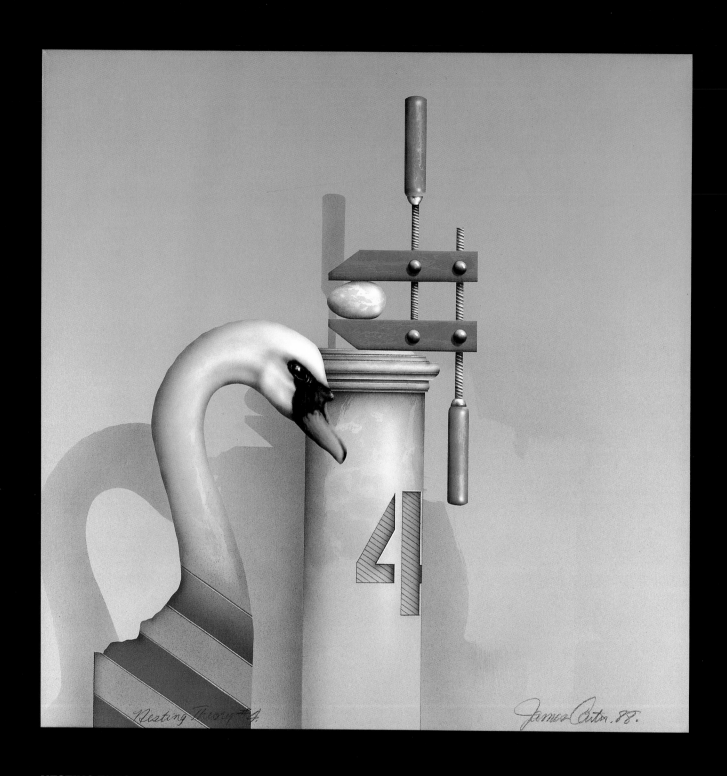

Nesting Theory #4.

James Carter. 88.

NESTING THEORY #4 ABOVE
CHANGING WEATHER OPPOSITE

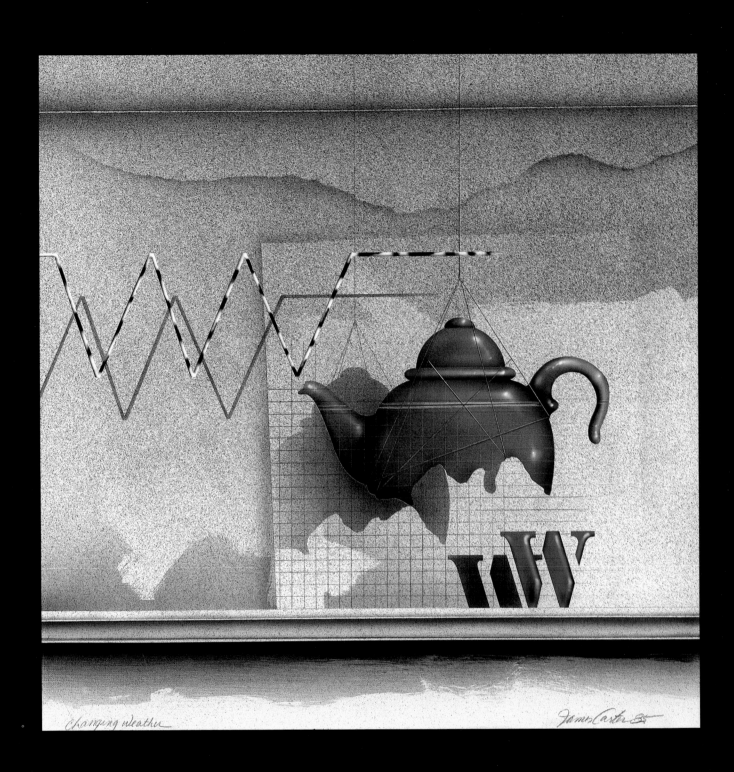

Changing Weather

James Carter

Traditional still lifes are the core of all of my compositions. Through the grouping of objects, related or not, I can create a believable situation yet still be free with the use of pattern and color. The shelf or mantel establishes a setting where the subjects can interact within the environment I choose for them.

THE PANTRY

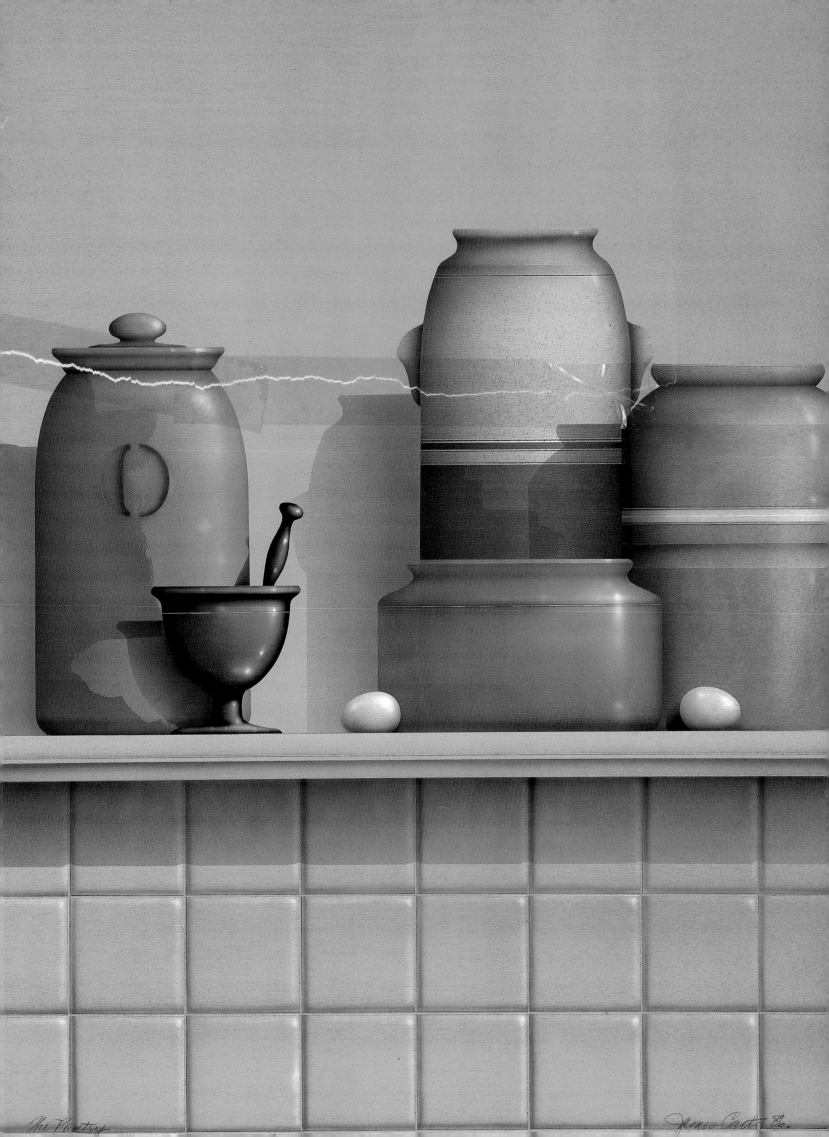

The Pantry James Carter 86.

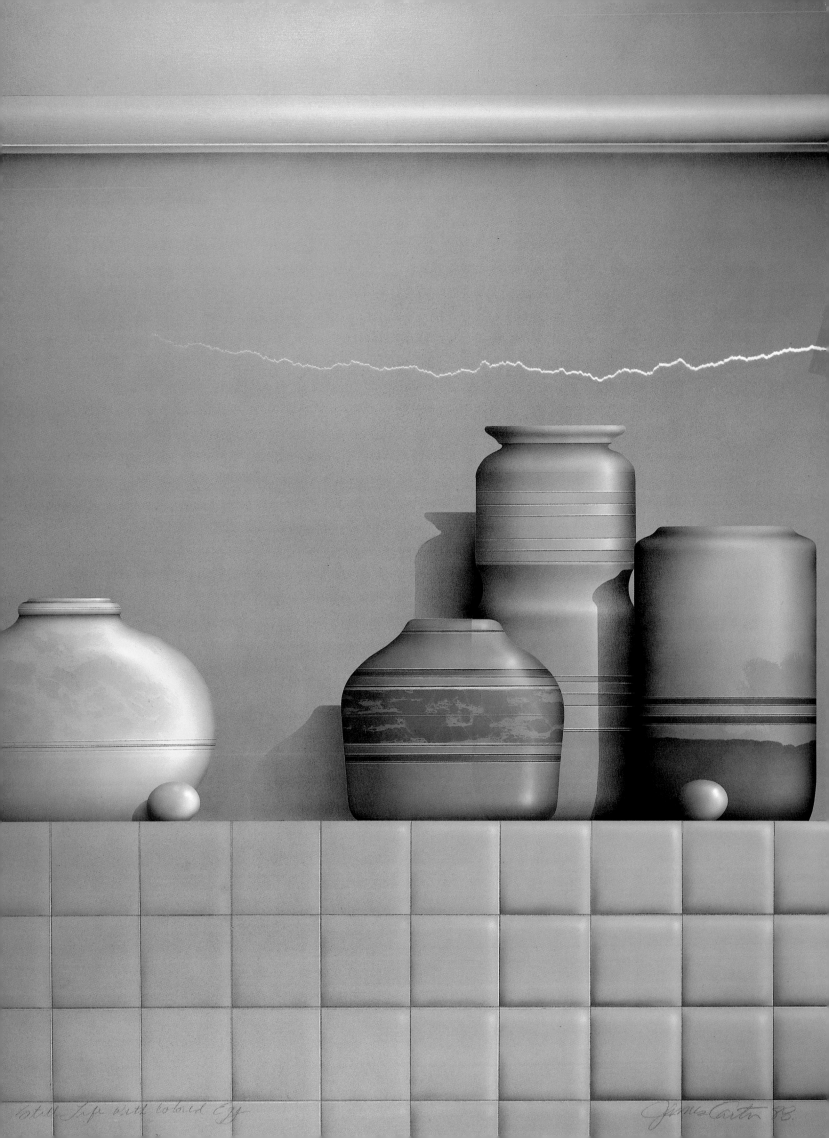

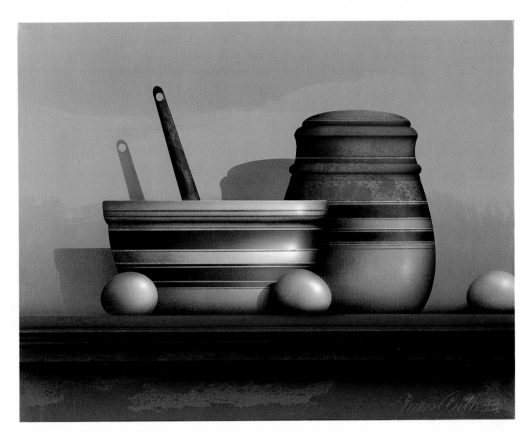

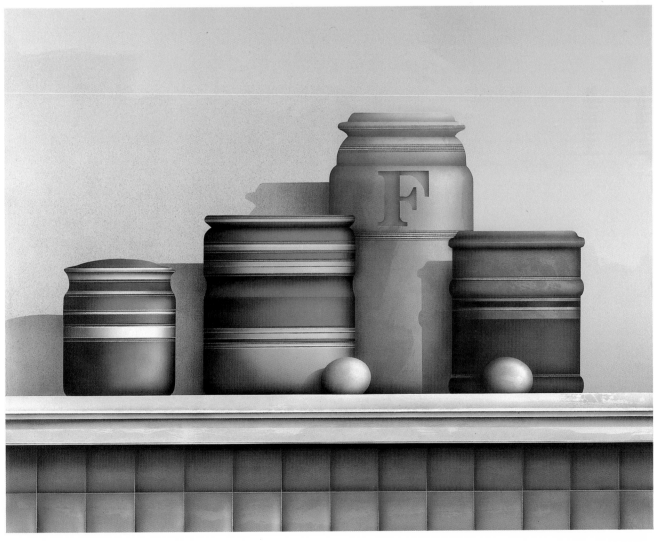

STILL LIFE WITH COLORED EGG OPPOSITE

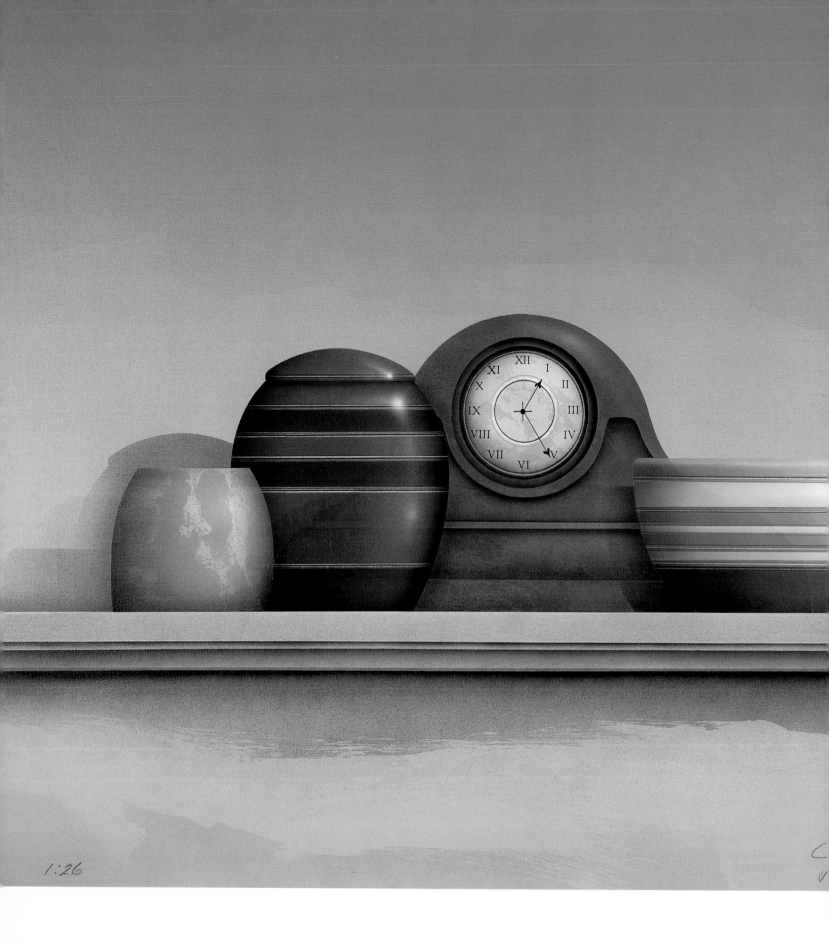

1:26

28

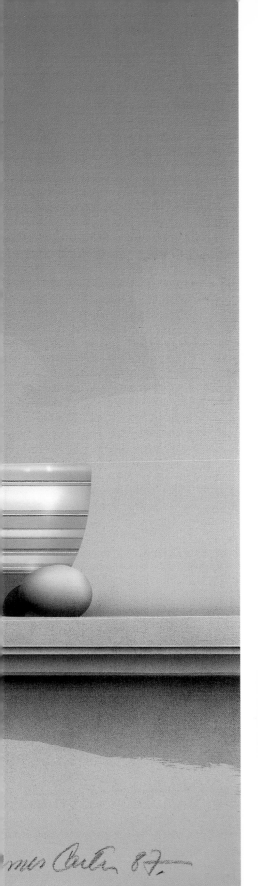

1:26 LEFT

PRETTY PITCHER BELOW

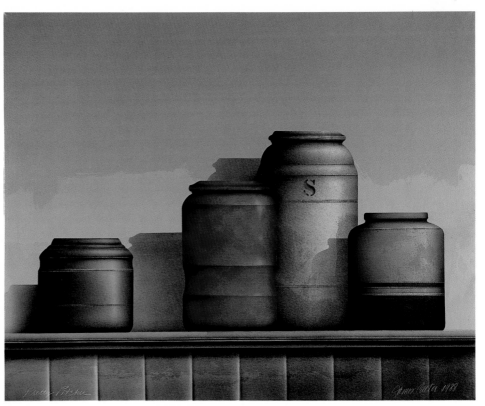

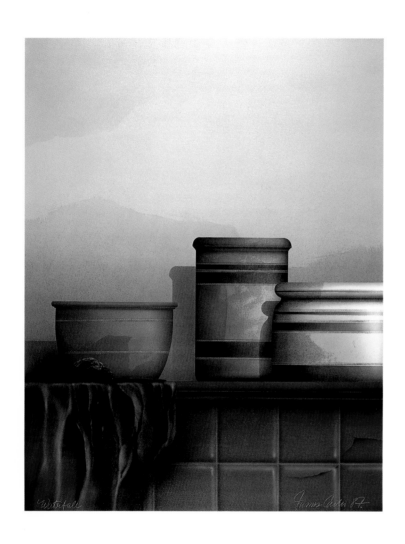

WATERFALL ABOVE

(FULL SIZE DETAIL, RIGHT)

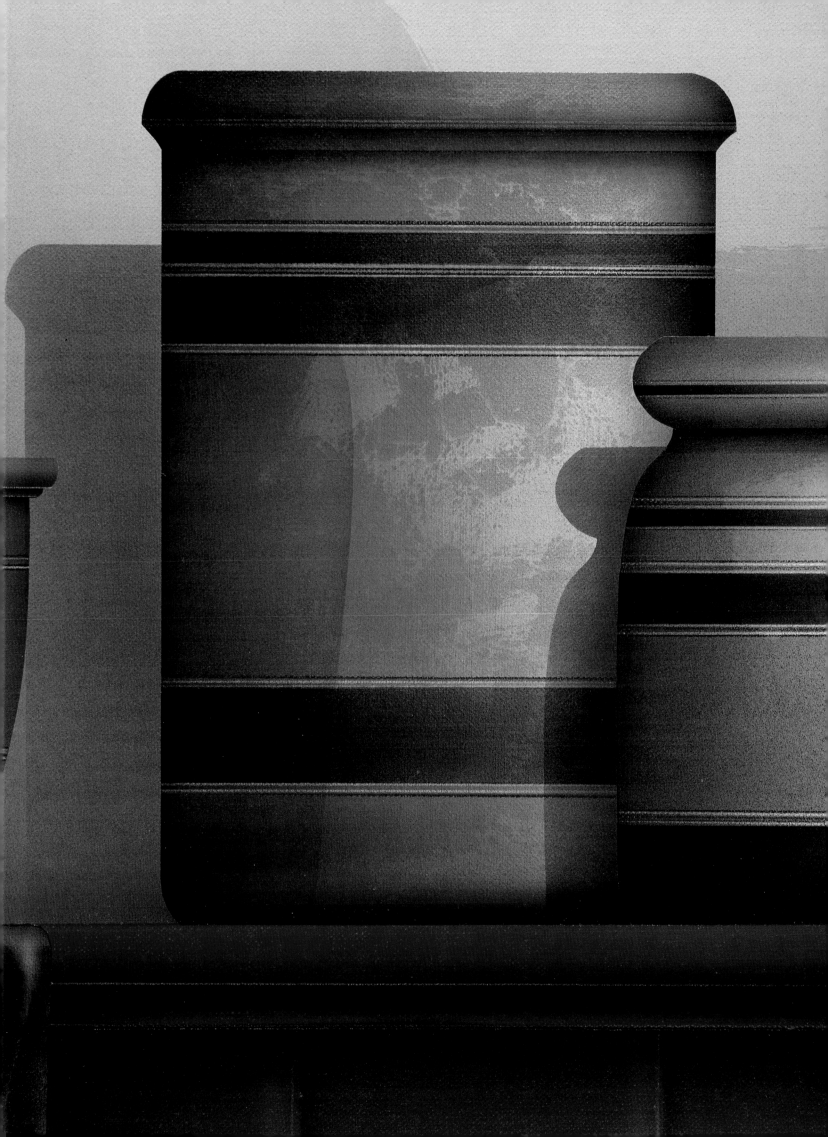

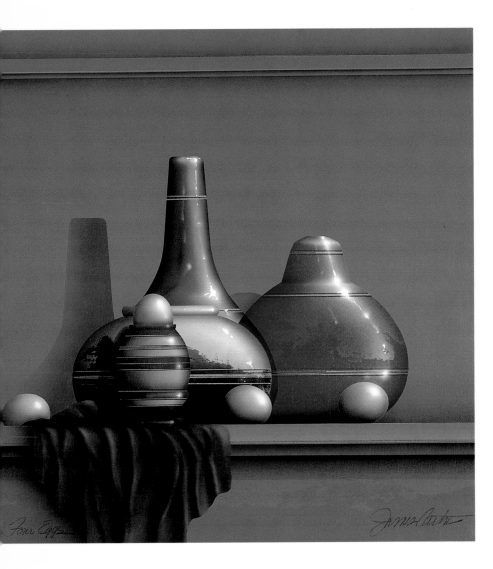

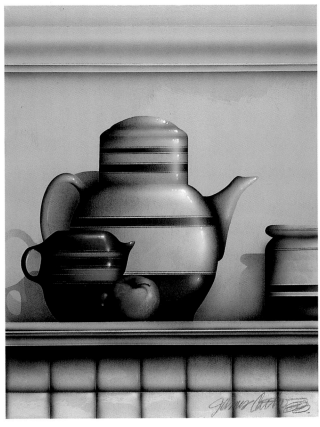

TEAPOT AND APPLE ABOVE
FOUR EGGS LEFT

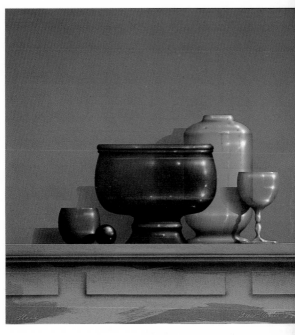

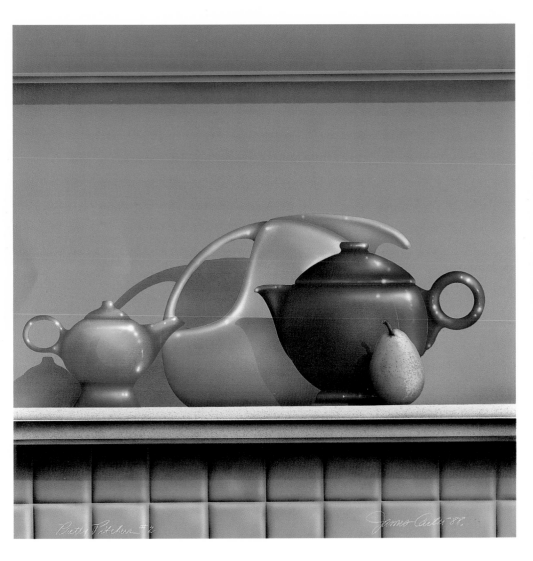

GLASS ABOVE
PRETTY PITCHERS #2 LEFT

33

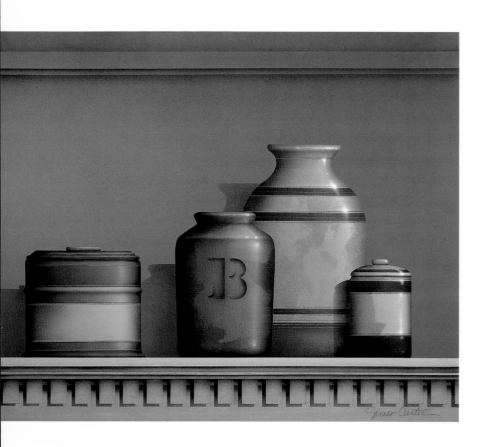

STILL LIFE WITH THE LETTER B ABOVE
PEPPER & SALT RIGHT

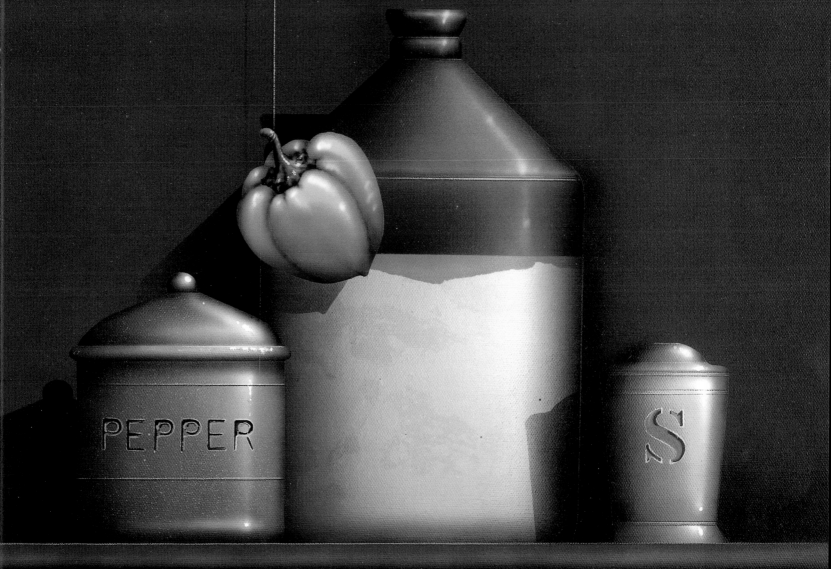

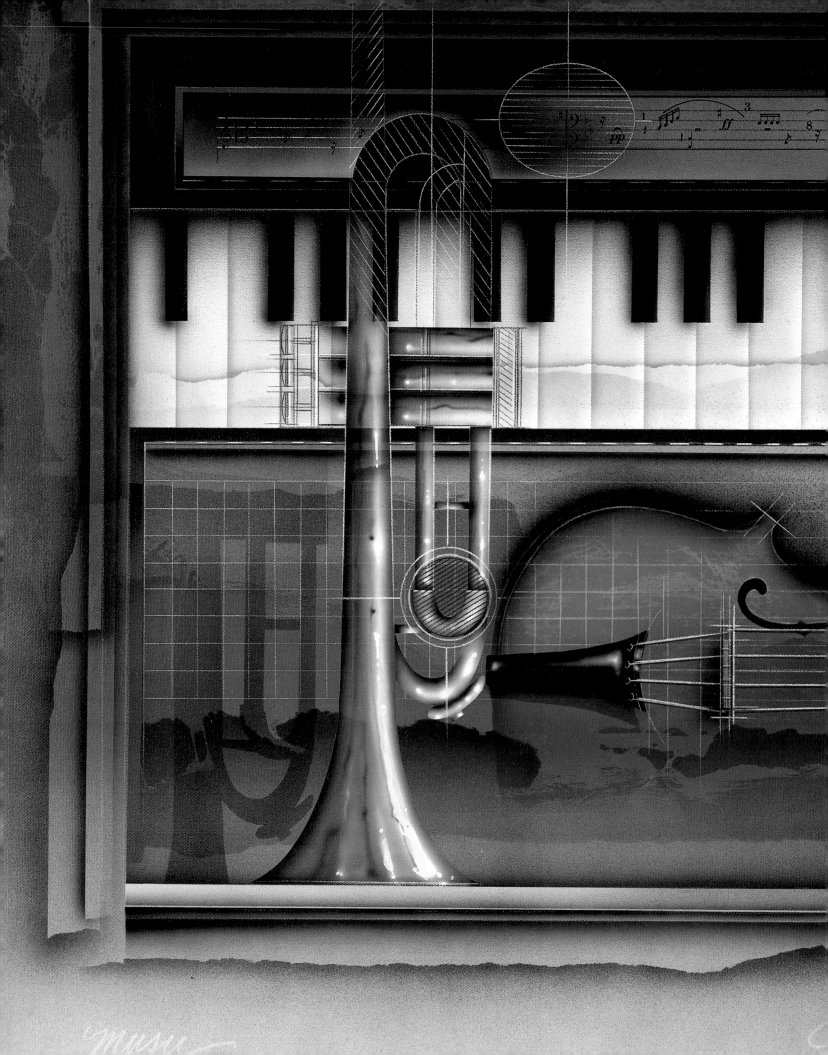

nstruments have sensuous
shapes, as do flowers or artists'
models. They are as visually
lyrical as they sound. Music is
reminiscent, it slows time, and
shapes memories.

MUSIC

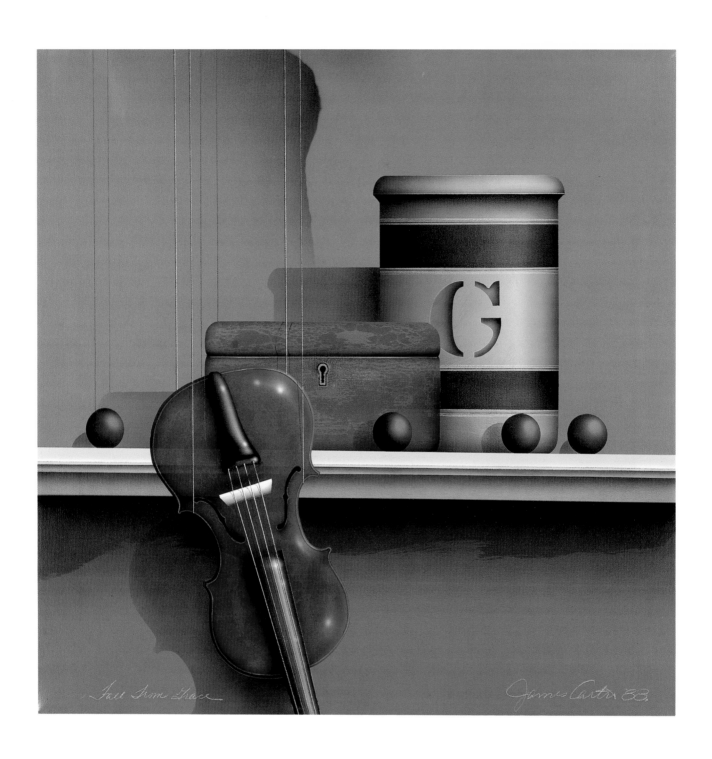

Fall From Grace James Carter 88.

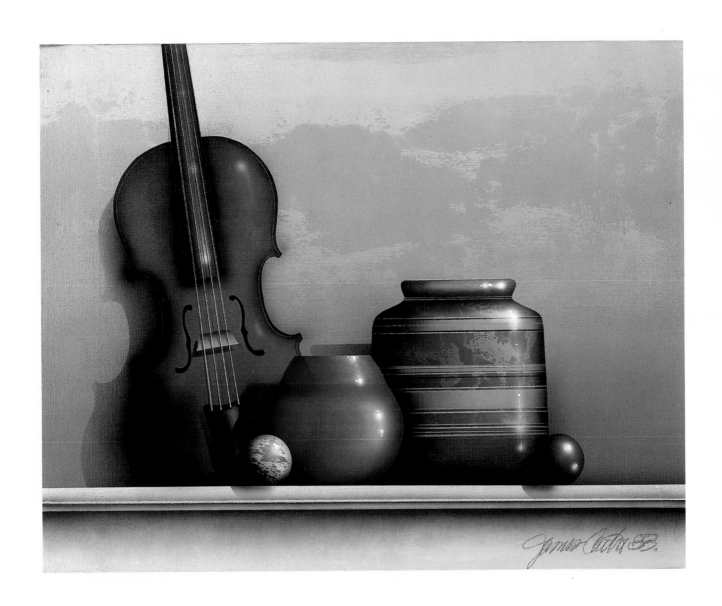

STILL LIFE WITH VIOLIN ABOVE
FALL FROM GRACE OPPOSITE

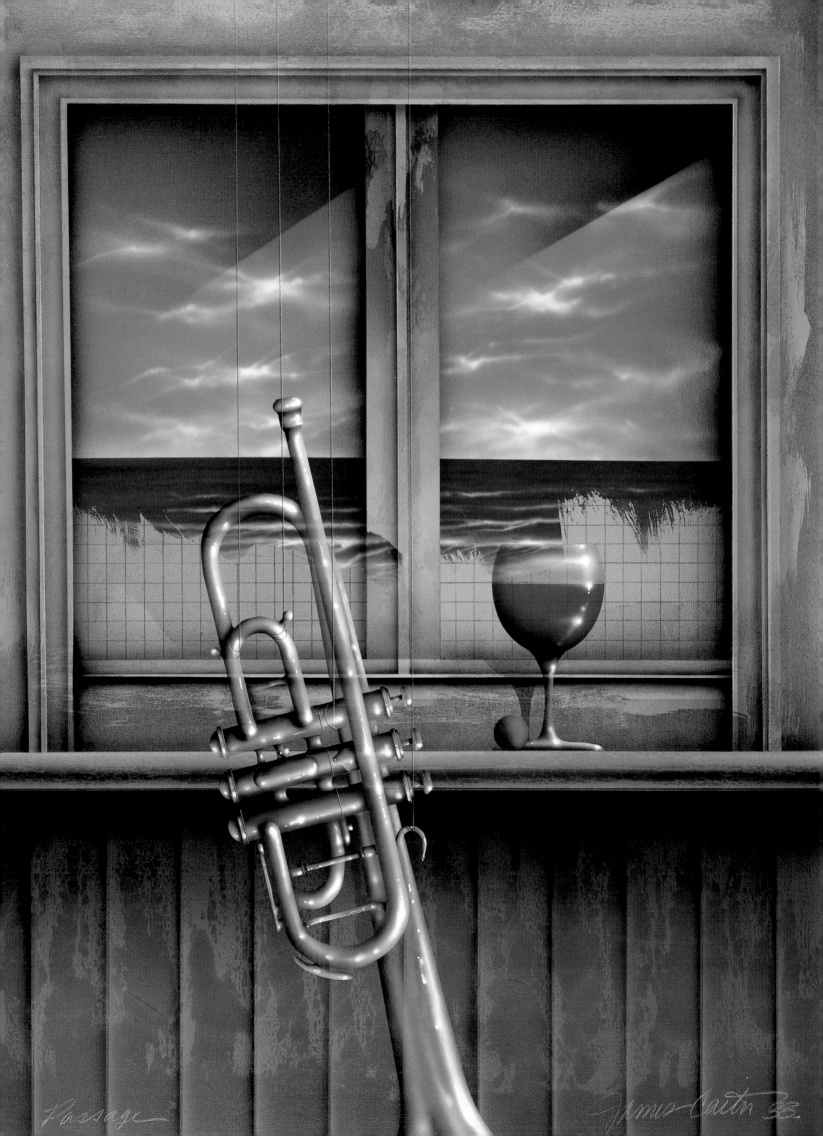

Passage James Carter

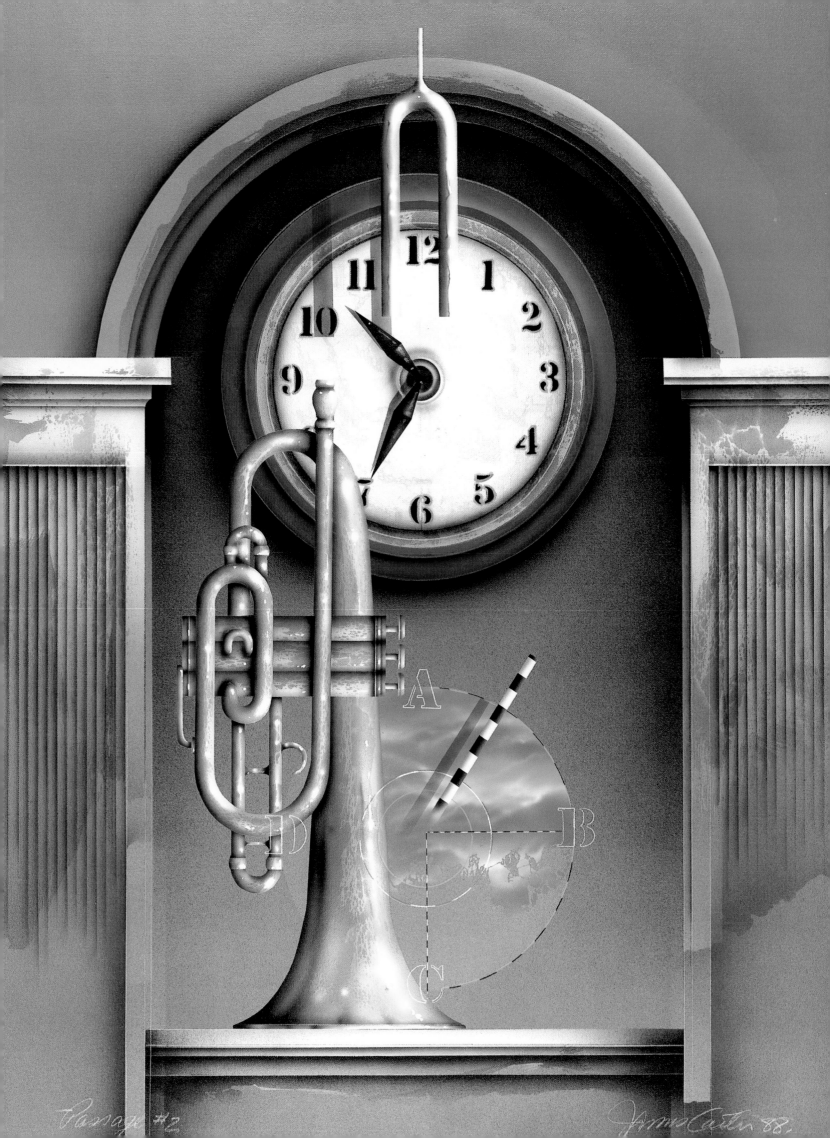

Passage #2 James Carter 88

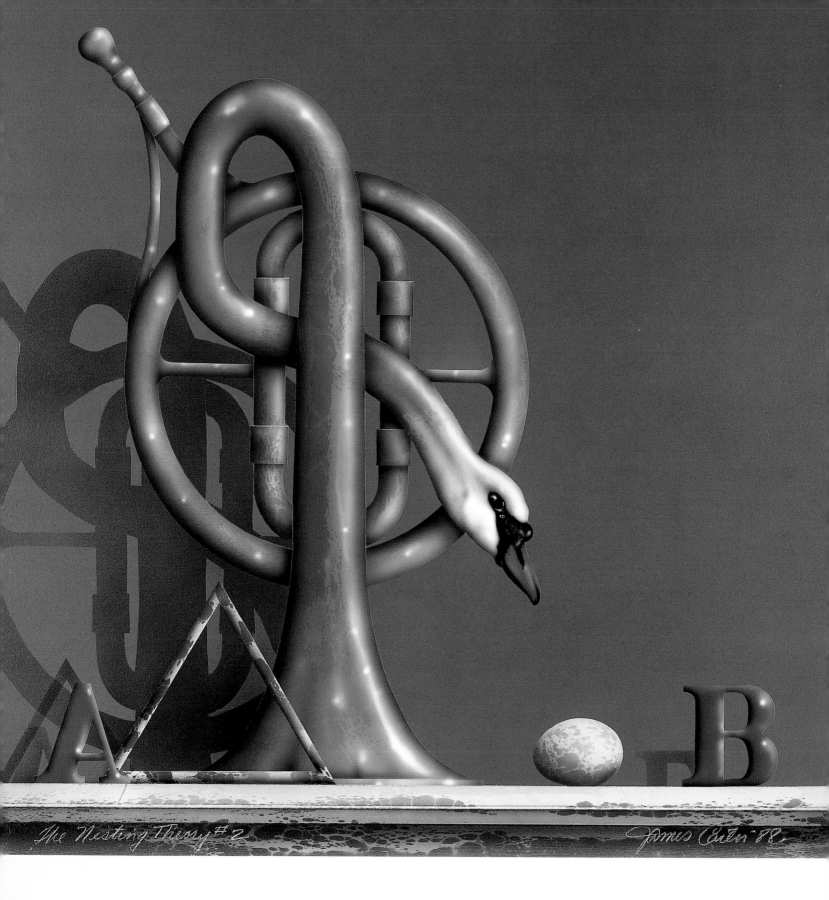

The Nesting Theory #2

James Gilie '88

THE NESTING THEORY #2 ABOVE
THE NESTING THEORY #3 OPPOSITE, TOP
CLEARING WEATHER OPPOSITE, BOTTOM

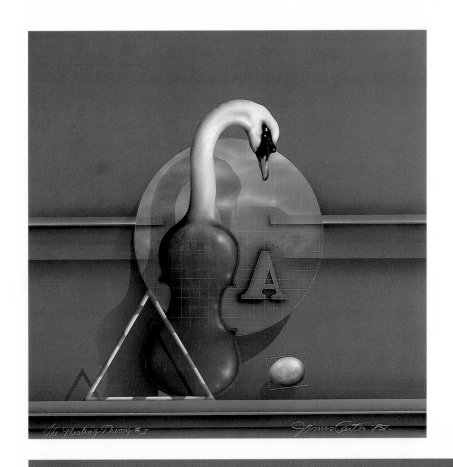

The Nesting Theory #3

James Carter '83

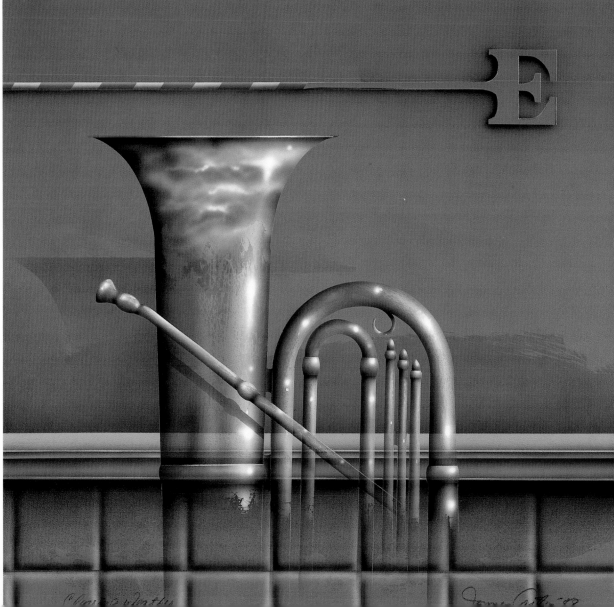

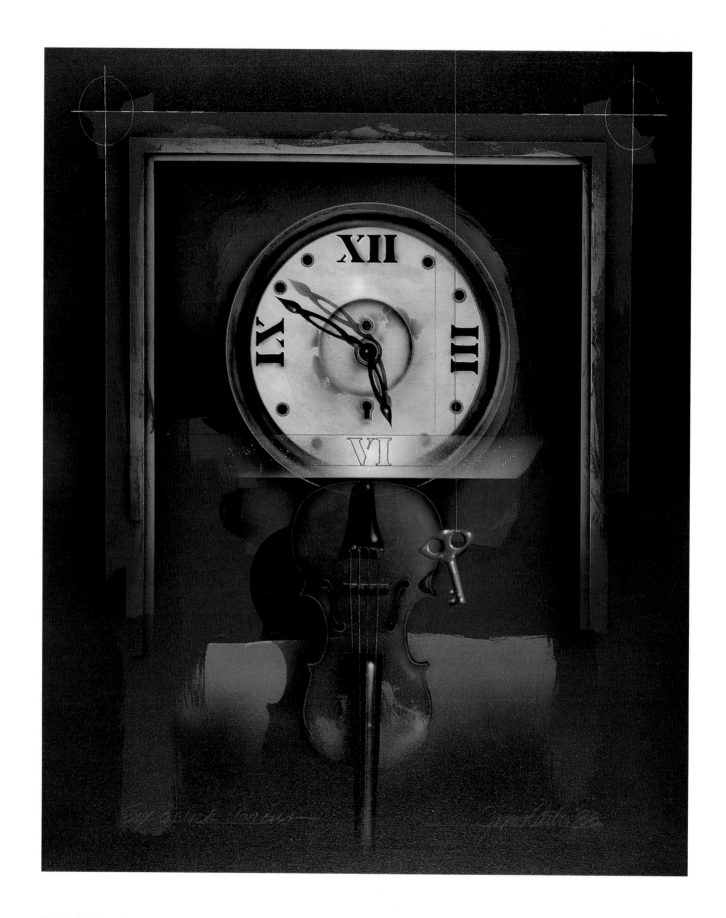

SIX O'CLOCK CONCERT ABOVE
PASSION PLAY OPPOSITE, TOP
(FULL SIZE DETAIL, PAGES 46 & 47)
MEMORY OPPOSITE, BOTTOM

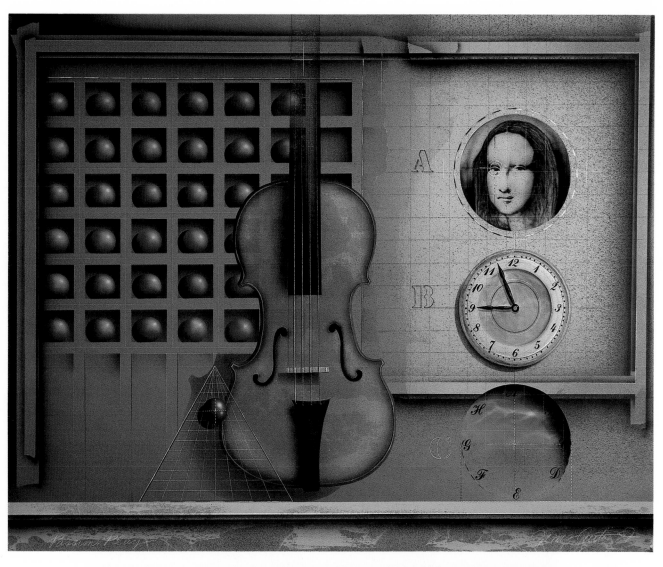

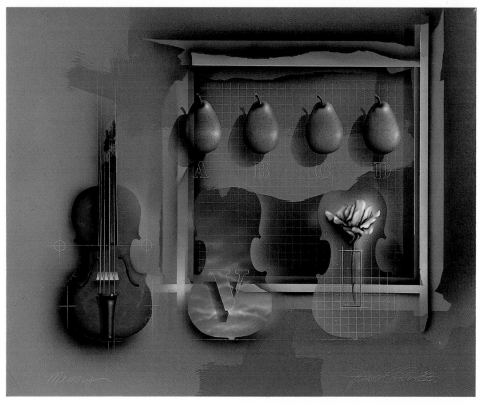

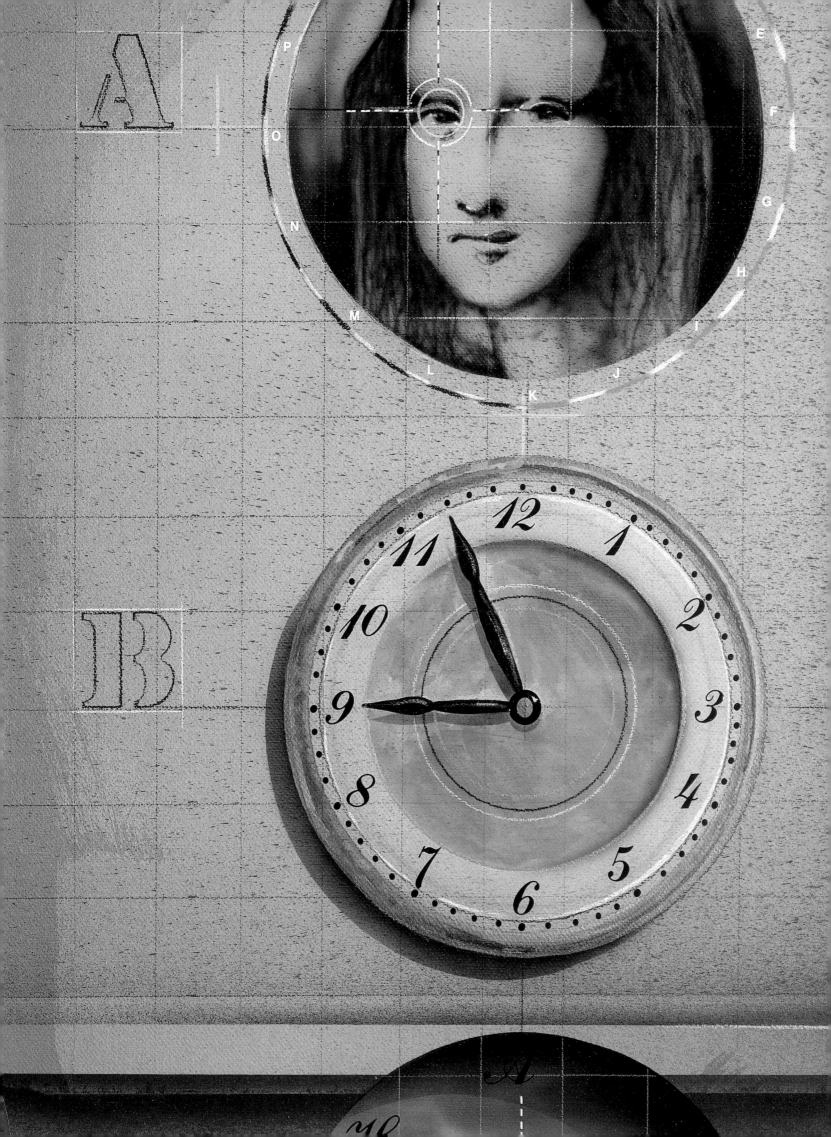

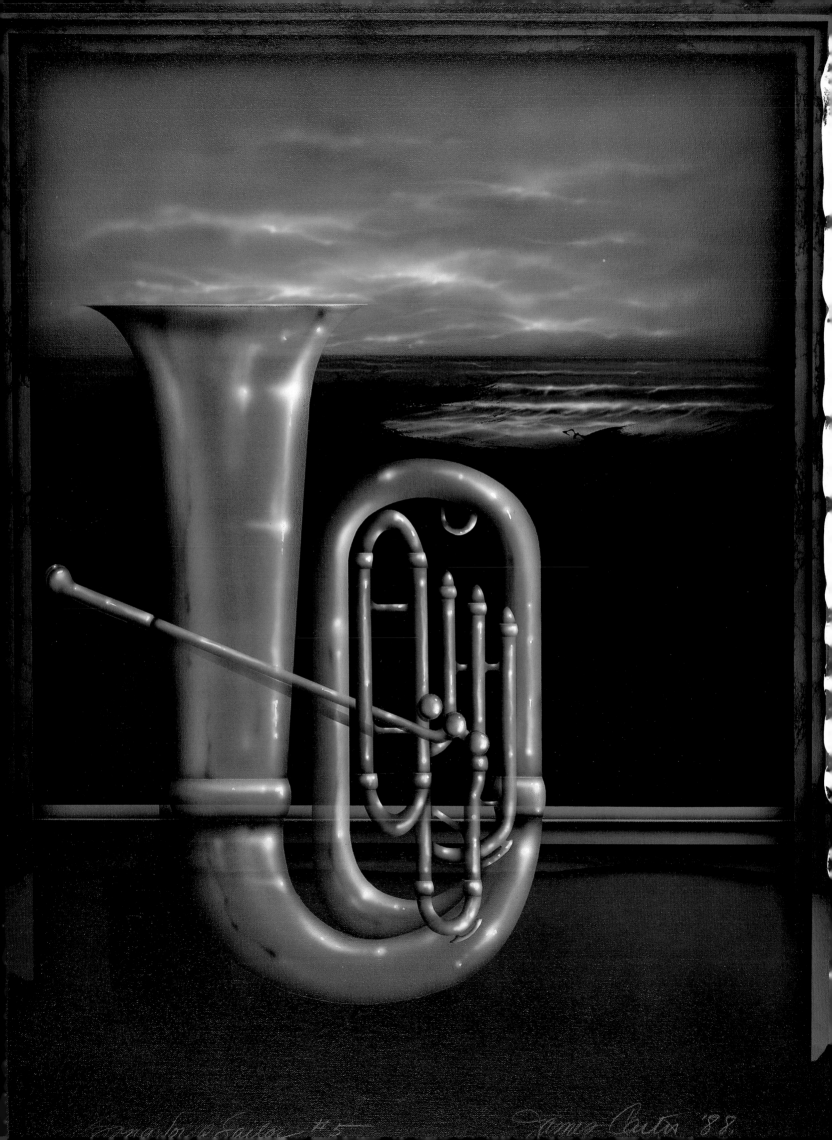

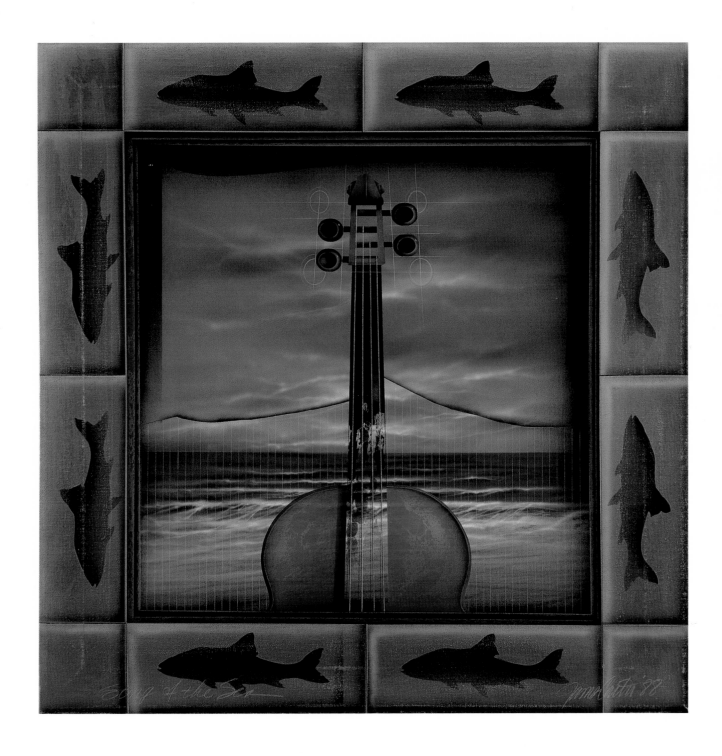

SONG OF THE SEA ABOVE
SONG FOR A SAILOR #5 OPPOSITE

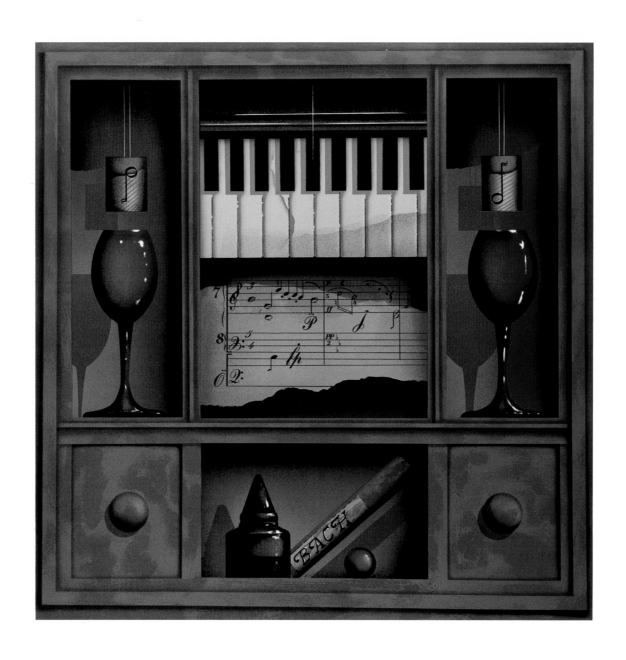

MUSIC BOX #1 ABOVE
MUSIC BOX #3 OPPOSITE

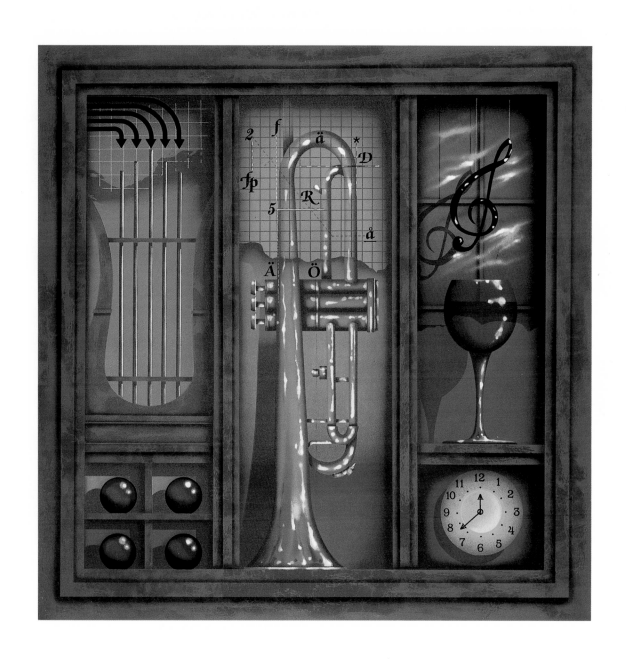

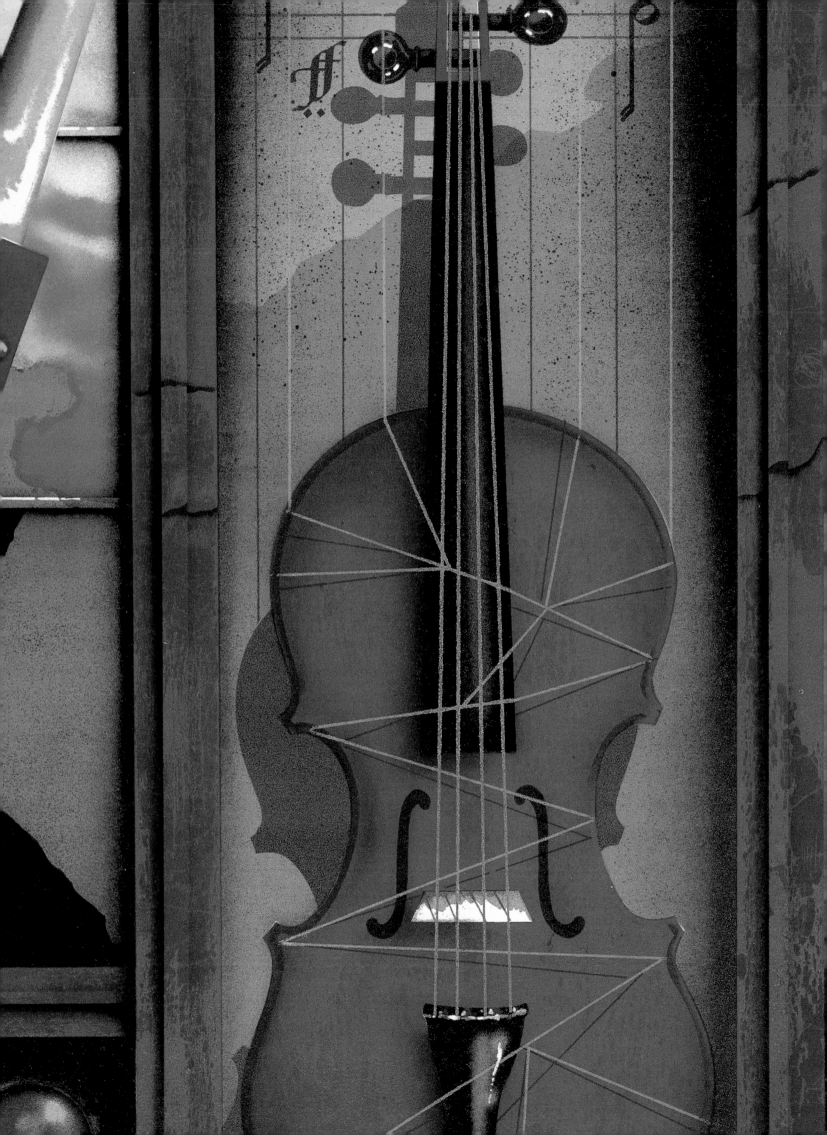

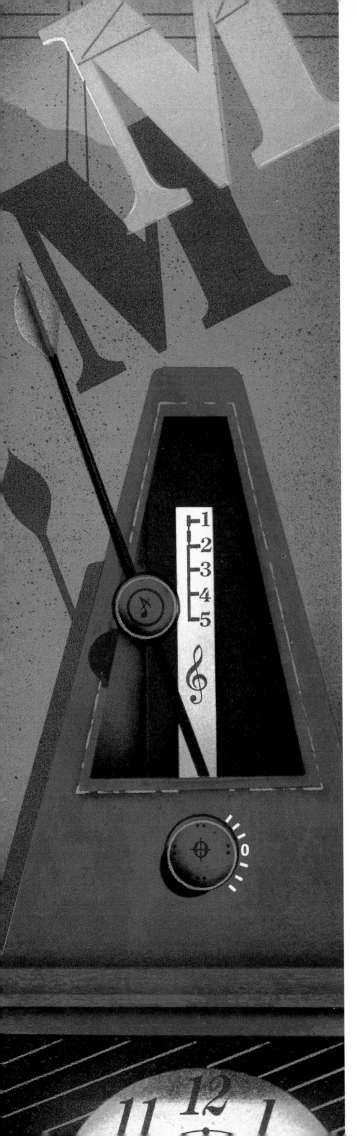

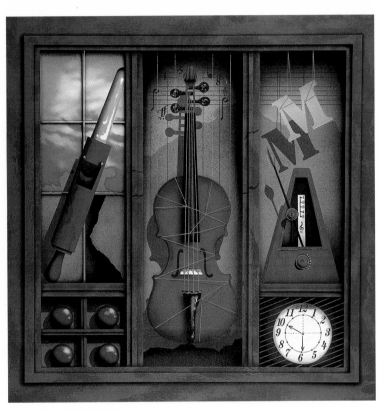

MUSIC BOX #2 ABOVE
(FULL SIZE DETAIL, LEFT)

ows, in field after field, seem unaware of any thing beyond their fences. Although lazy and slow, cows display a personality all their own. Whether they float weightlessly in the air or are pulled along by a single string, their mystique is there. It's part of who they are. Cows have inexhaustible uses.

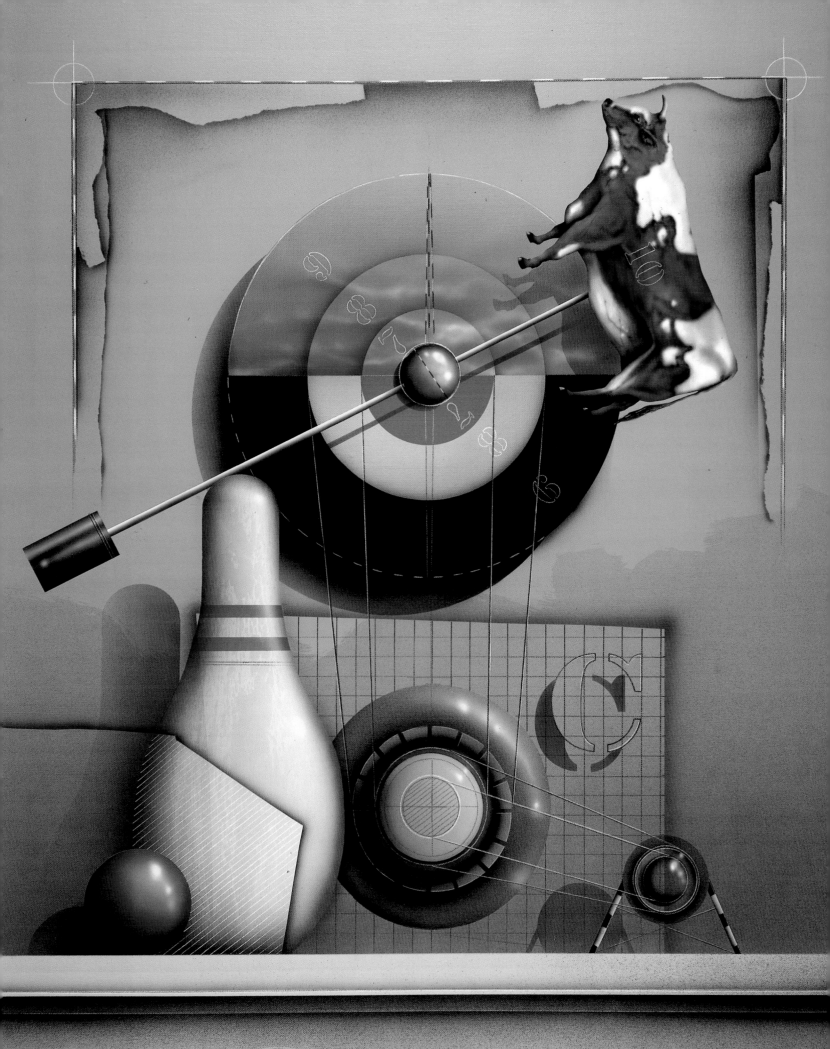

Carnival #2
James Carter '98

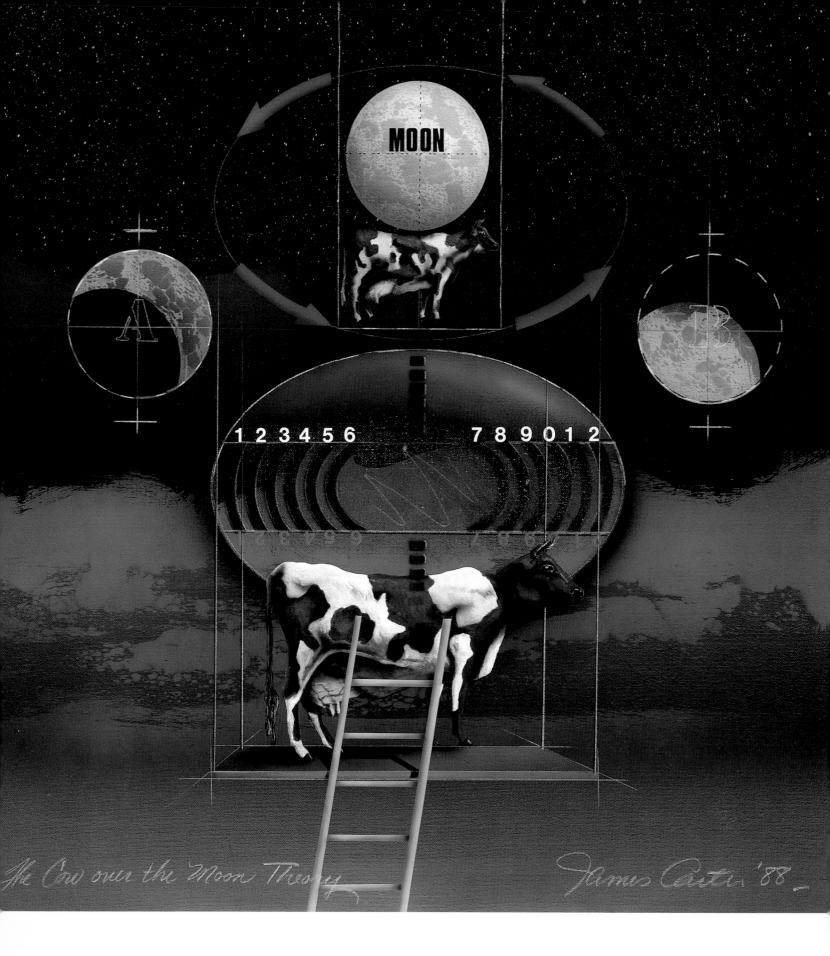

THE COW OVER THE MOON THEORY ABOVE
STUDY #1 BELTDRIVE MOON JUMPING MACHINE OPPOSITE

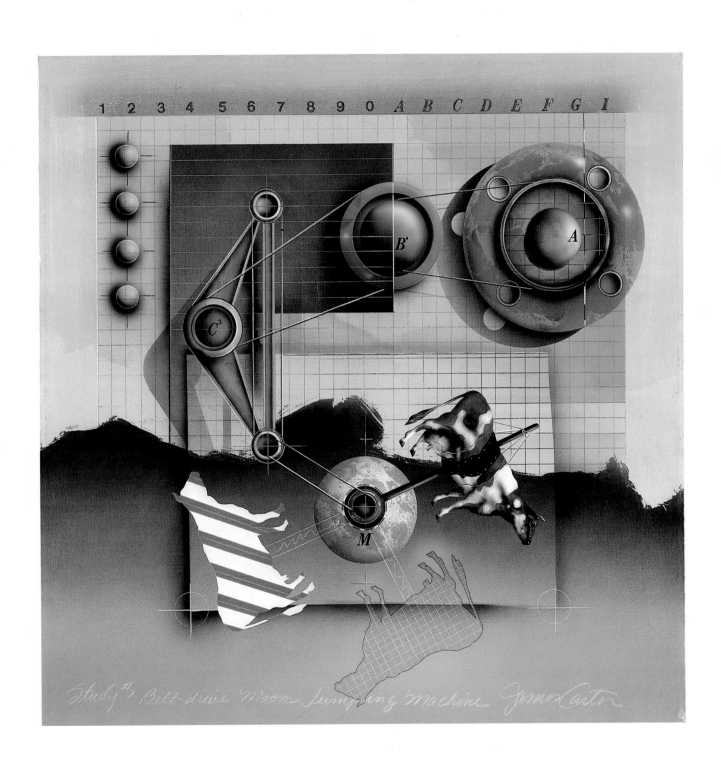

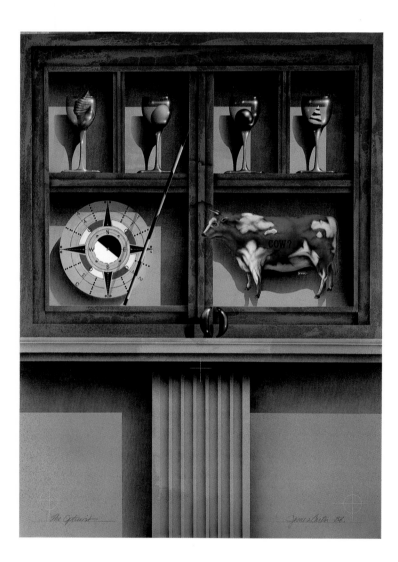

THE OPTIMIST ABOVE
(FULL SIZE DETAIL, RIGHT)

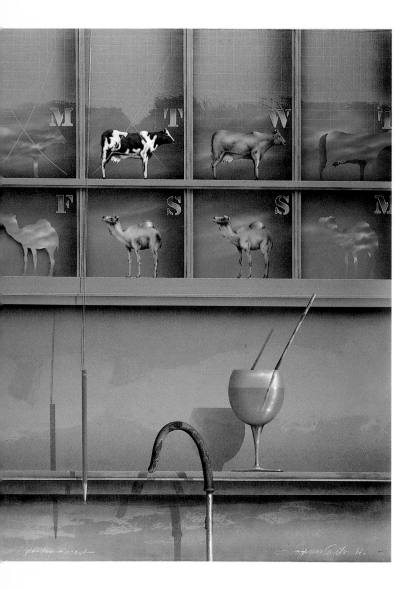

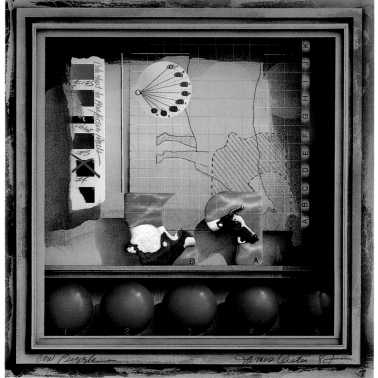

EIGHT-DAY FORCAST [sic] ABOVE
COW PUZZLE RIGHT

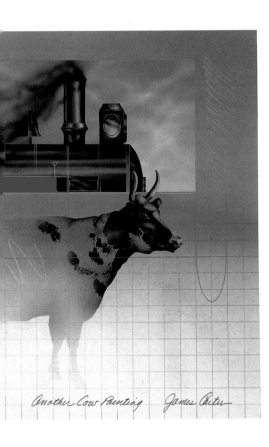

ANOTHER COW PAINTING LEFT
TOY COW BELOW

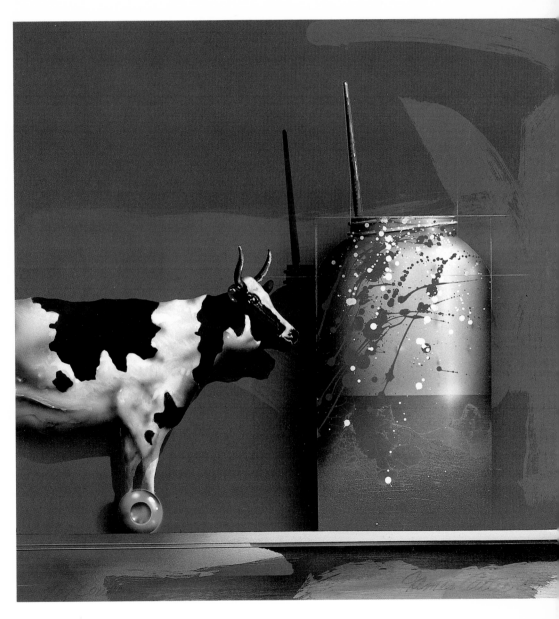

Paint cans are great subjects—right under my nose in my studio, the materials of the trade are all around me. With layers of splattered color, the paint can pieces afford me a freedom and looseness that are evident in my studio still lifes.

PAINT CANS

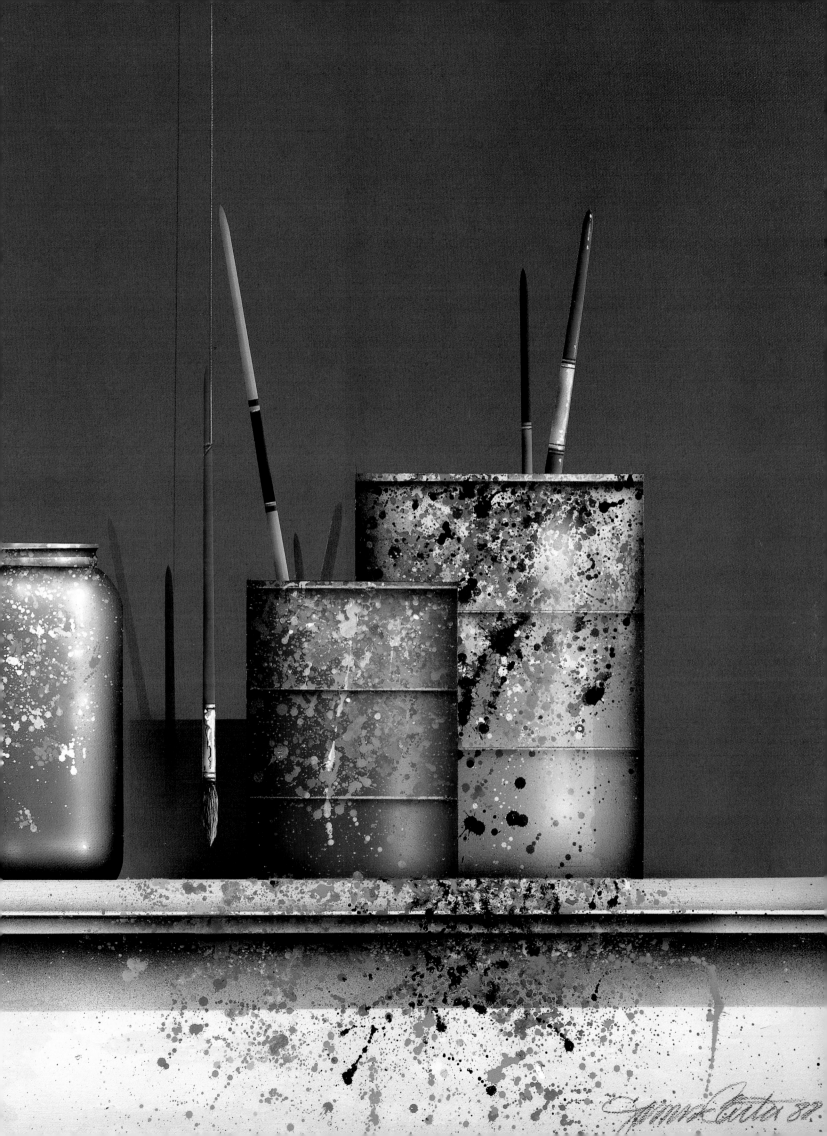

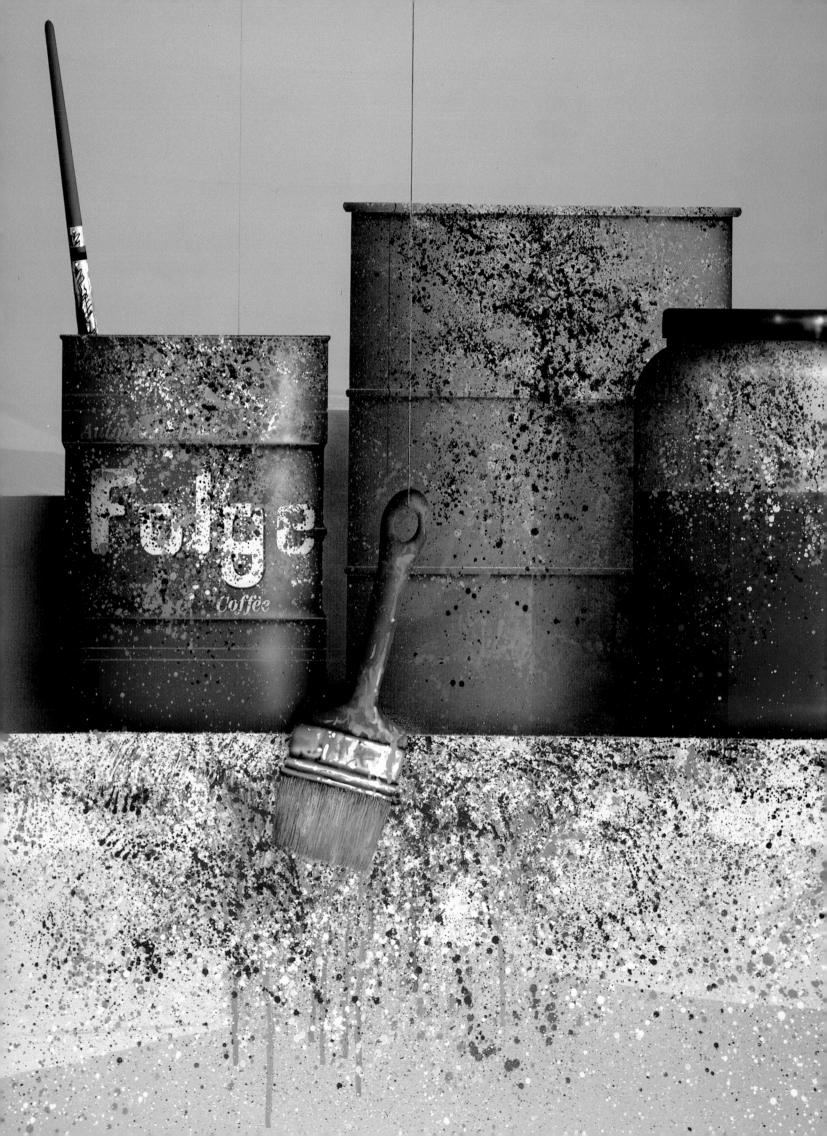

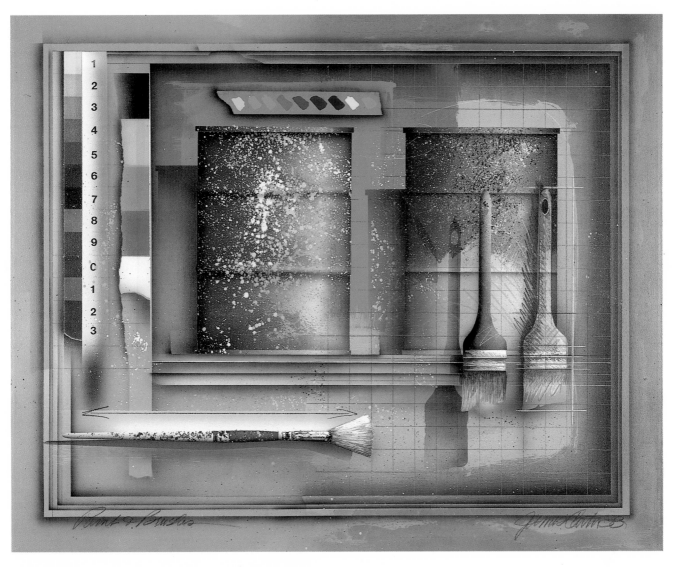

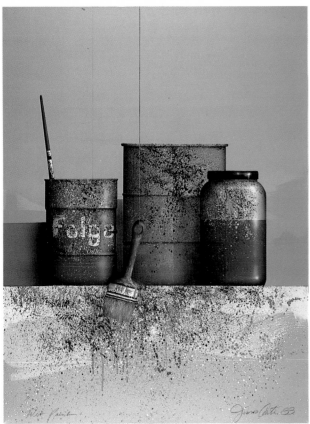

PAINT & BRUSHES ABOVE
WET PAINT BELOW
(OPPOSITE, DETAIL)

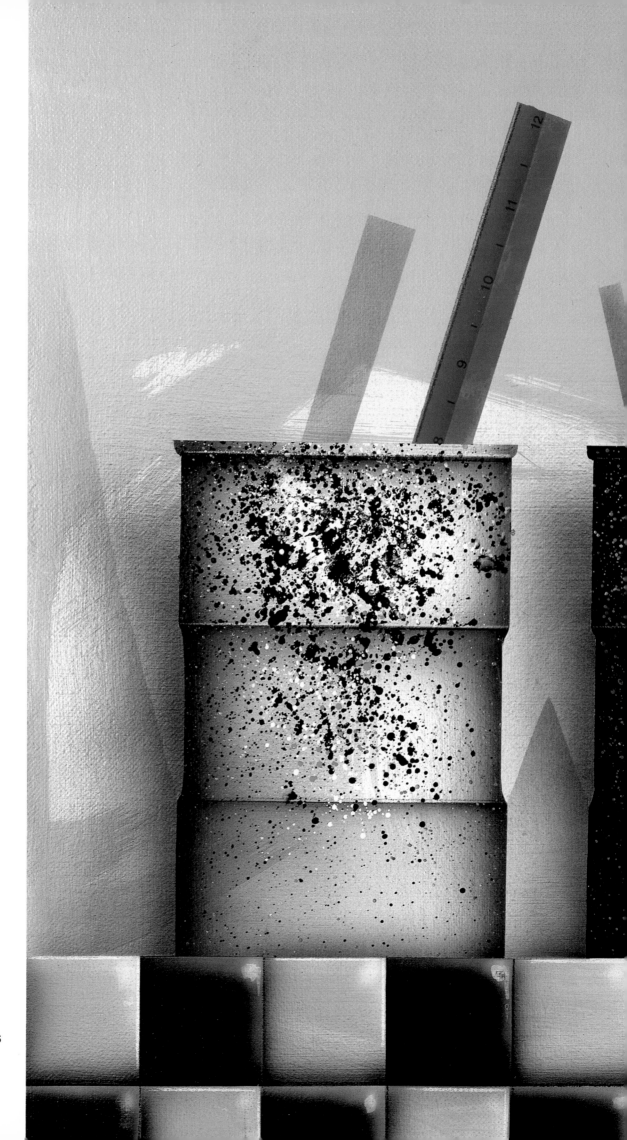

UNTITLED: PAINT CANS

66

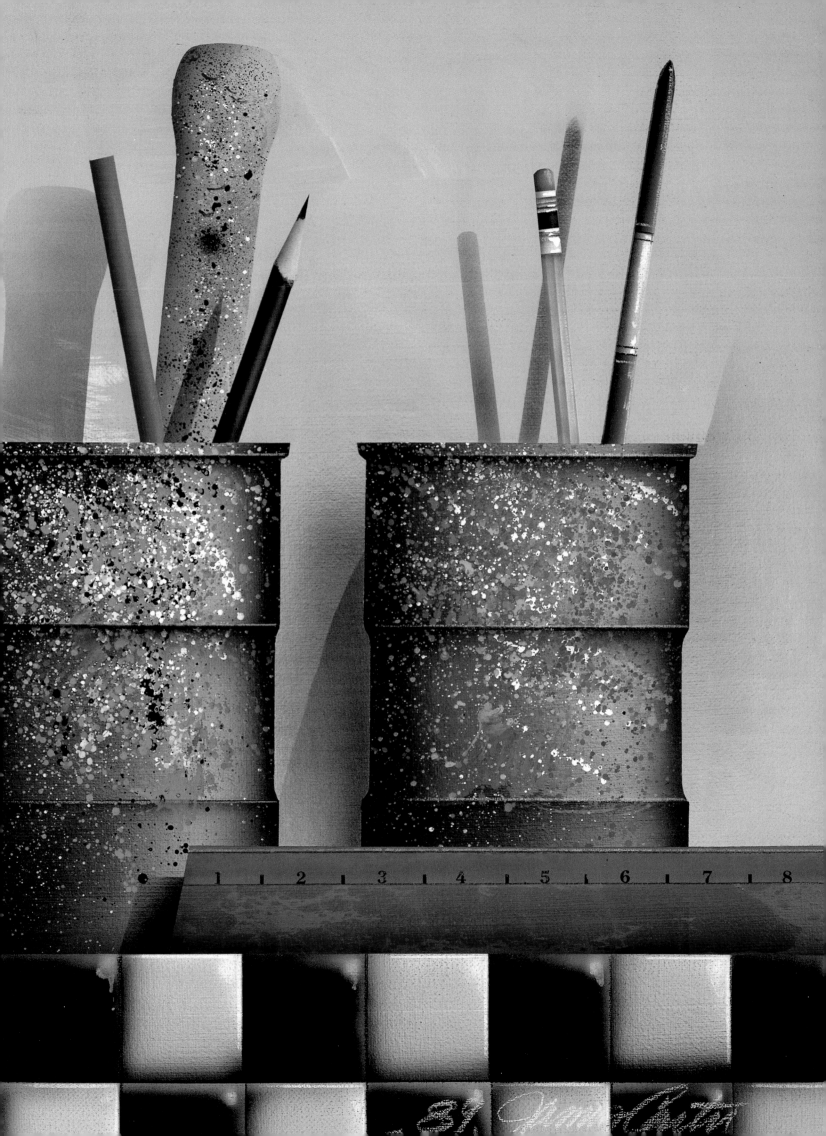

PAINT CANS WITH COLORED PENCILS TOP
STILL LIFE WITH GLUE CAN BOTTOM

PAINT CAN STUDY TOP
PAINT CAN AND TOOLS BOTTOM

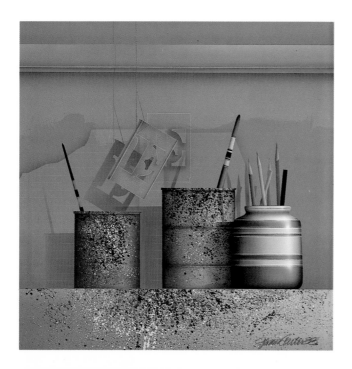

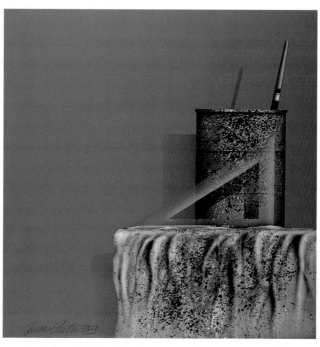

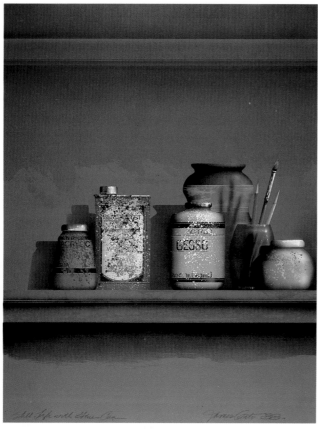

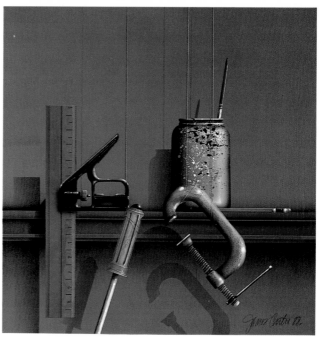

I STILL CAN'T BELIEVE IT'S NOT BUTTER

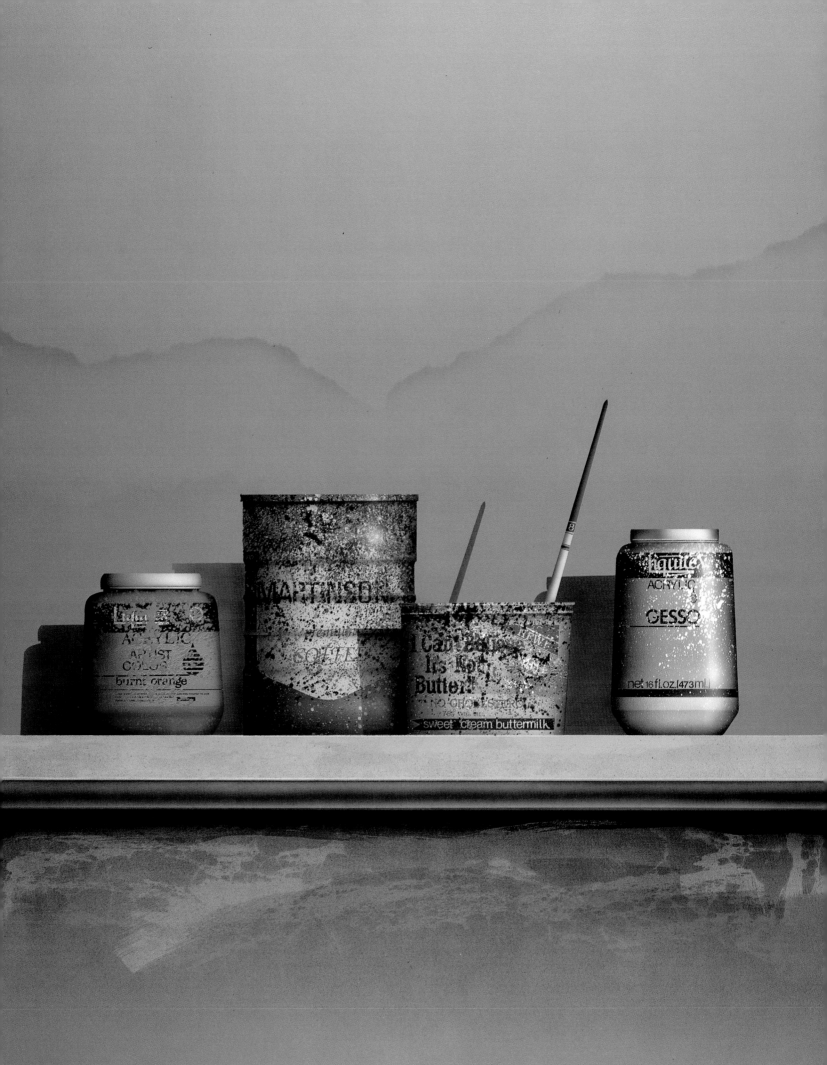

I Still Can't Believe it's not Butter James Carter 83

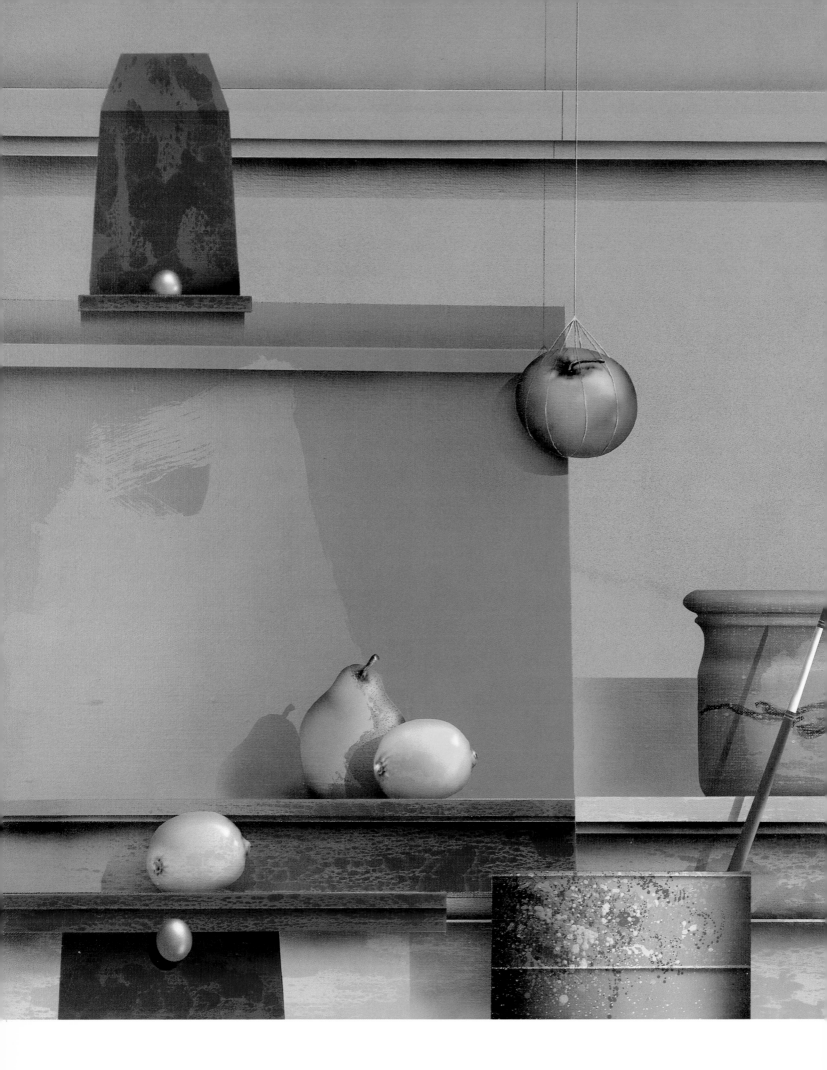

STILL LIFE LEFT
STUDY FOR STUDIO SOUTH #2 BELOW
STUDY GESSO & PAINT CAN PAGE 72

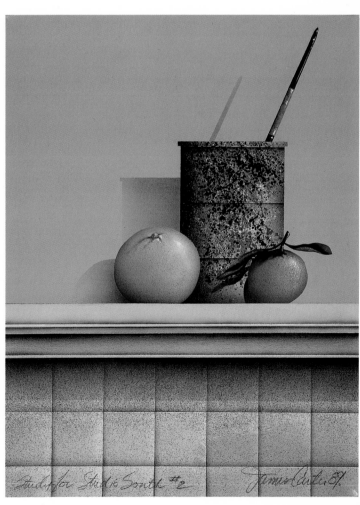

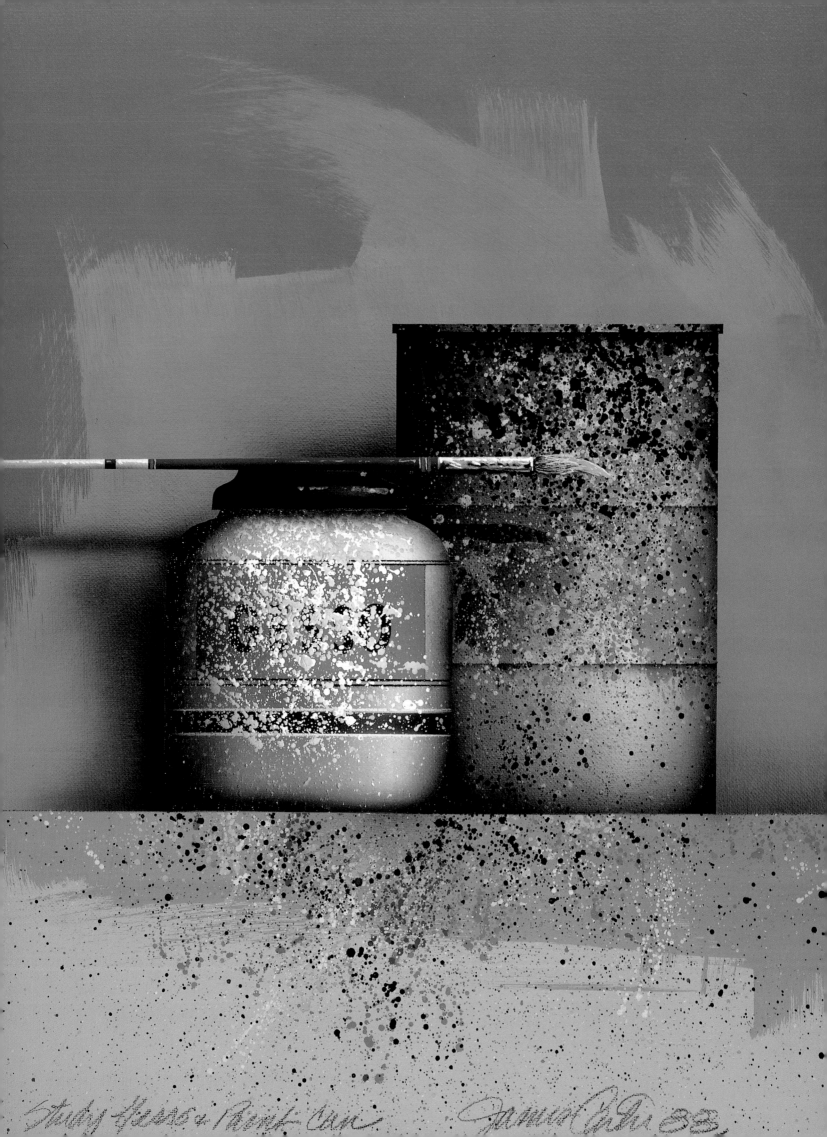

Study Gesso & Paint Can

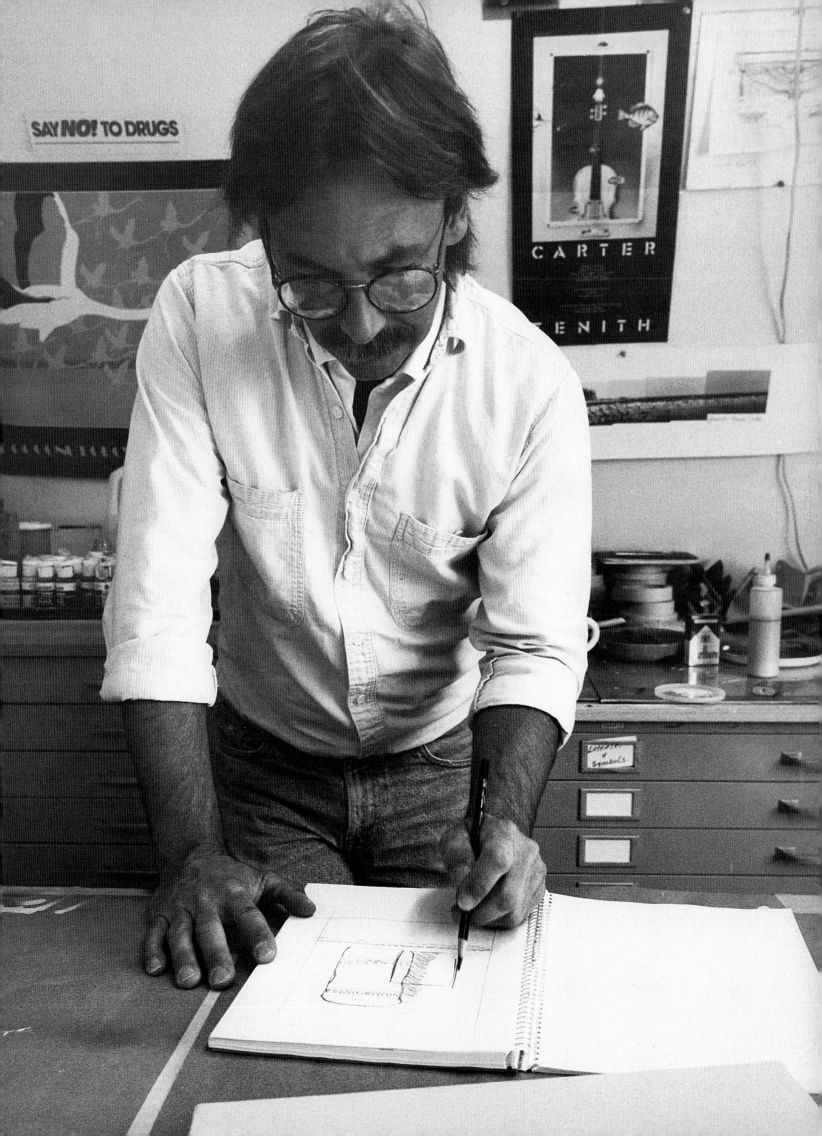

JAMES CARTER—
THE PROCESS BEHIND THE PAINTING

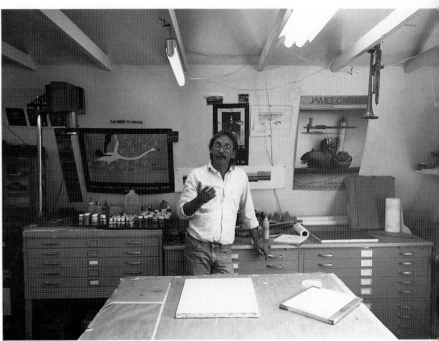

PHOTOGRAPHIC ESSAY BY ALBERT SQUILLACE

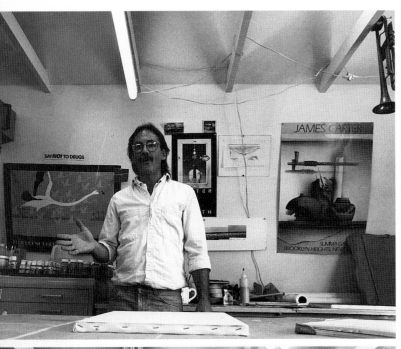
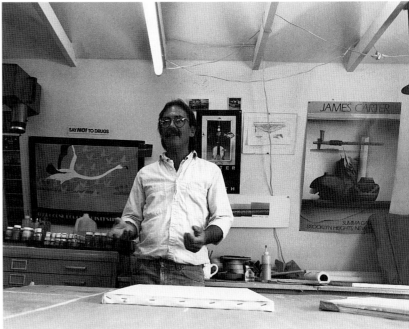
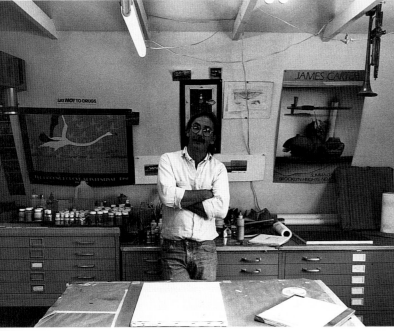

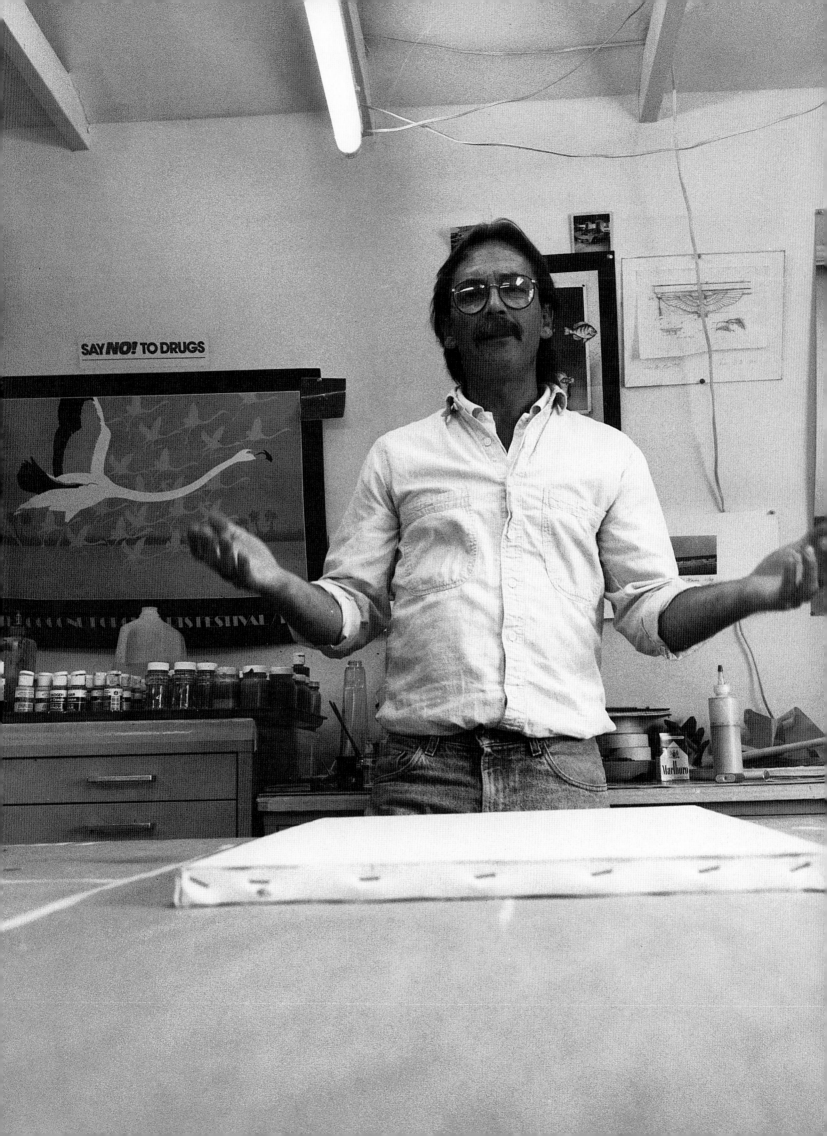

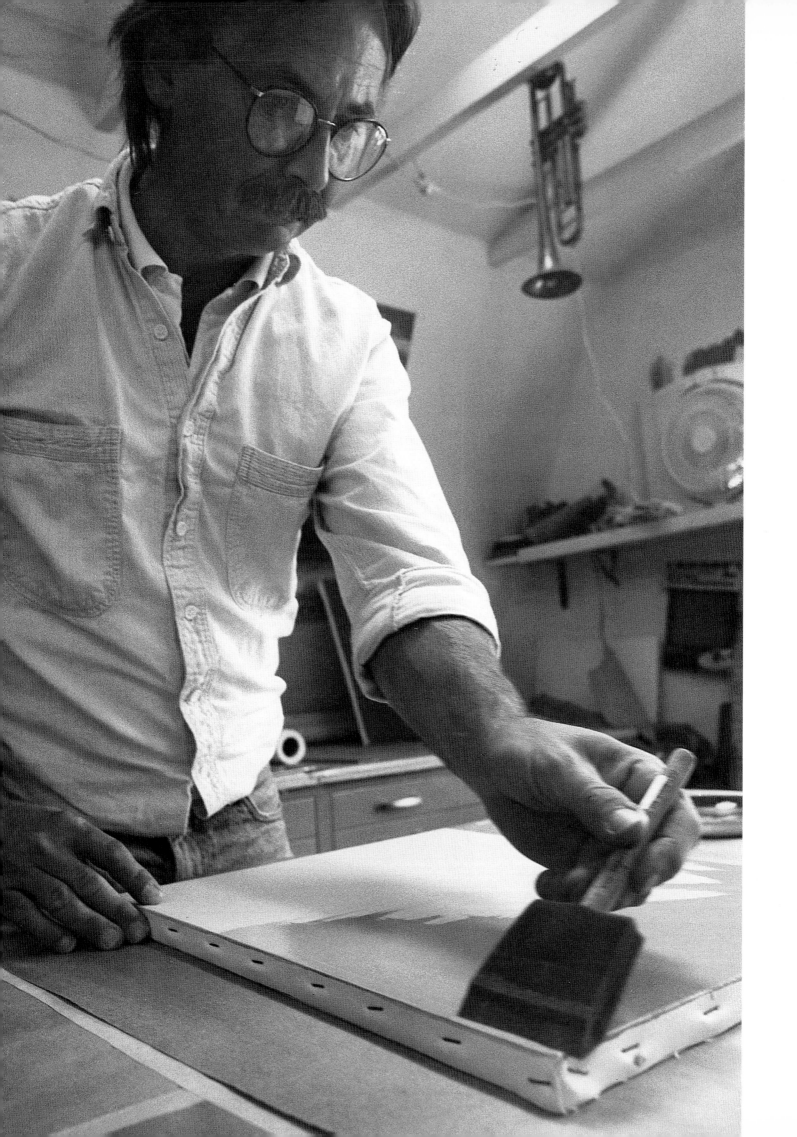

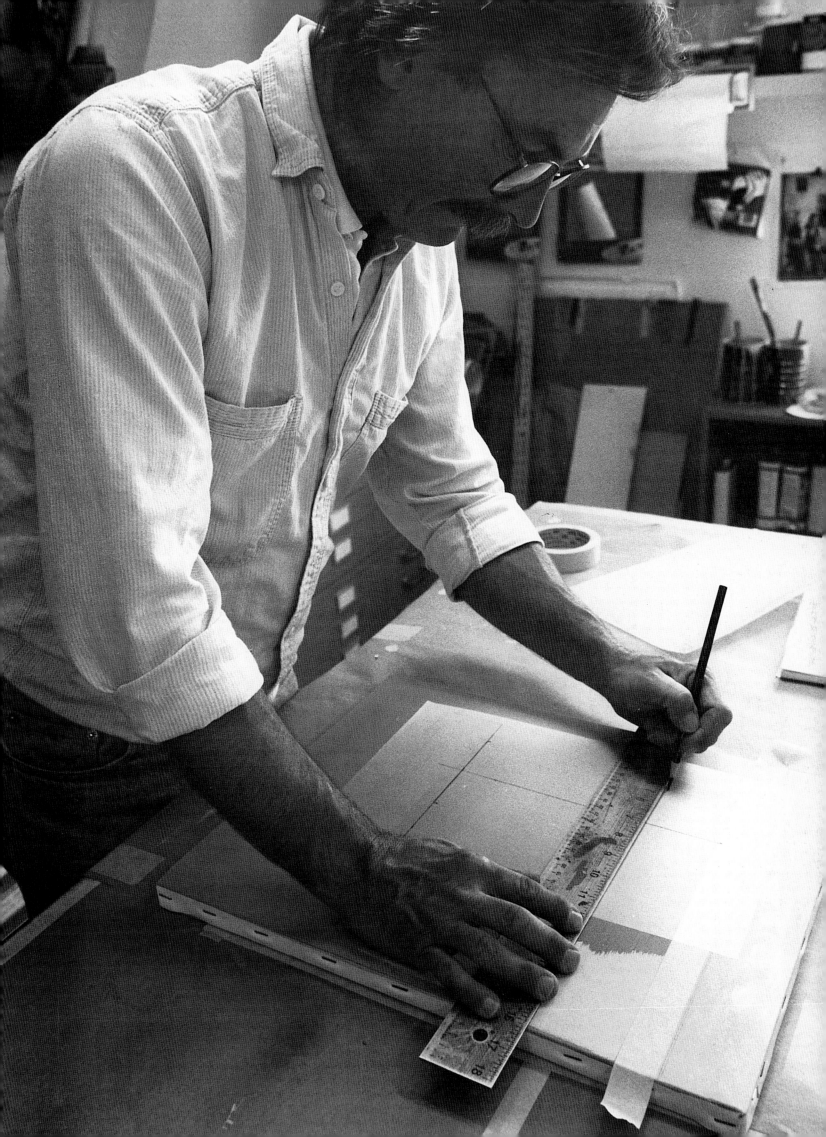

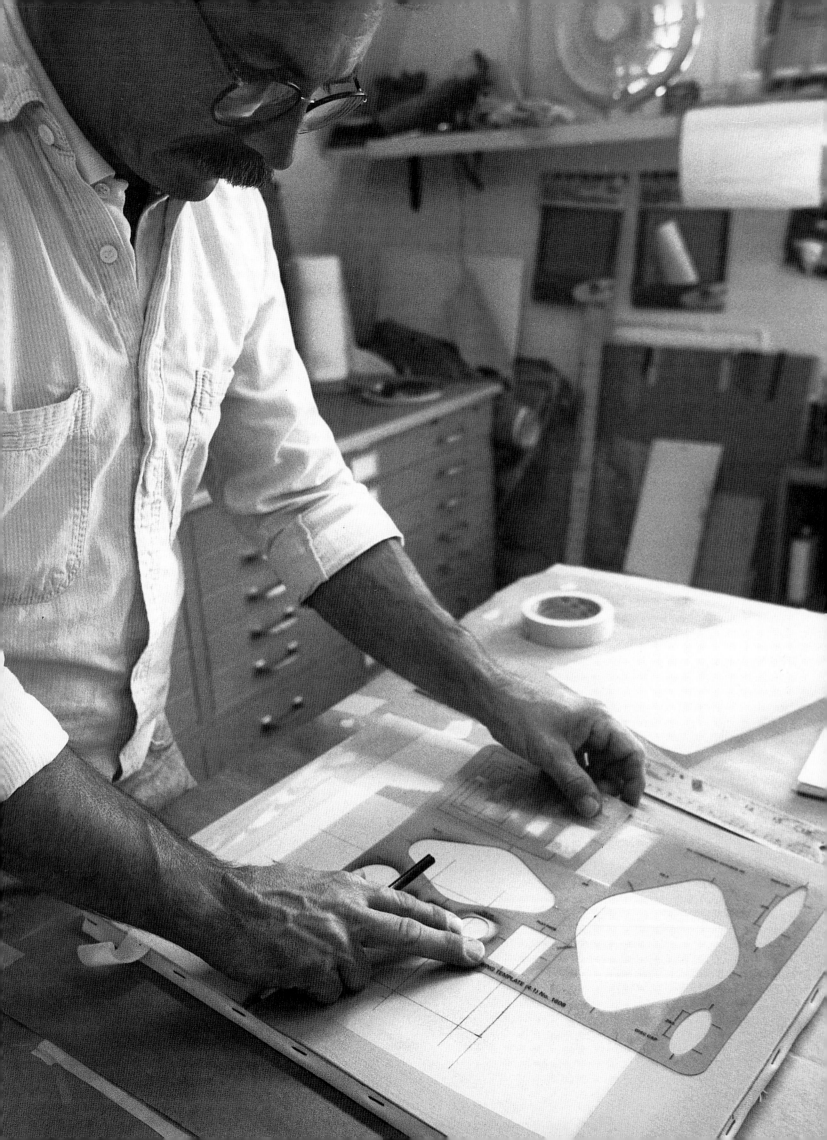

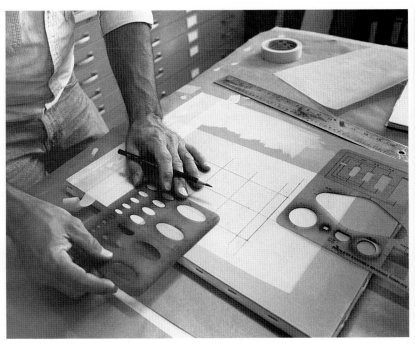

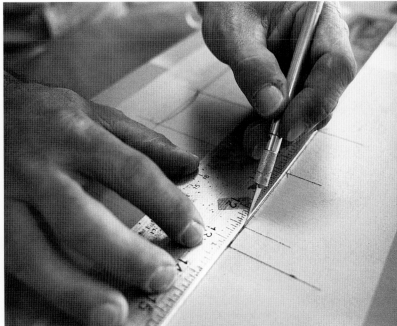

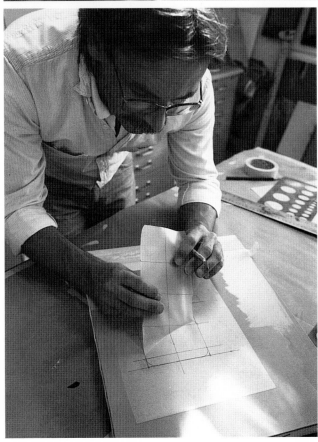

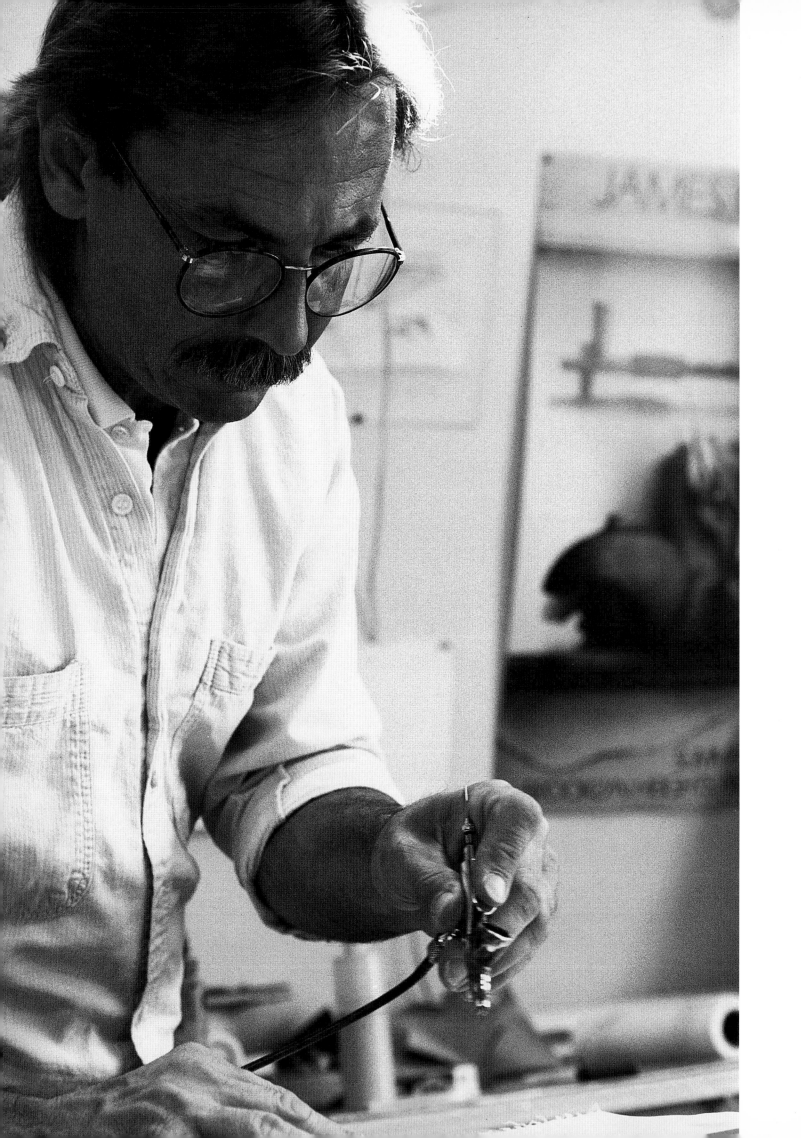

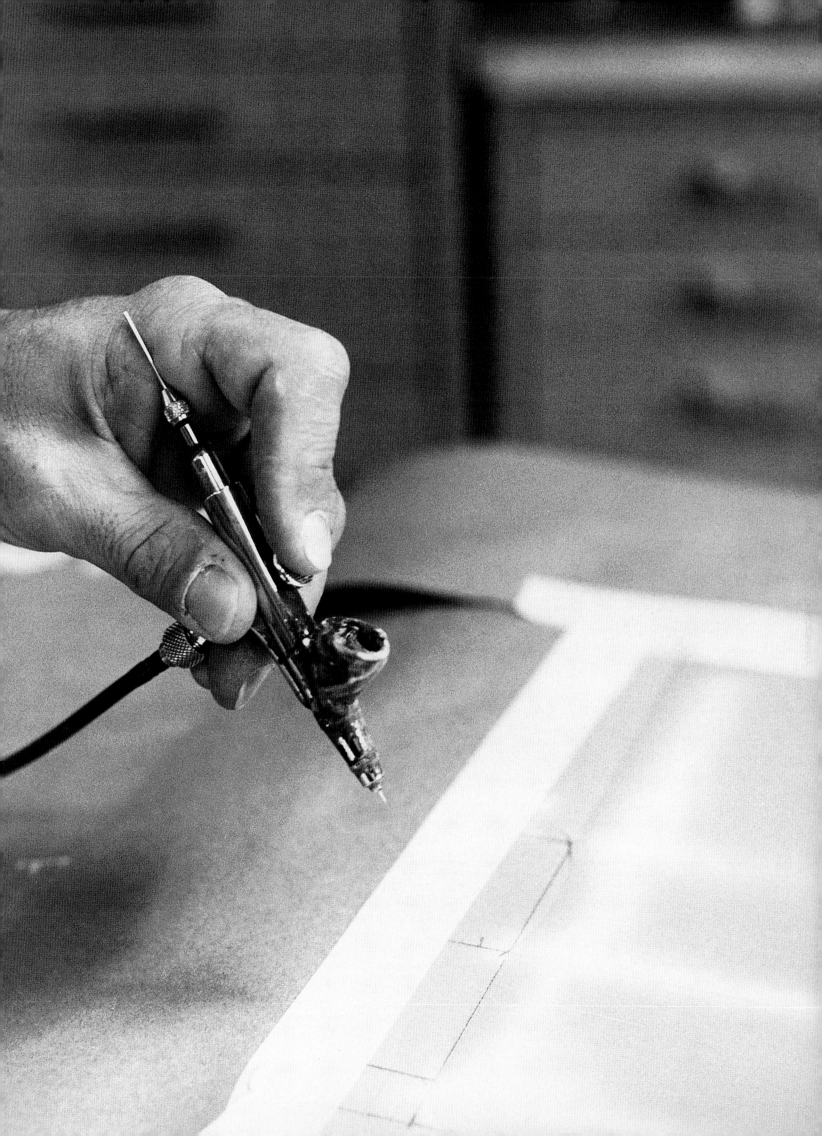

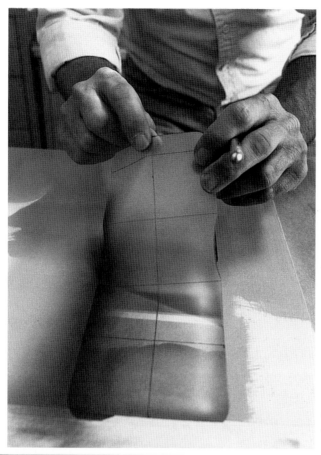

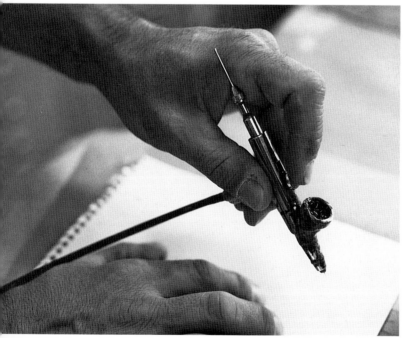

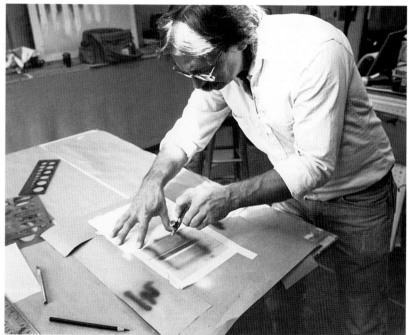

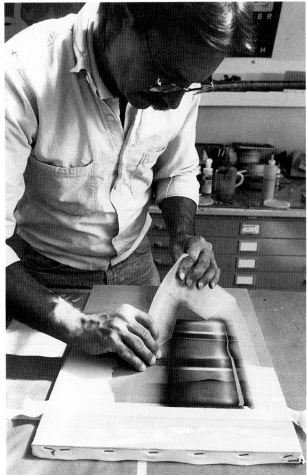

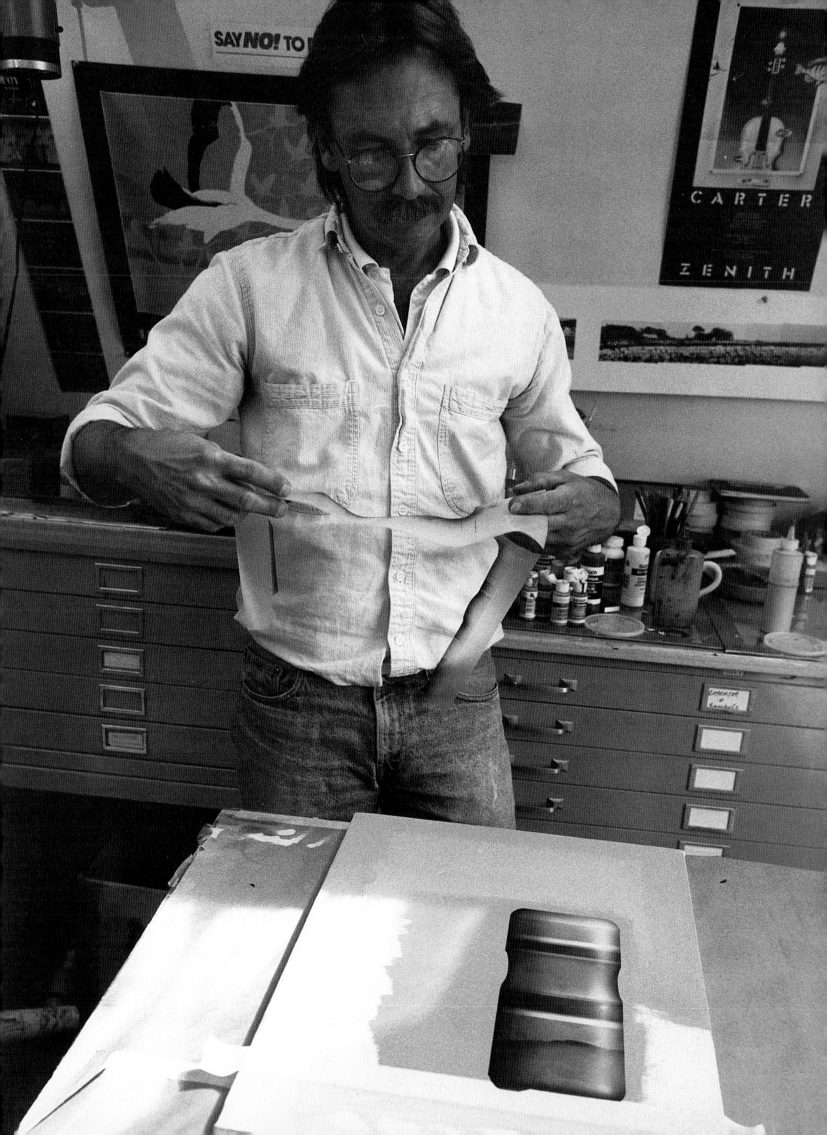

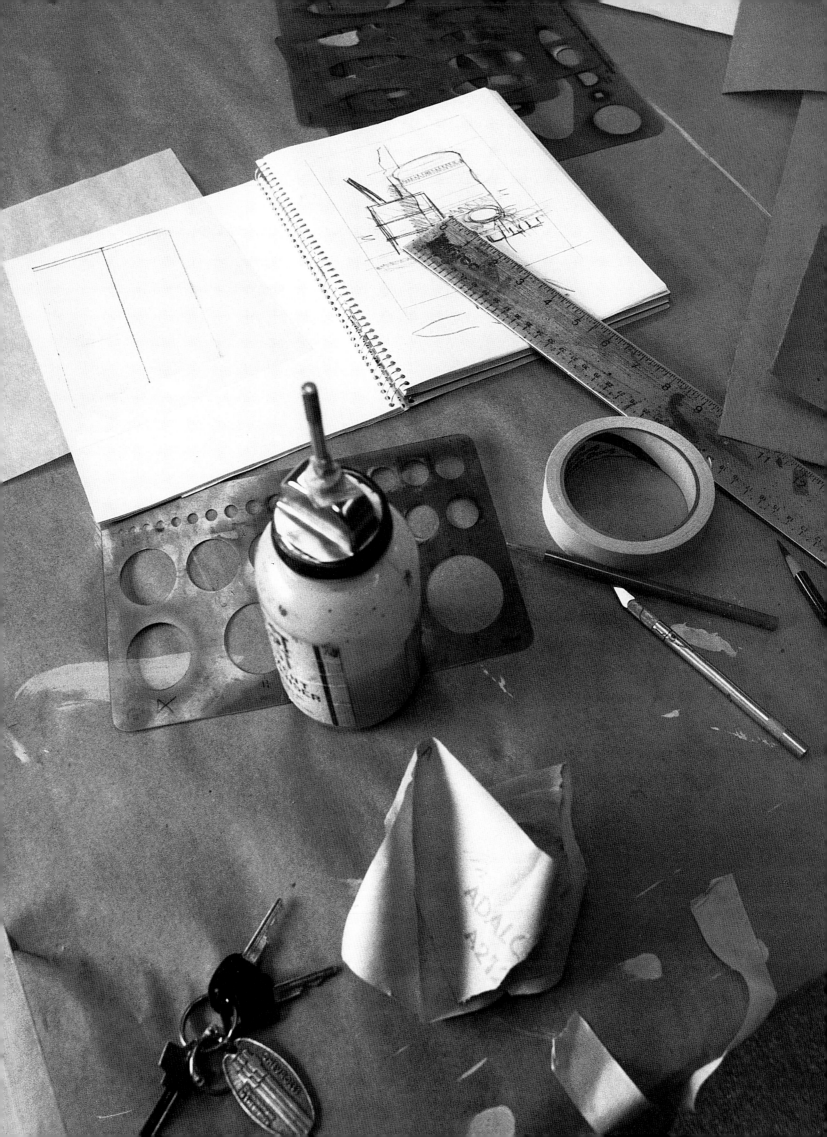

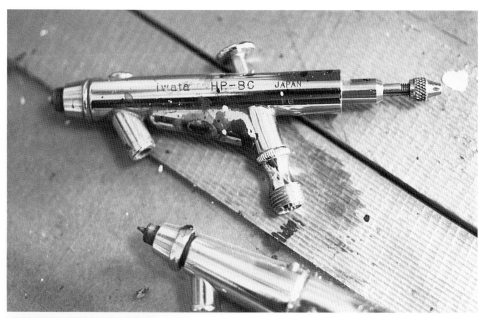

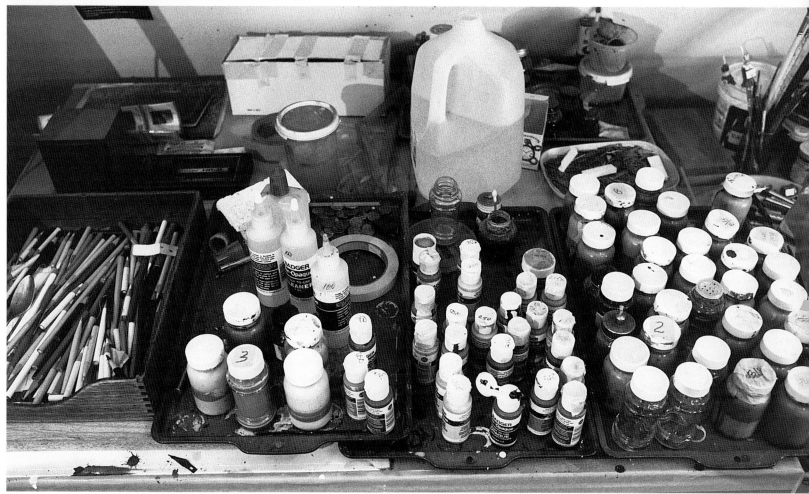

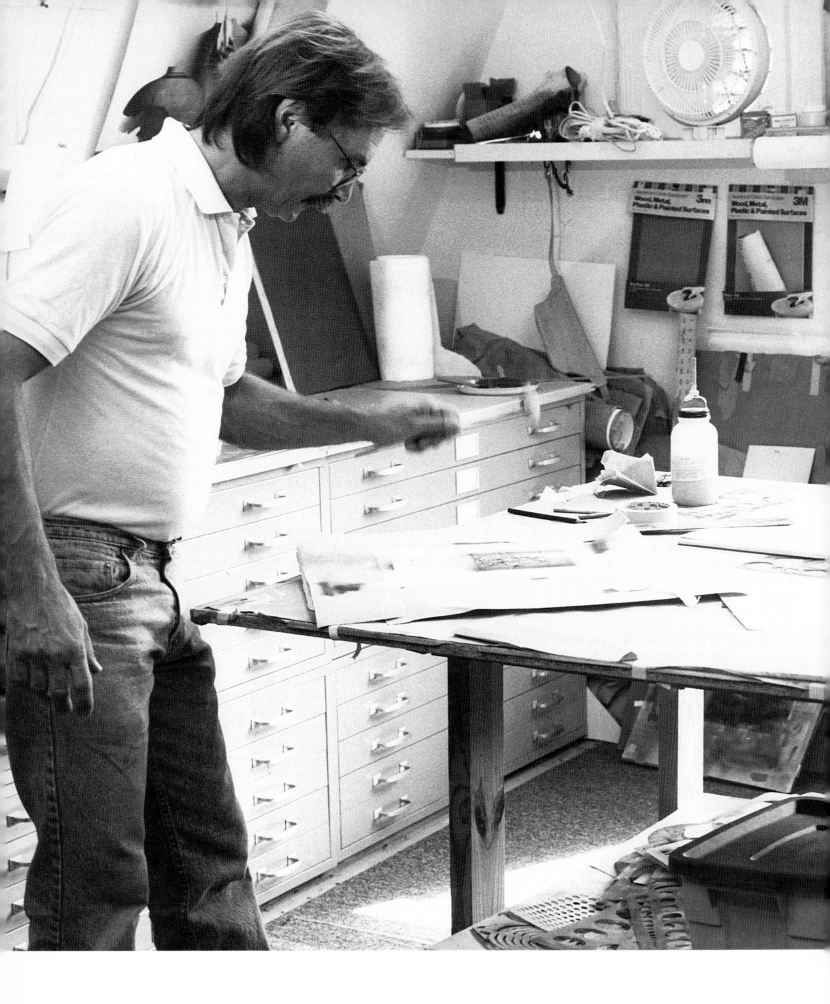

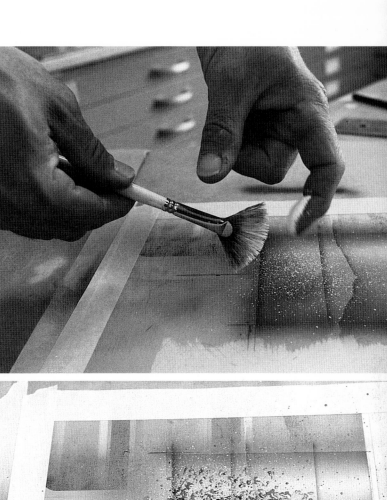

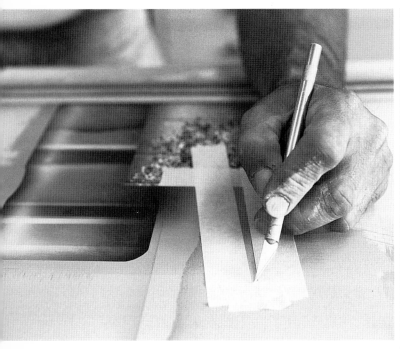

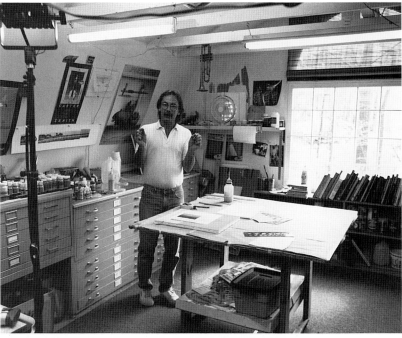

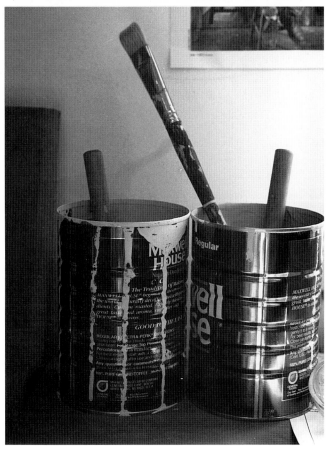

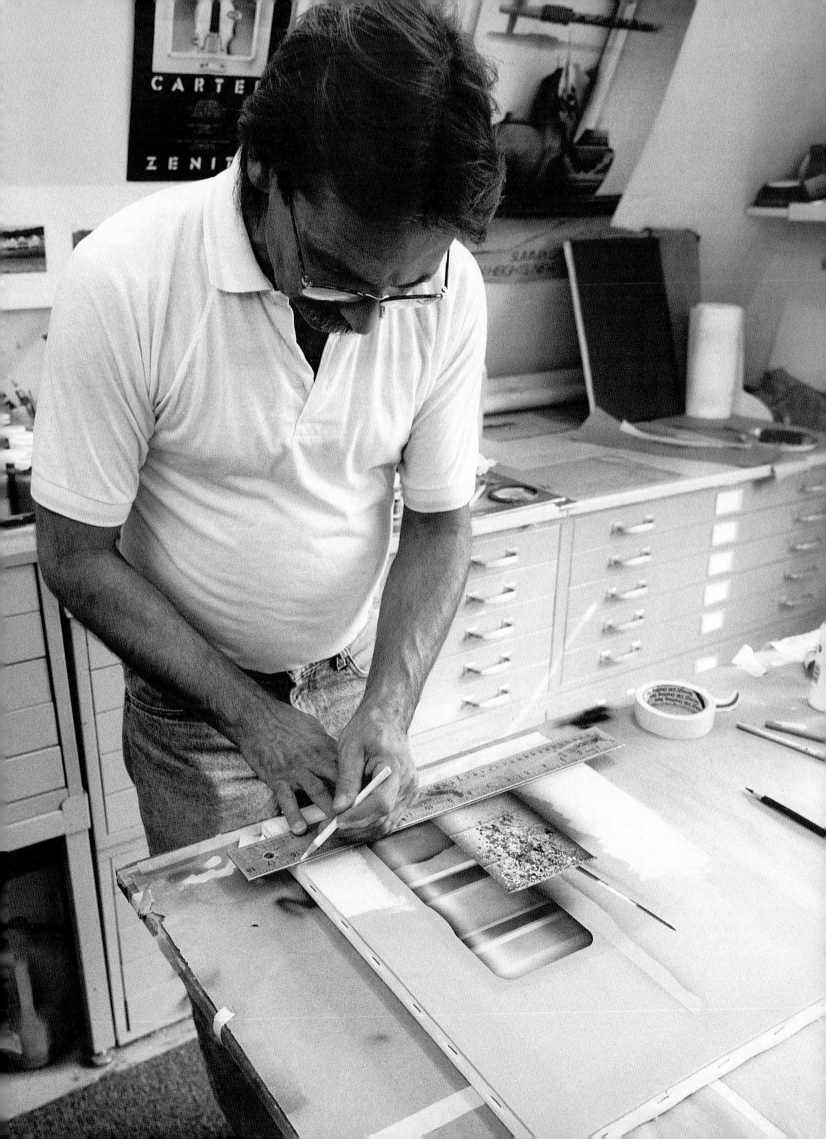

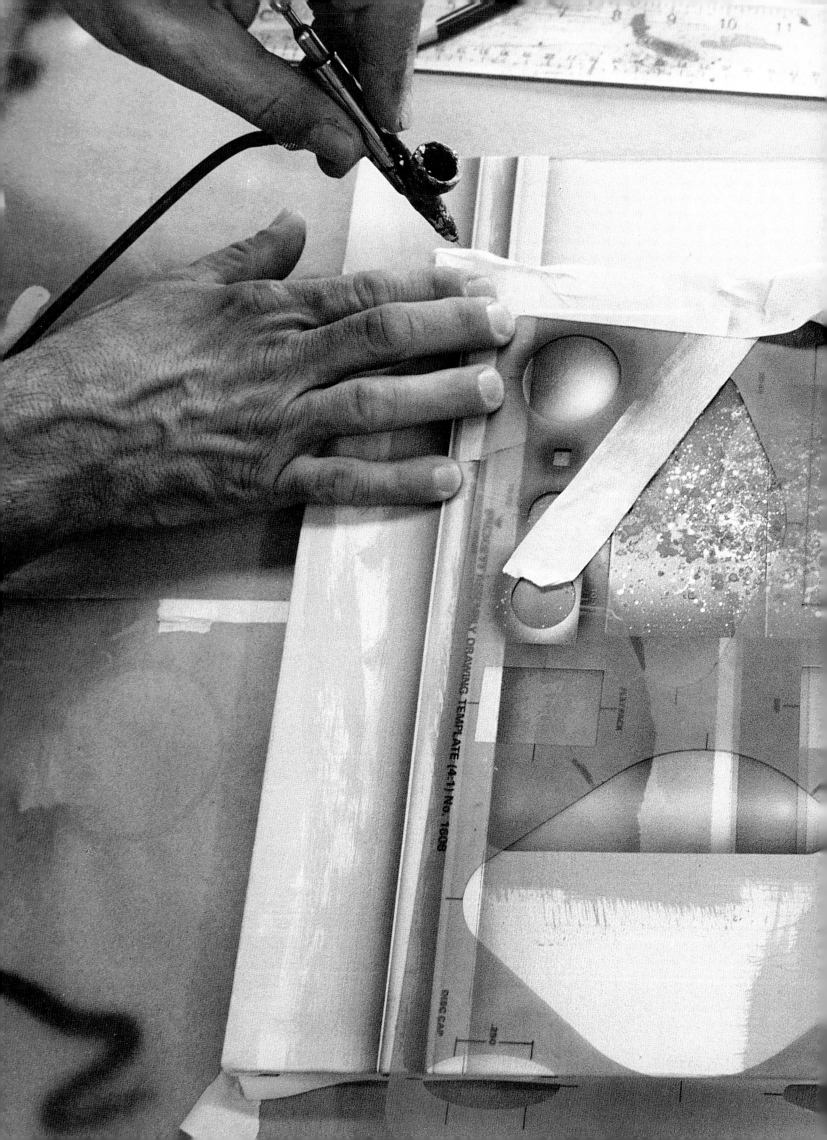

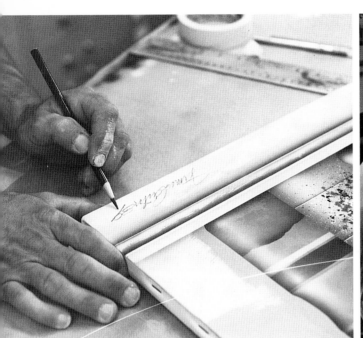

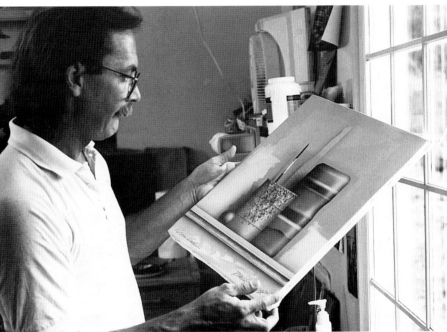

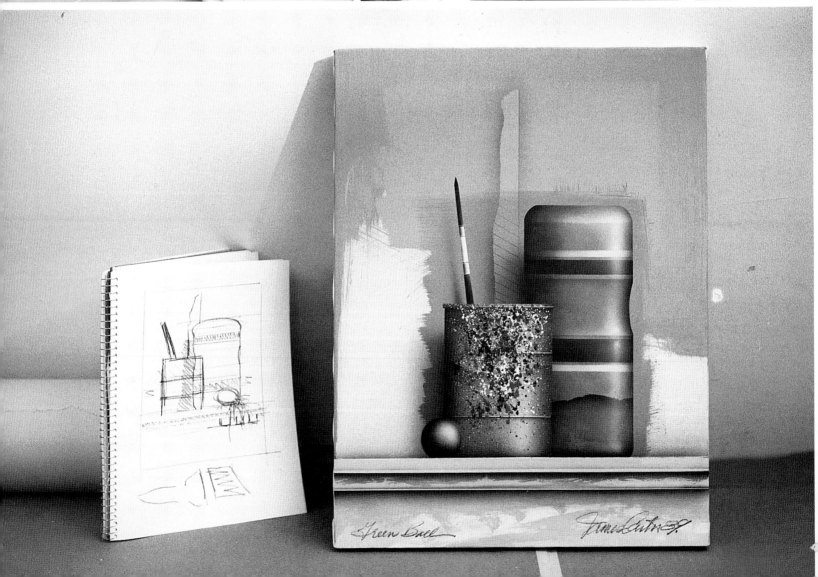

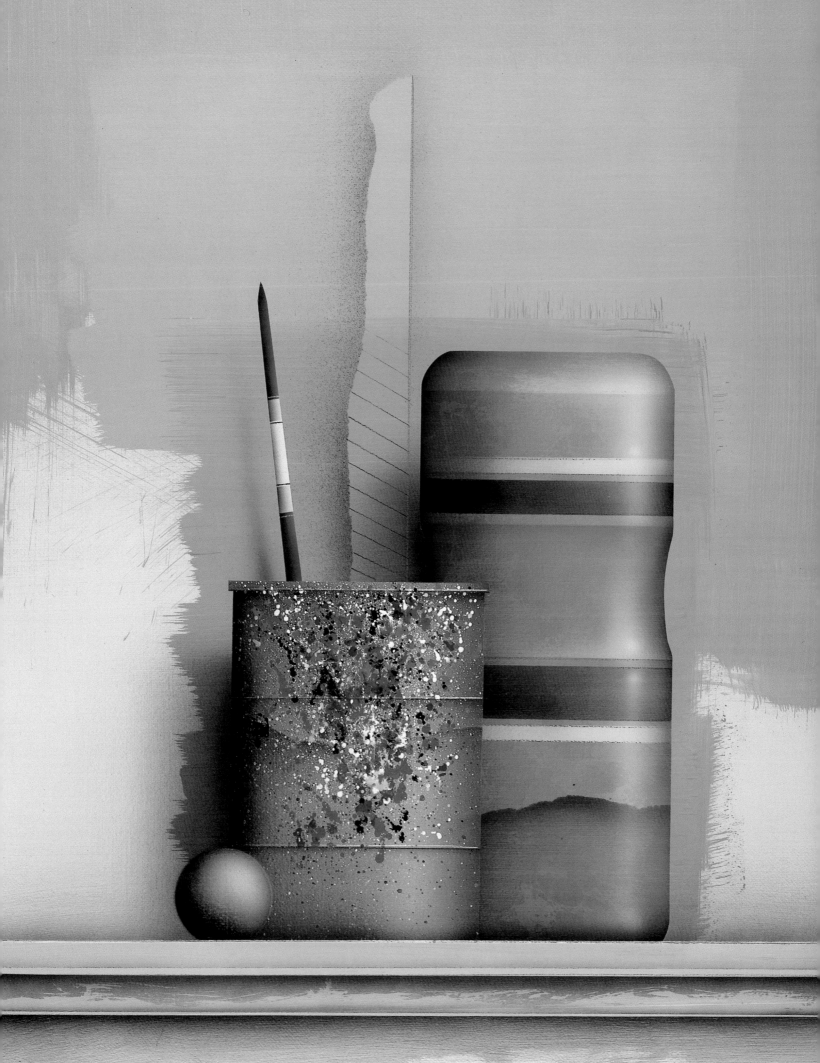

Green Ball

Weather vanes are pushed about by winds and rain, never getting the recognition they deserve. I paint weather vanes so you don't have to crane your neck to see them atop a house, or wonder what the squeaking noise is overhead in the wind.

WEATHER VANE

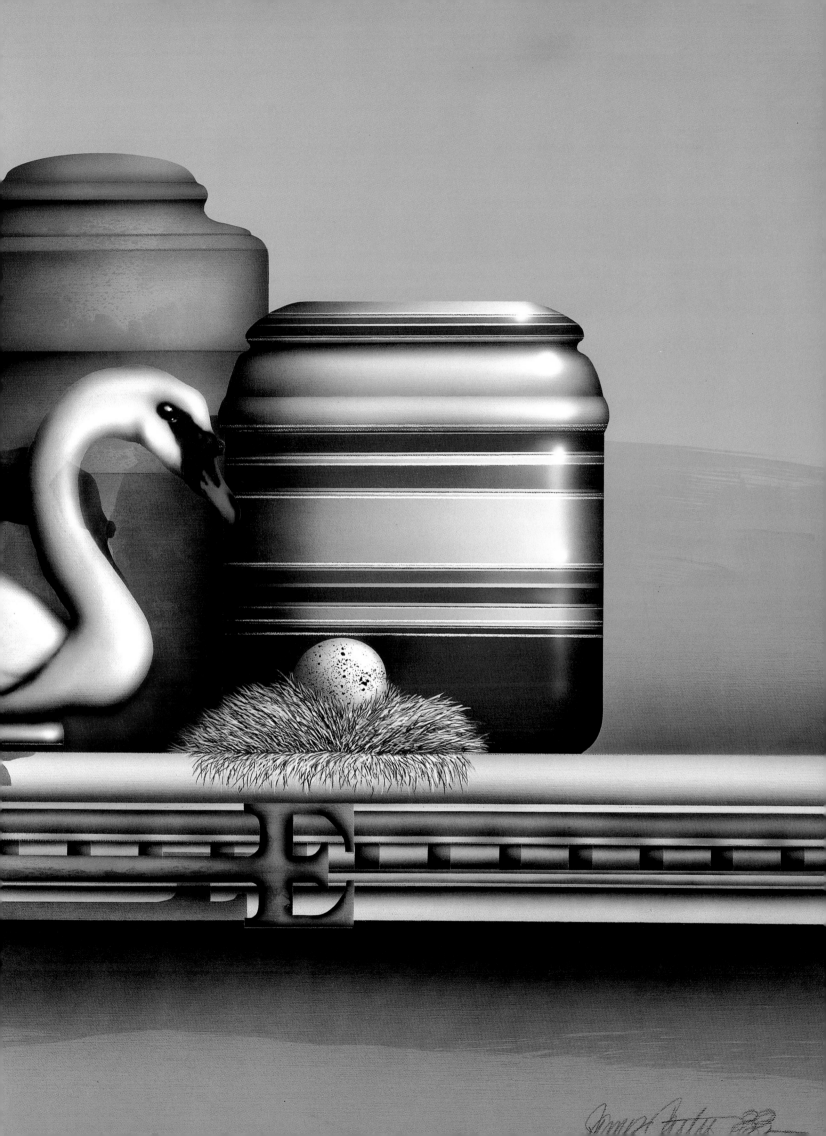

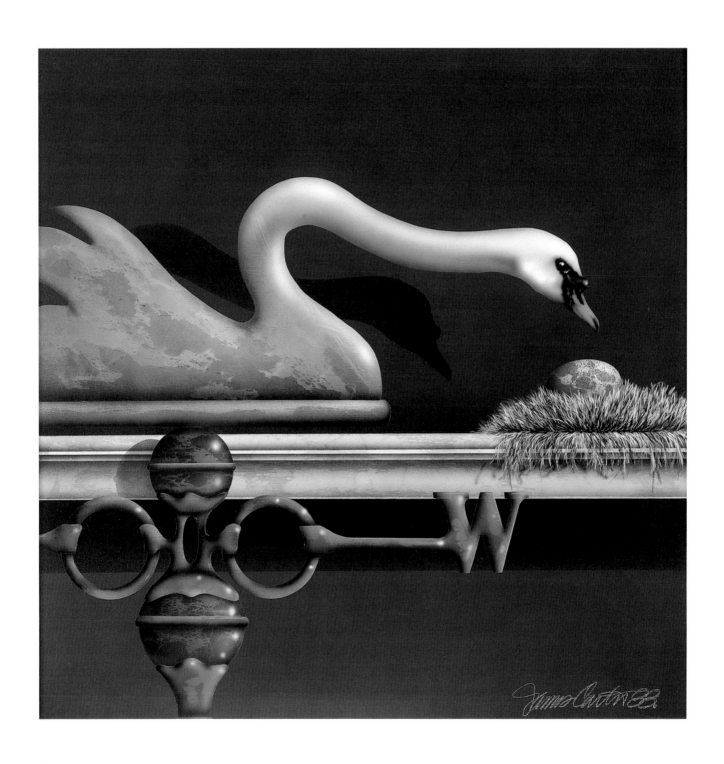

SWAN AND EGG ABOVE
EIGHT-FIFTEEN OPPOSITE

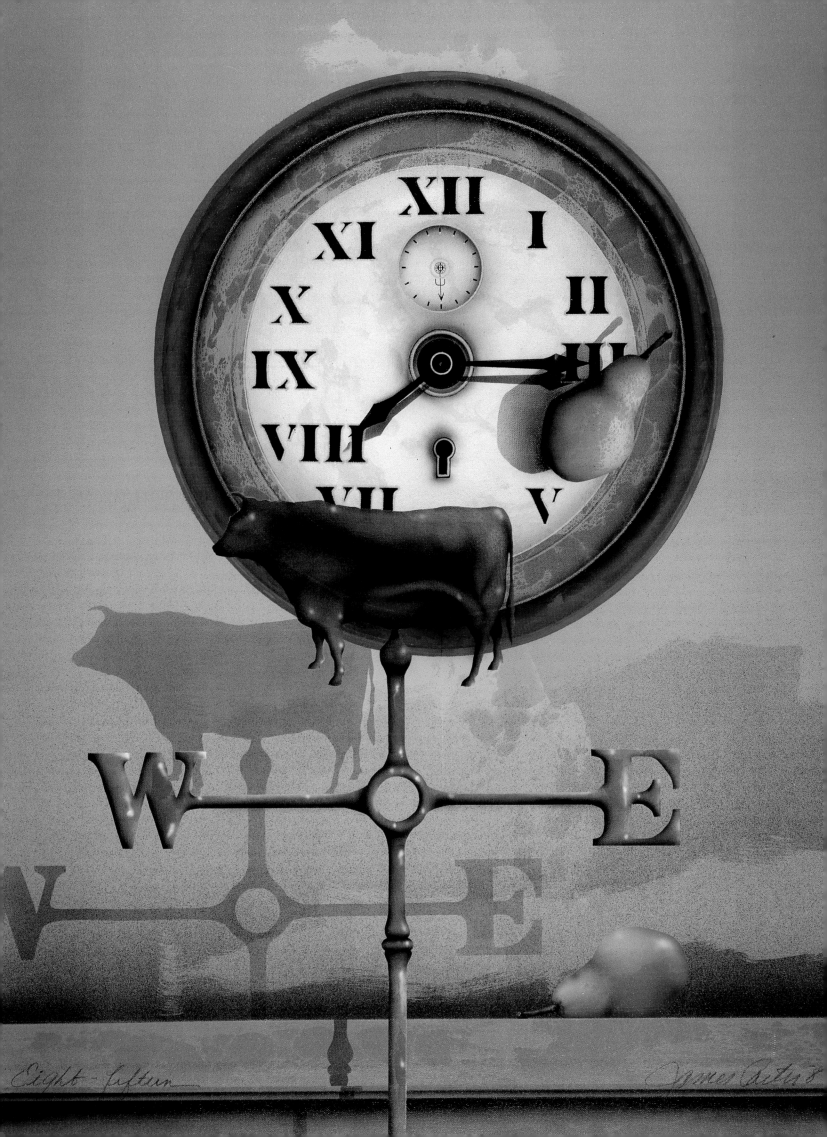

Eight-Fifteen *James Peterson*

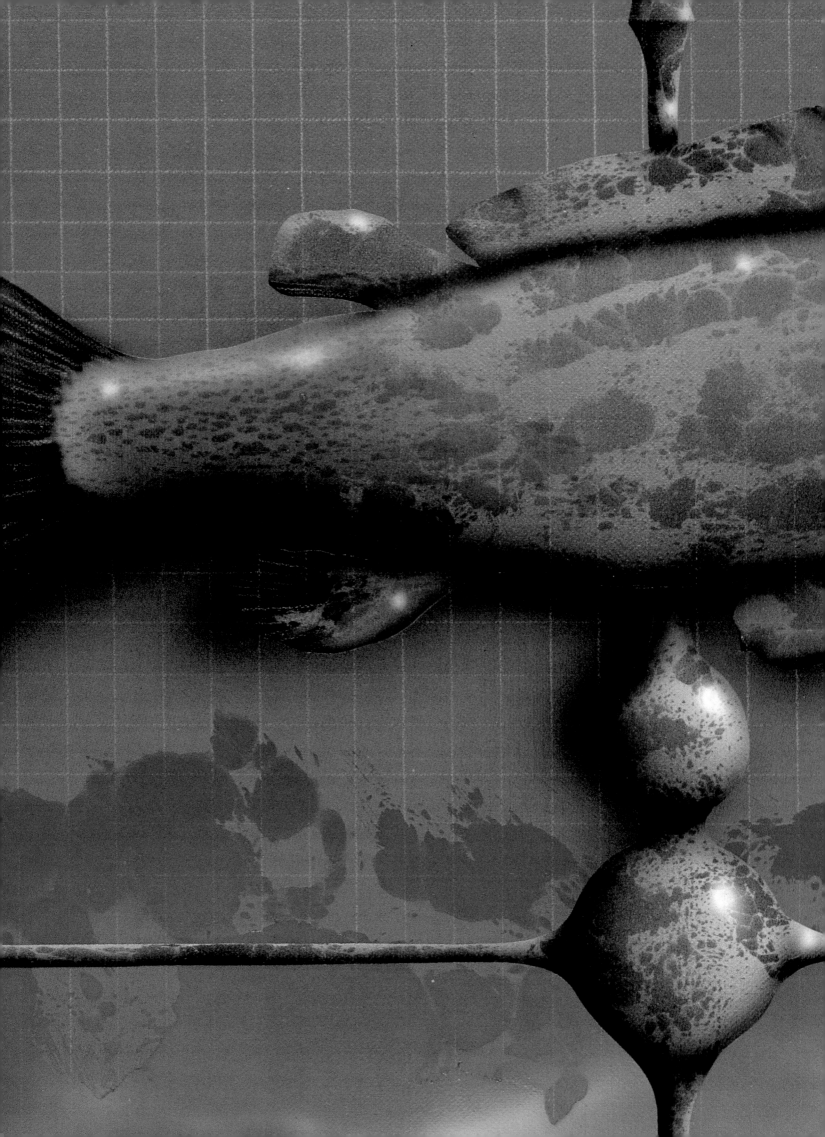

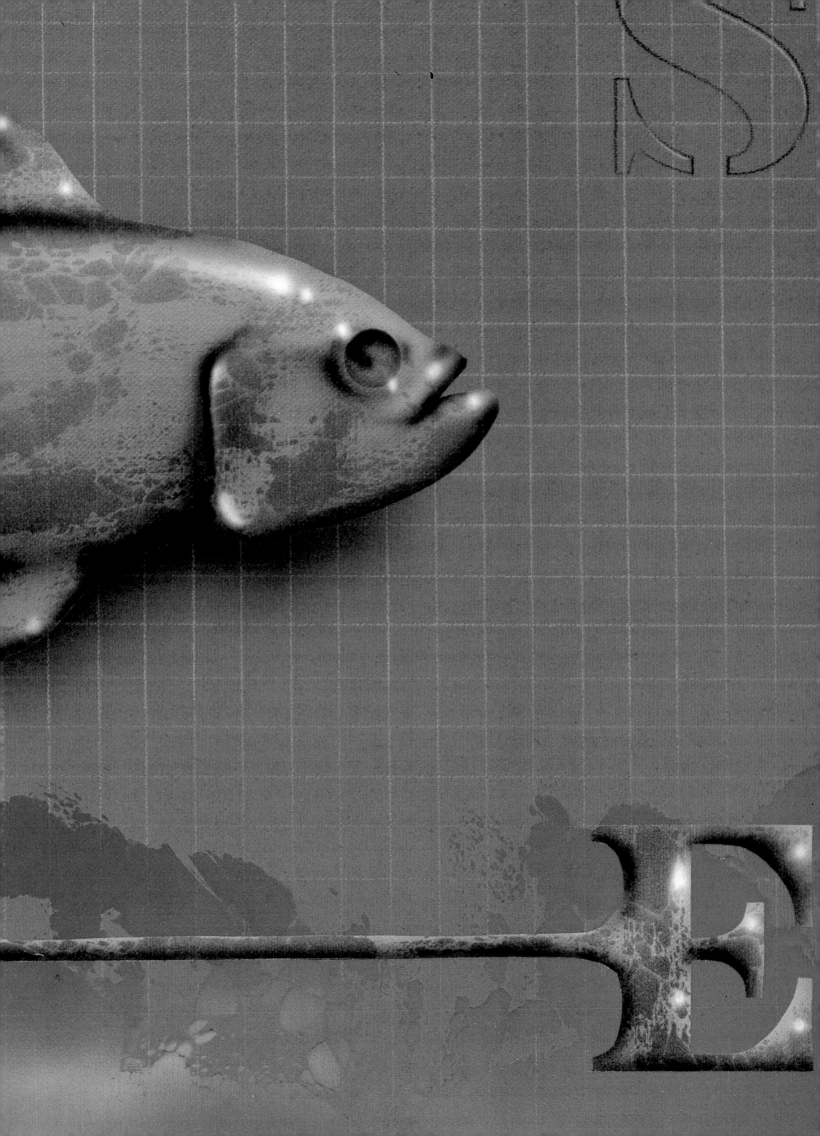

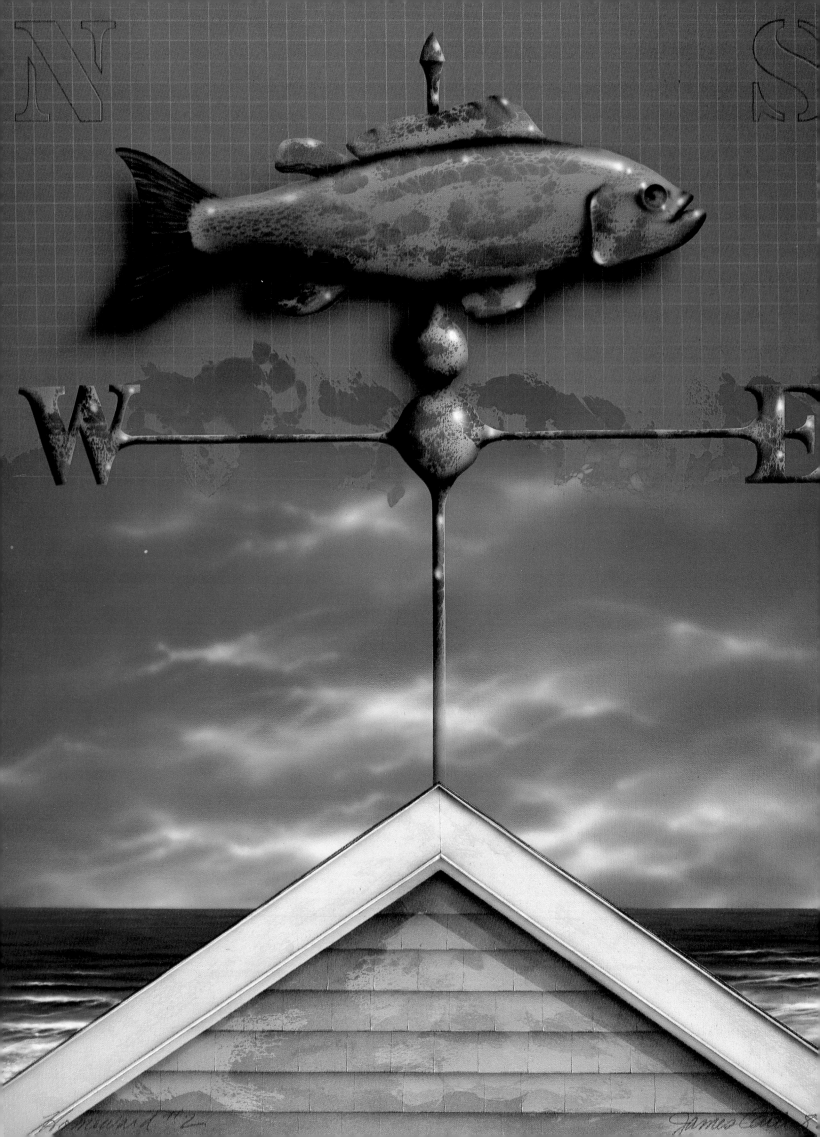

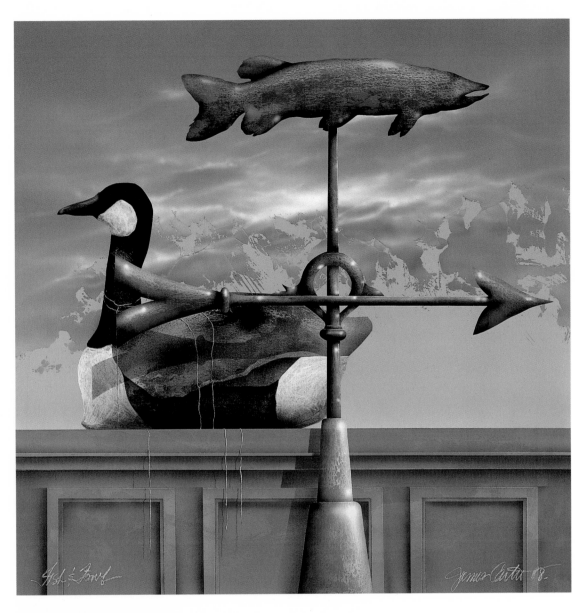

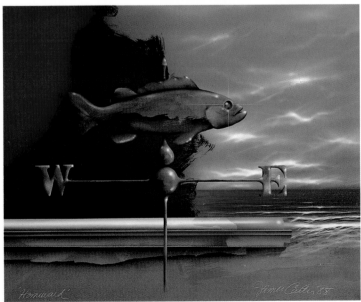

FISH & FOWL TOP
HOMEWARD BOTTOM
HOMEWARD #2 OPPOSITE
(FULL SIZE DETAIL, PAGES 102 & 103)

The fish out of water is not as doomed as it may appear. Like floating cows and exotic nesting birds on a mantel, the fish in my paintings are as natural out of water as in the water. There are as many different and beautiful fish as there are people. My fish are elegant and colorful denizens of the deep that I choose to portray in the most unlikely settings.

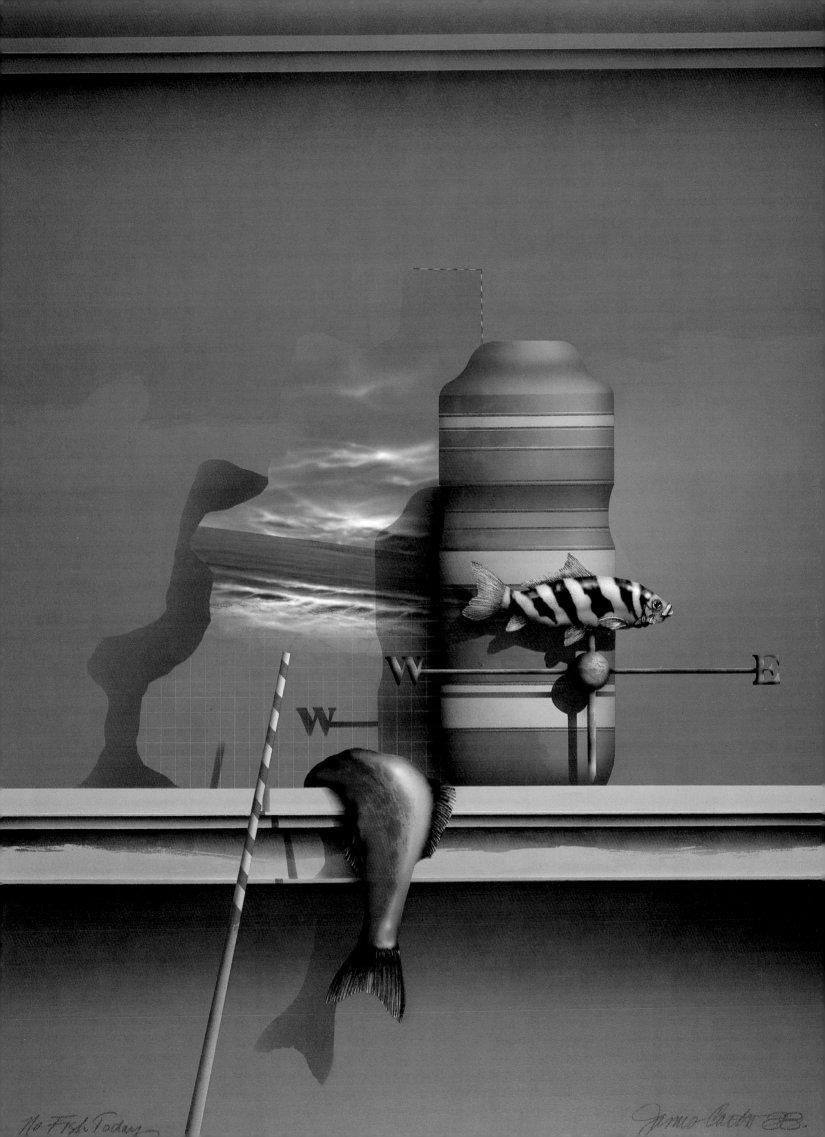

No Fish Today

James Carter 83

BEACH TIME BELOW
UN MARE DI PASSIONE RIGHT

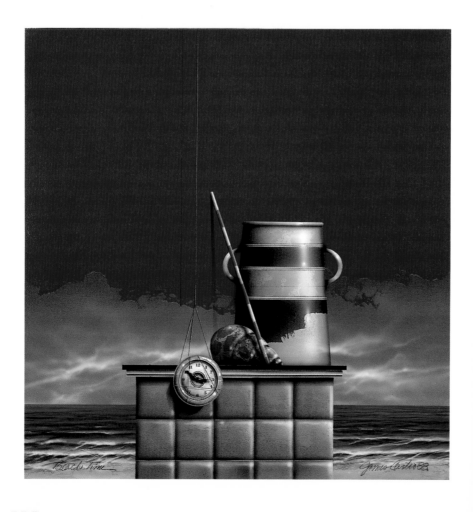

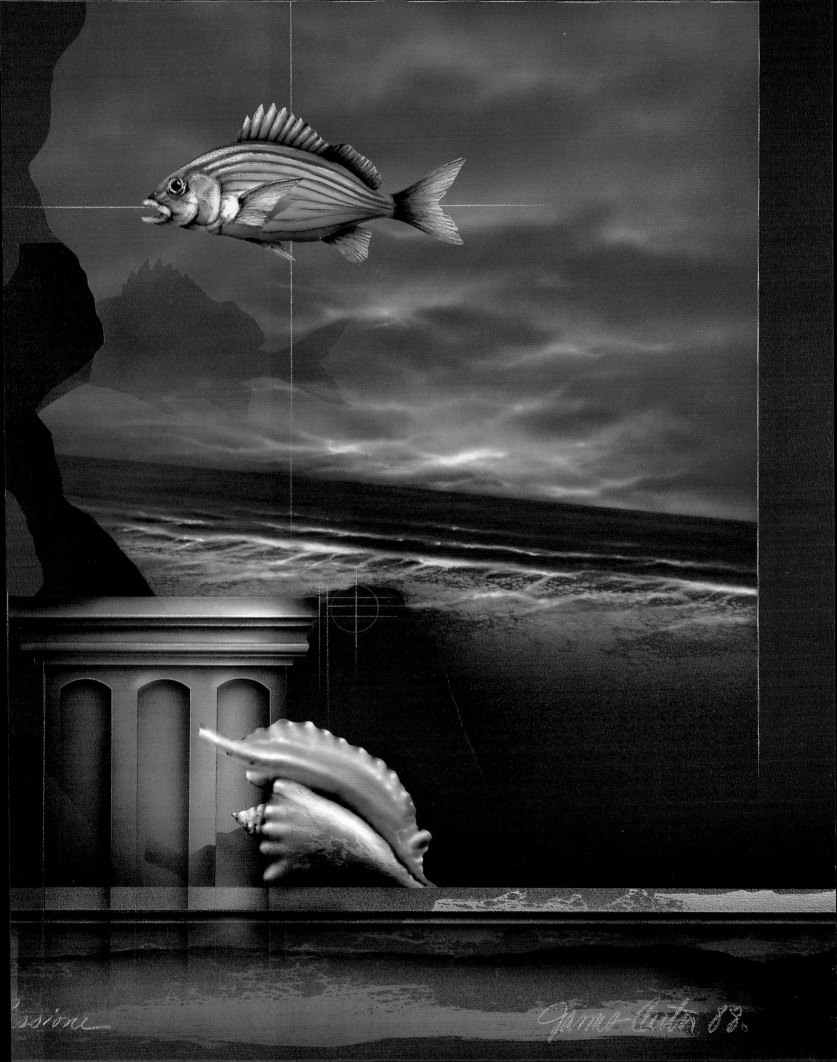

C D E F G H I J K

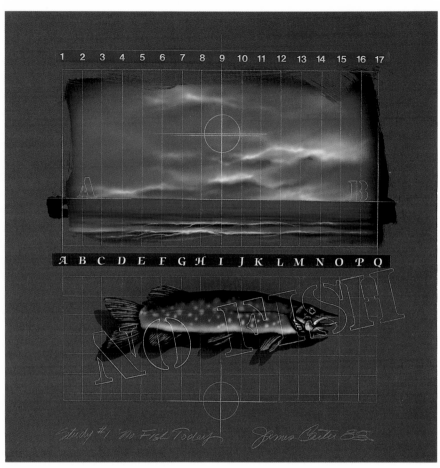

STUDY #1 NO FISH TODAY ABOVE

(FULL SIZE DETAIL, LEFT)

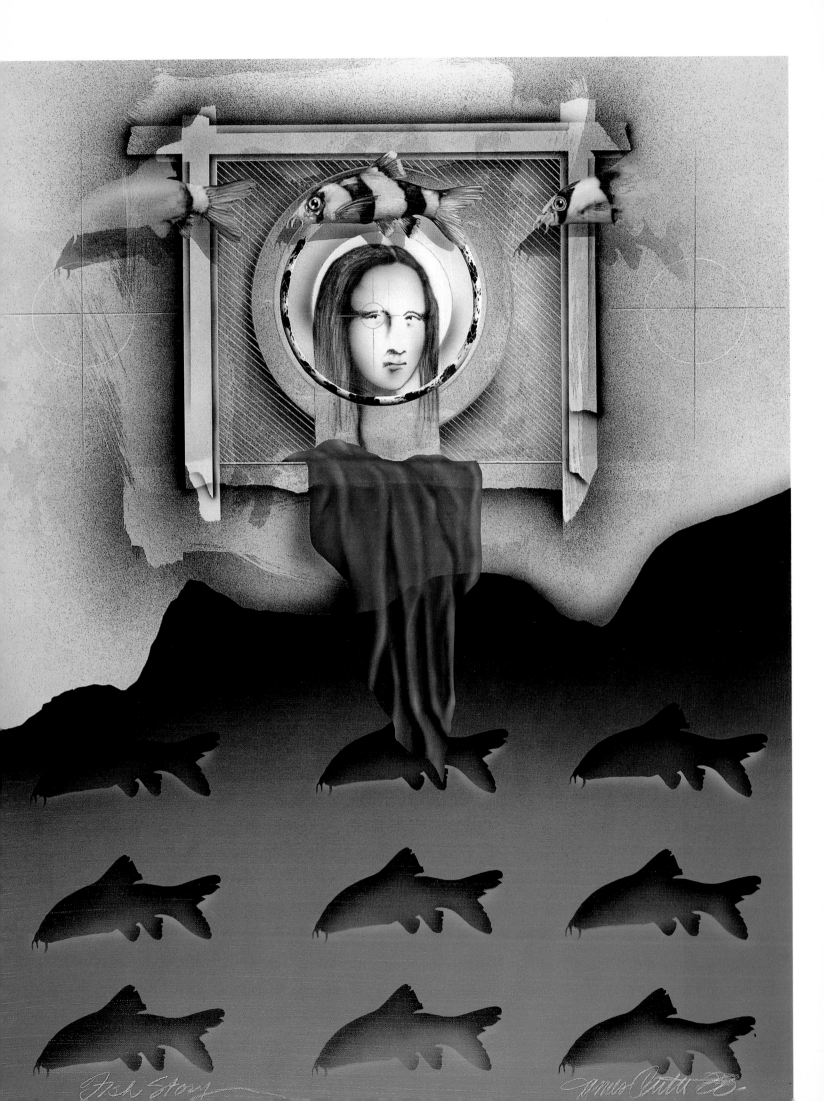

Fish Story

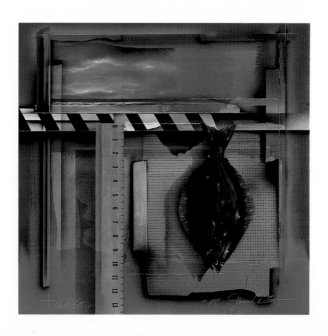

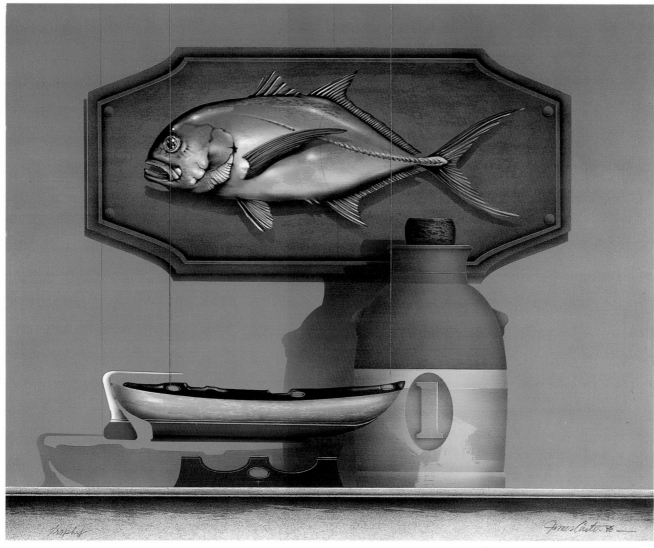

FISH STORY TOP
TROPHY ABOVE
FISH STORY OPPOSITE

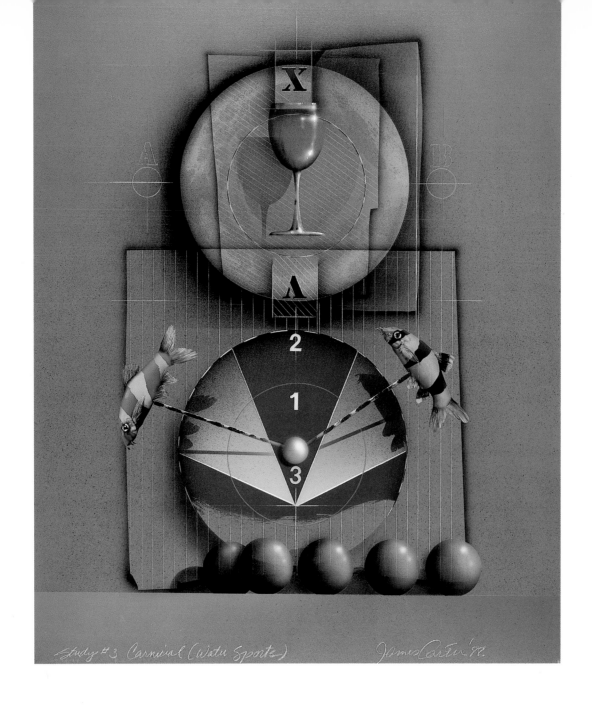

Study #3 Carnival (Water Sports) James Carter '97.

STUDY #3 CARNIVAL (WATER SPORTS) ABOVE
ANOTHER FISH STORY RIGHT

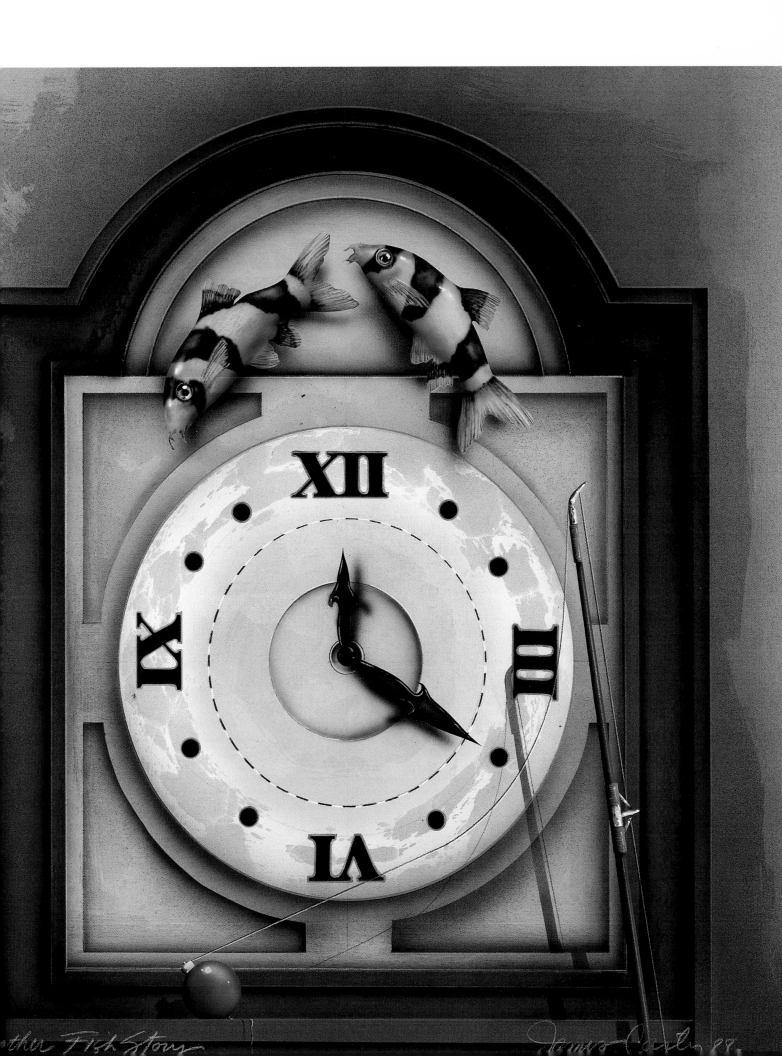

Mechanical renderings have precise line and graphism, and it is the drawing, not the subject that truly fascinates me. I take the simplest excerpts from early inventions, add such elements as cows and fish to its equation, creating a whimsical visual plan.

FIG.49B

POINT OF DEPARTURE FIG. 49B

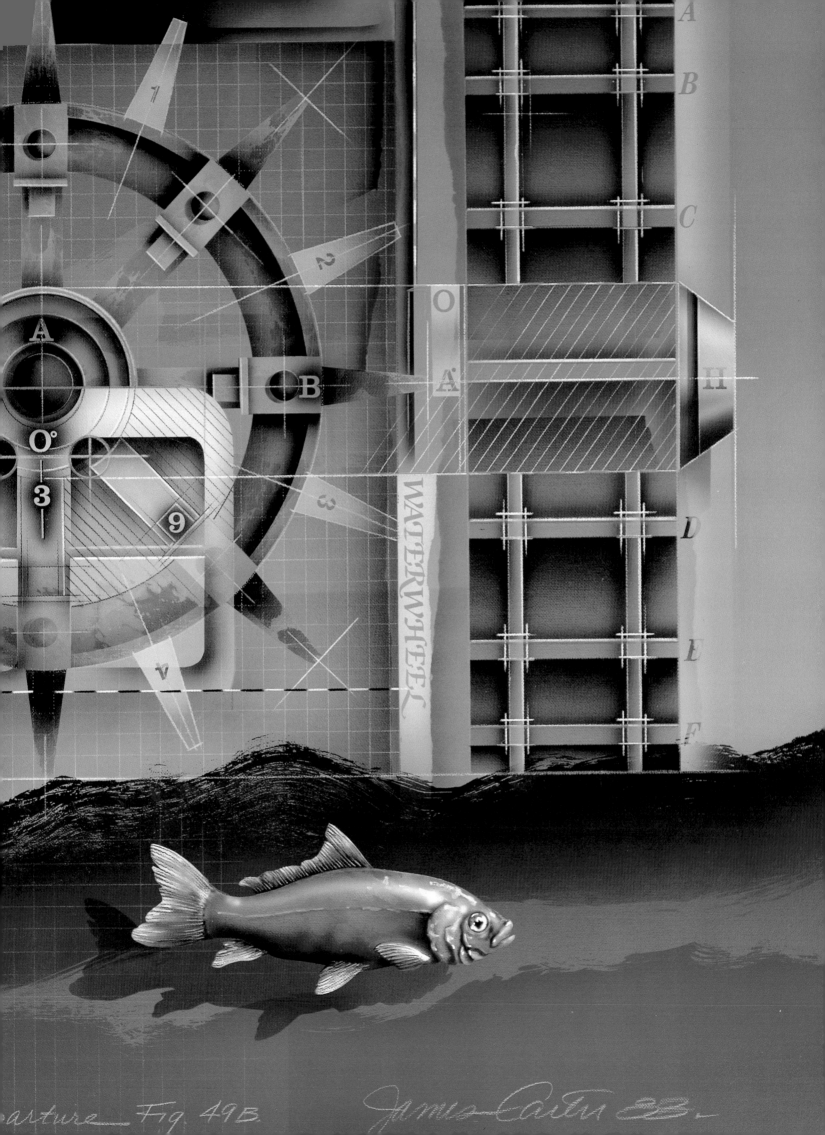

WATERWHEEL

arture Fig. 49B. James Carter 23.

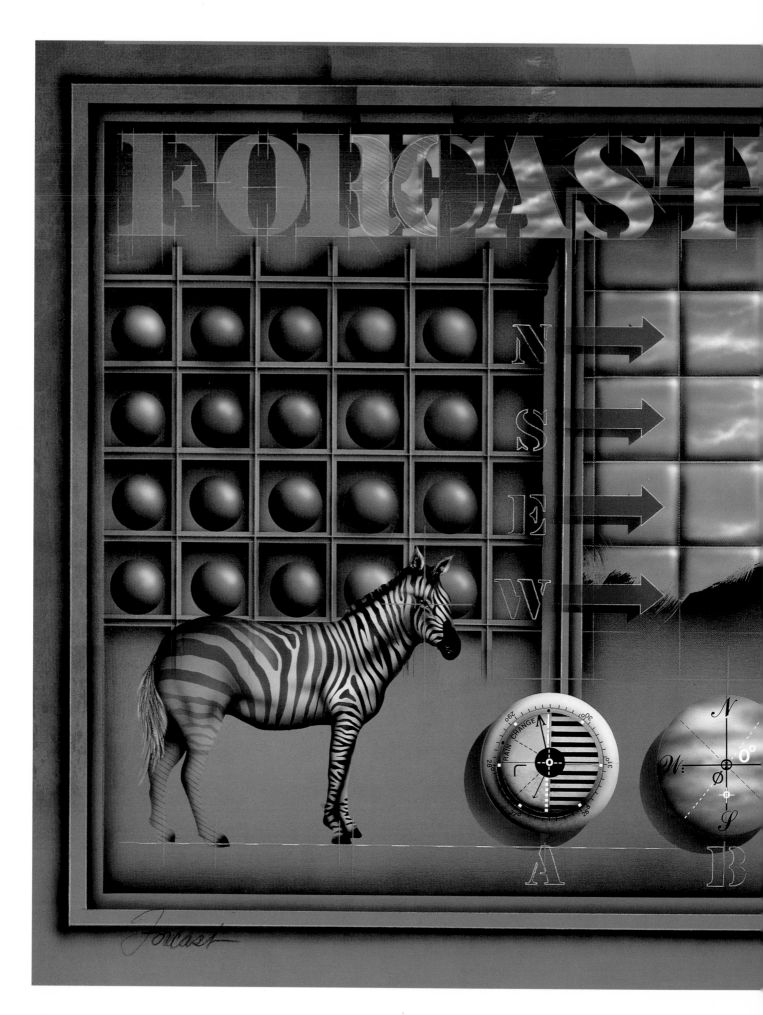

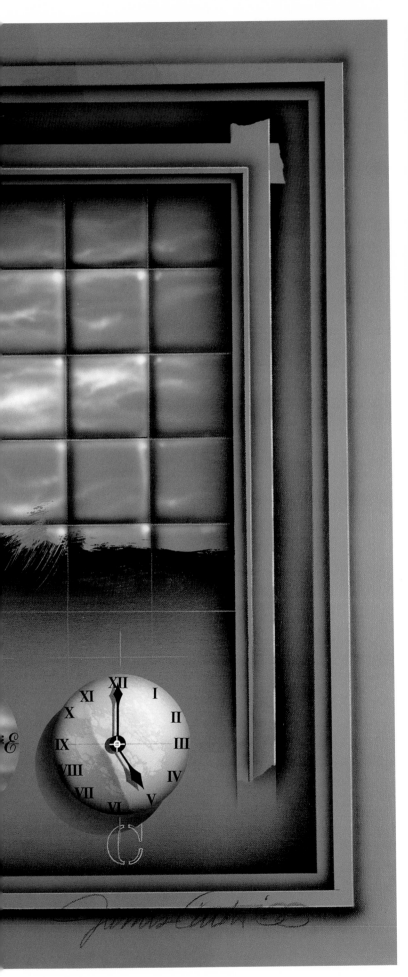

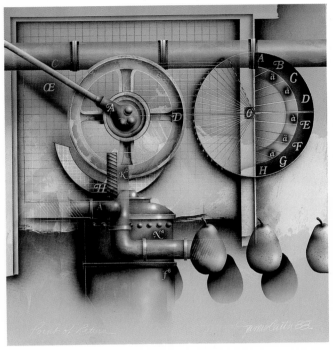

POINT OF RETURN ABOVE
FORCAST [sic] LEFT

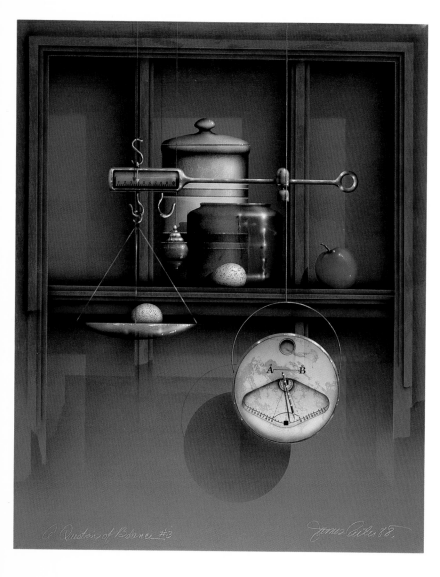

A QUESTION OF BALANCE #3 ABOVE

(FULL SIZE DETAIL, RIGHT)

120

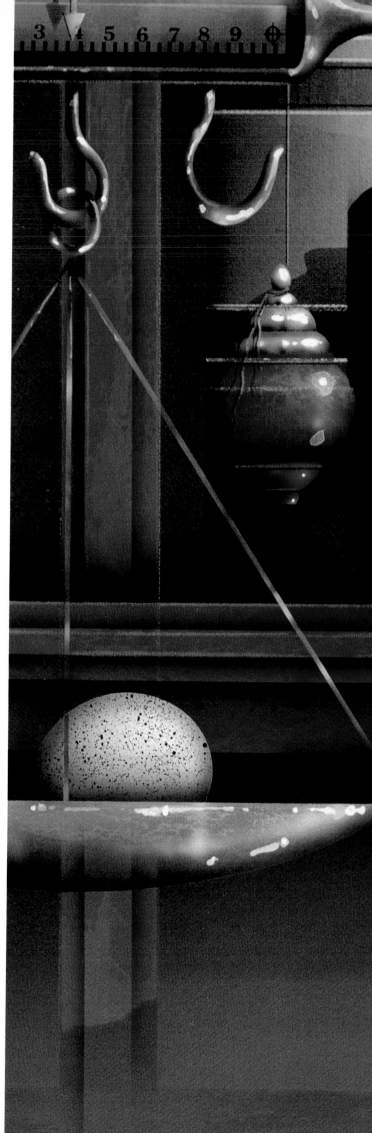

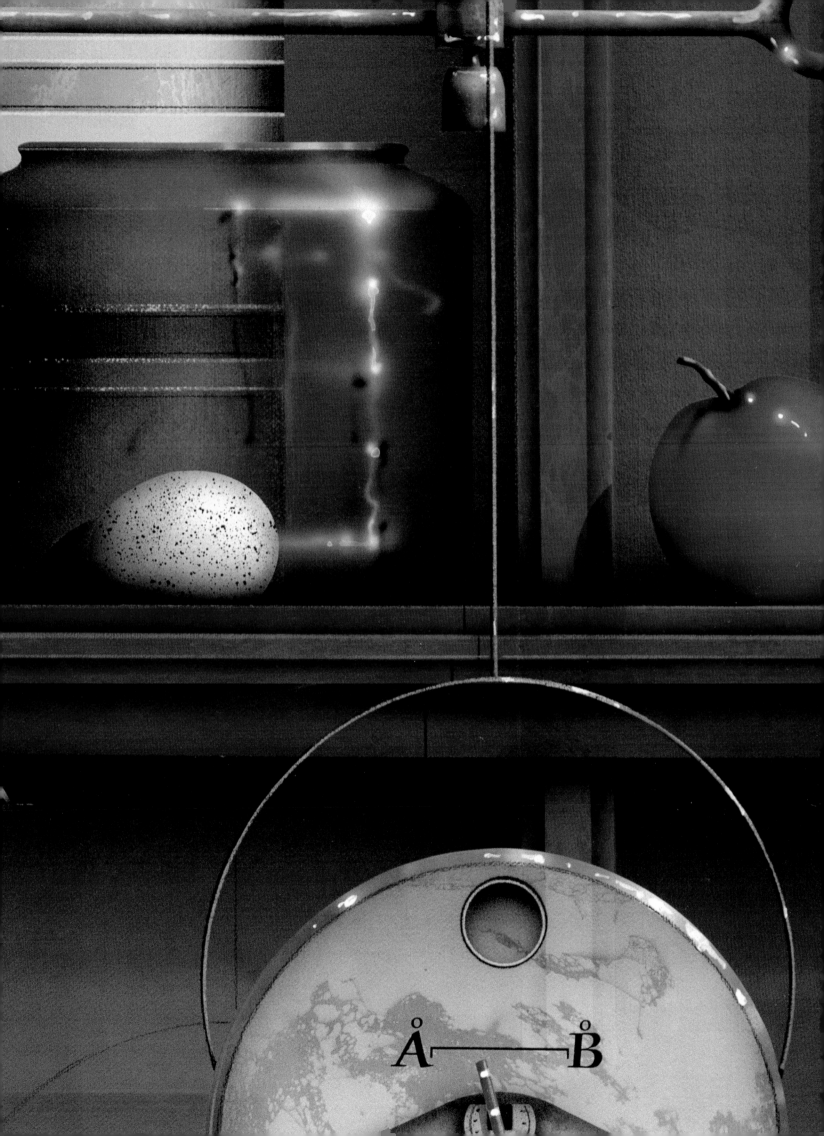

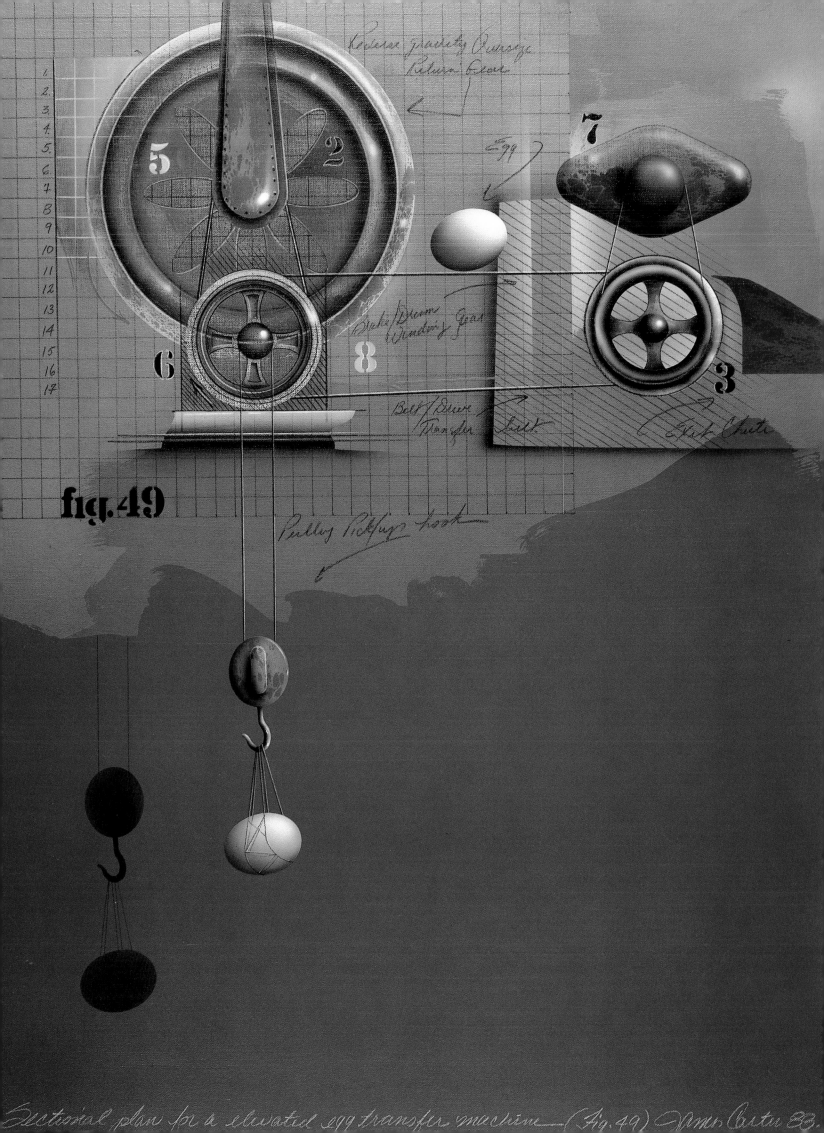

fig.49

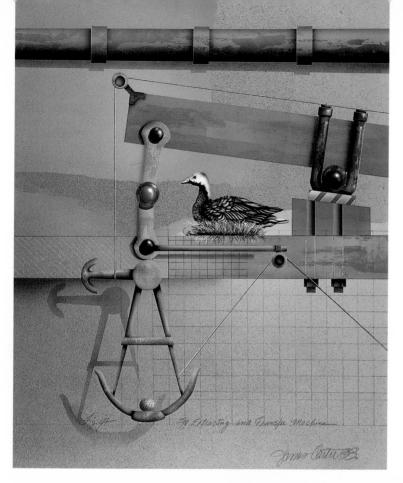

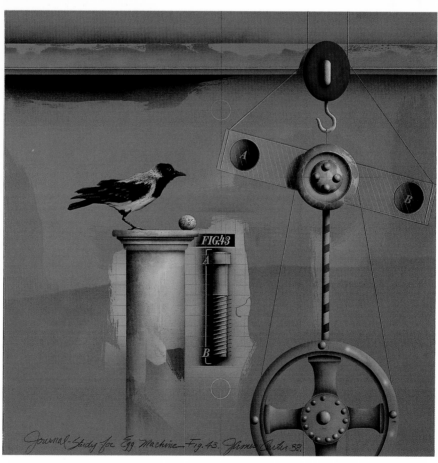

EGG EXTRACTING AND TRANSFER MACHINE ABOVE
JOURNAL—STUDY FOR EGG MACHINE FIG. 43 BELOW
**SECTIONAL PLAN FOR A ELEVATED EGG TRANSFER
MACHINE (FIG. 49)** [sic] OPPOSITE

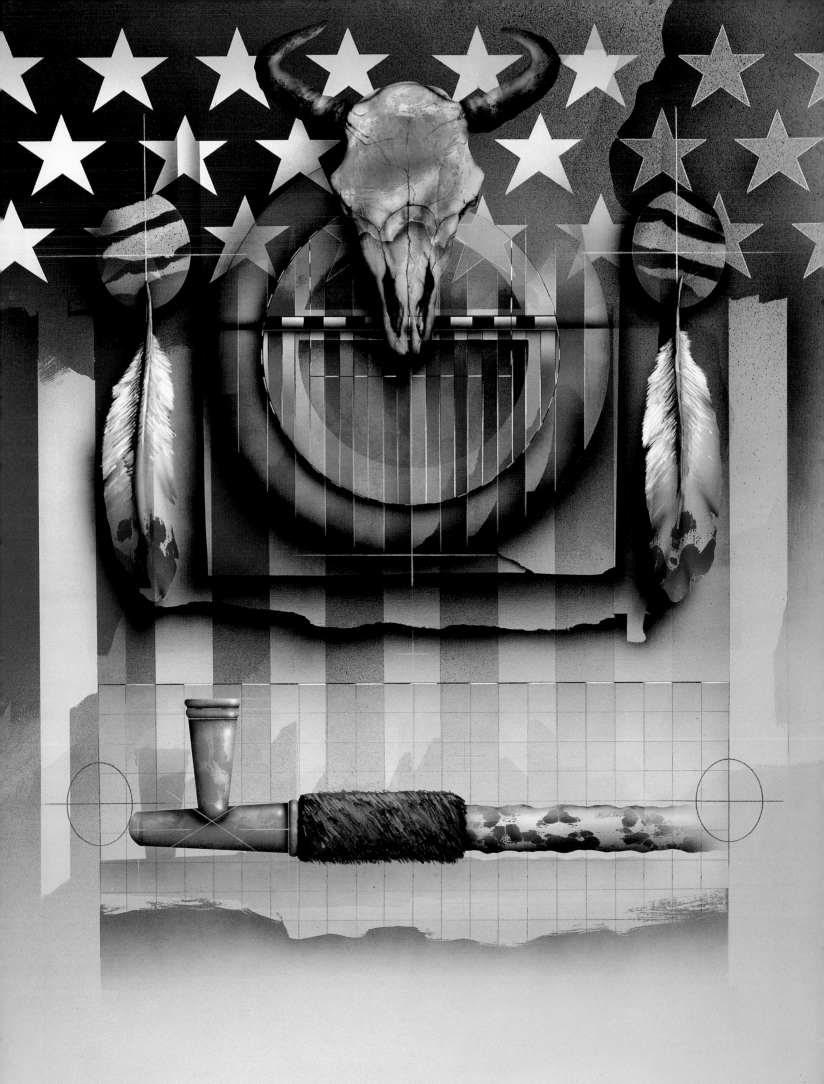

Fall from Grace (Study #1 The Flexible Dream)

Haunting symbols of the southwest, the buffalo and artifacts of the Indian, are full of messages about the tragic fates of the innocent. My intention is to preserve their memory and remember their importance in history. I use the American flag as a backdrop and a symbol. In integrating these symbols, I can achieve the ultimate contrast that is my portrait of America.

FALL FROM GRACE (STUDY #1 THE FLEXIBLE DREAM)

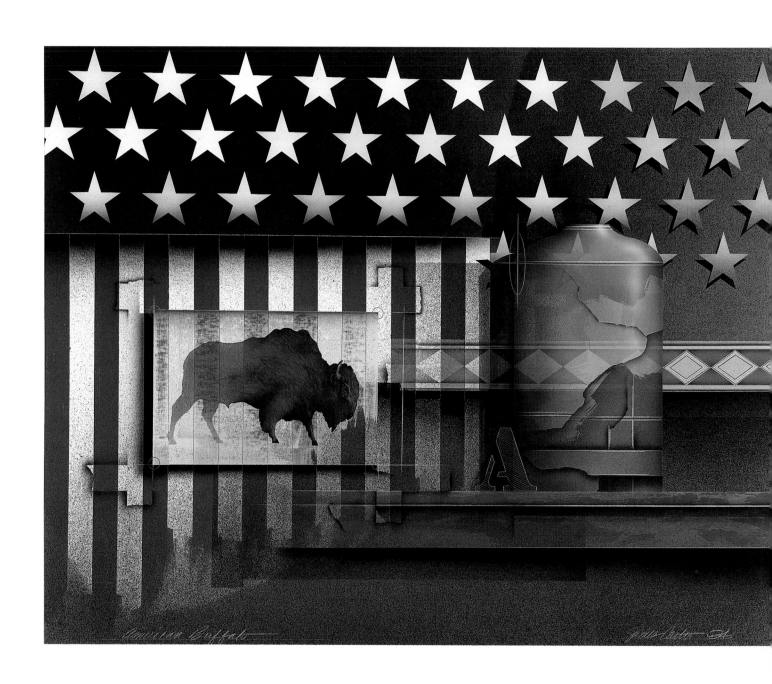

AMERICAN BUFFALO ABOVE
STRIPES OPPOSITE, TOP
THE APPARITION OPPOSITE, BOTTOM

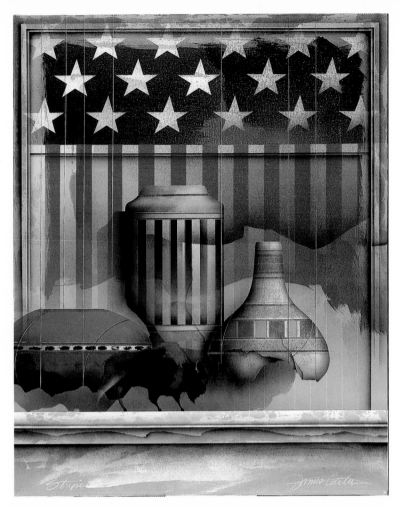

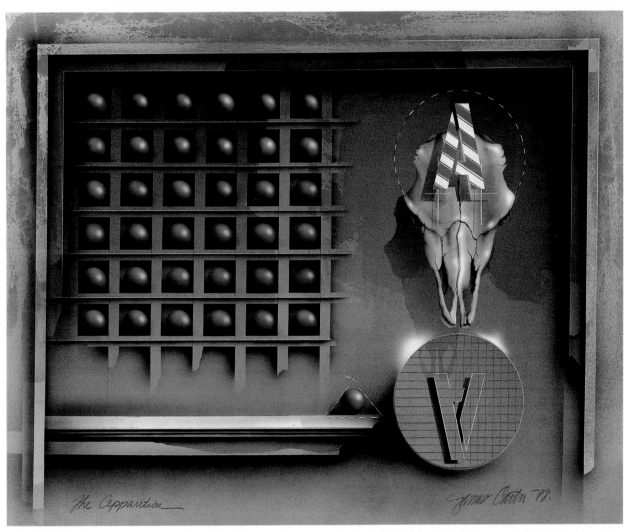

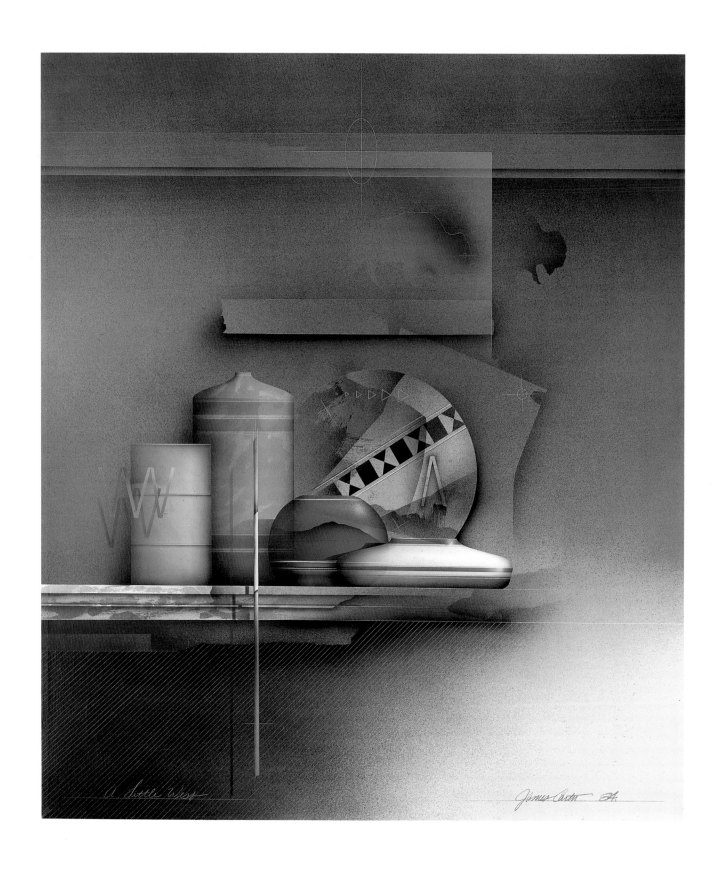

A LITTLE WEST ABOVE
SEA AND AIR OPPOSITE

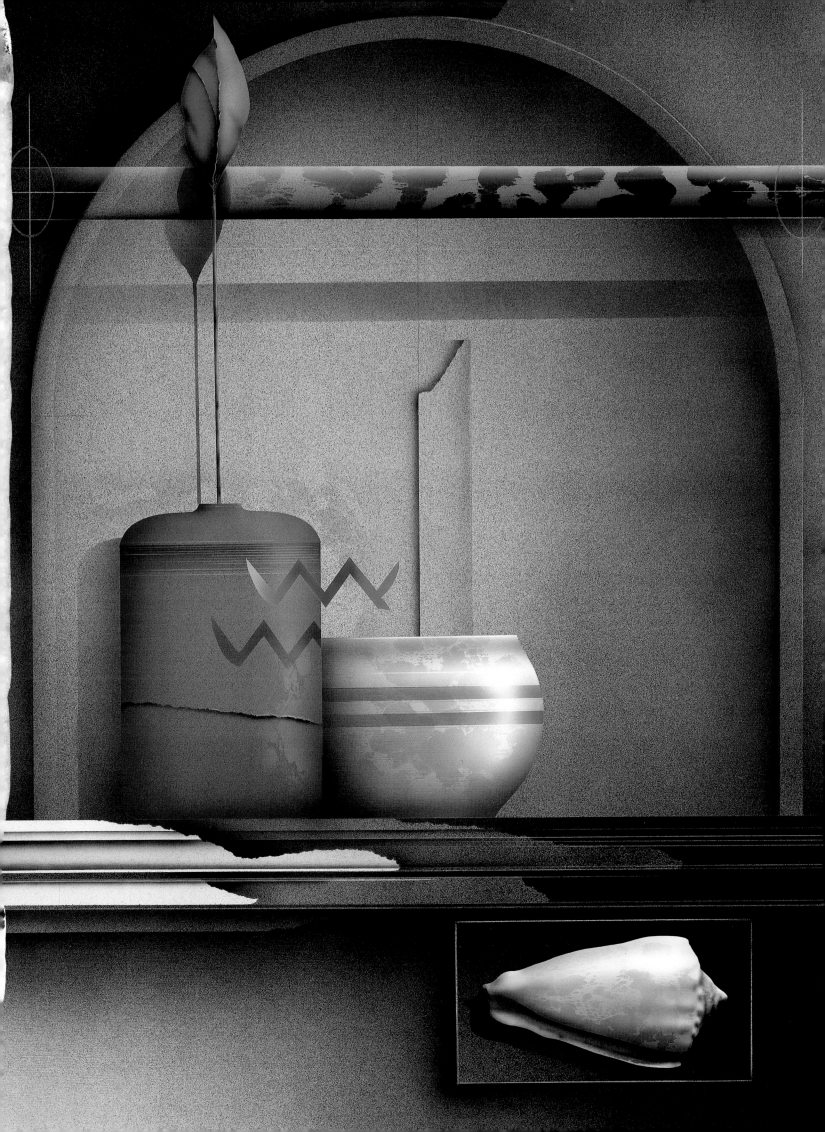

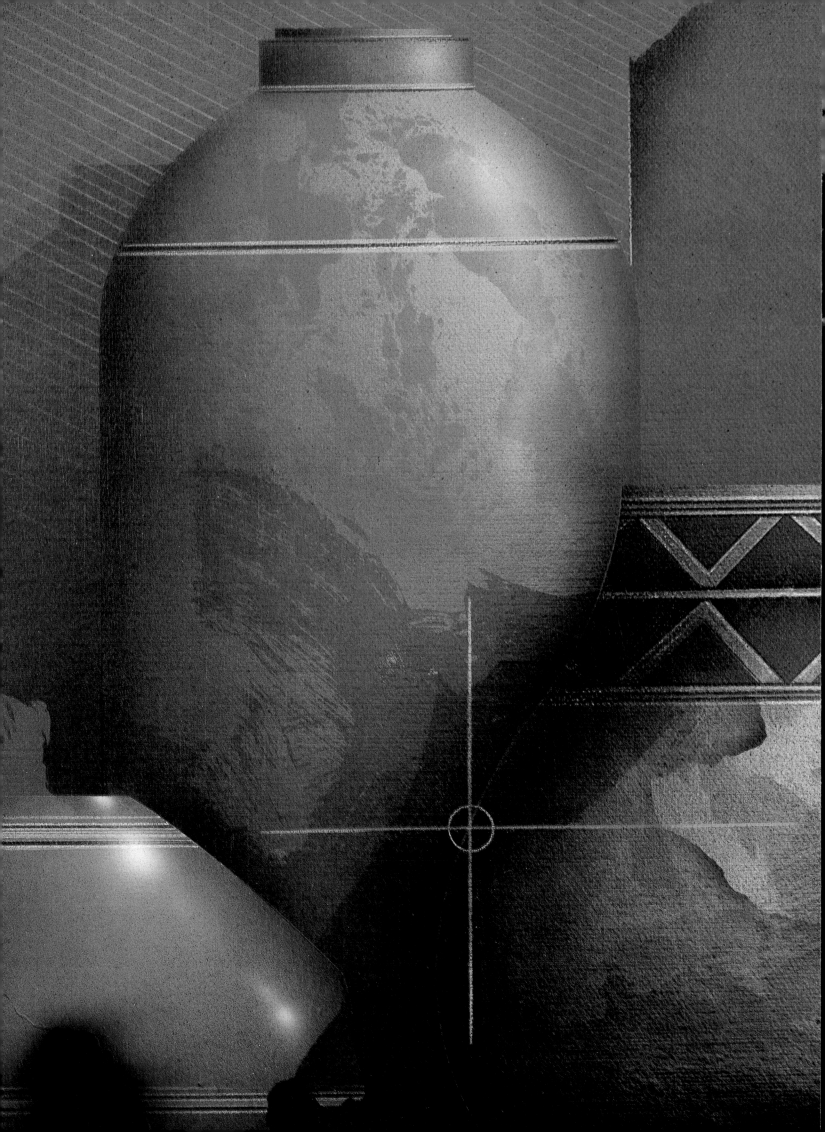

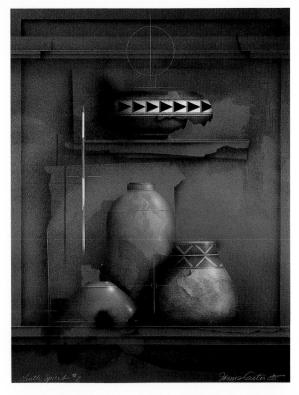

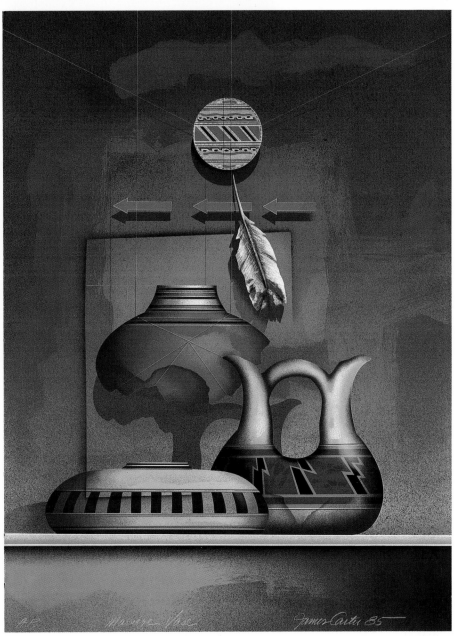

GENTLE SPIRIT #2 TOP
(FULL SIZE DETAIL, OPPOSITE)
MARRIAGE VASE BOTTOM

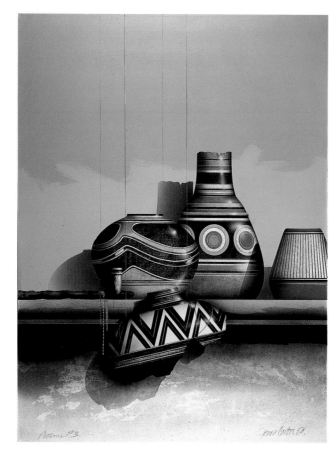

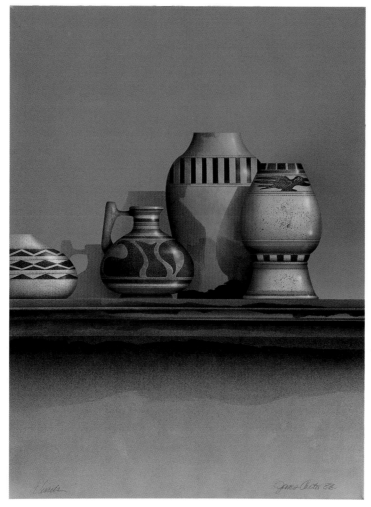

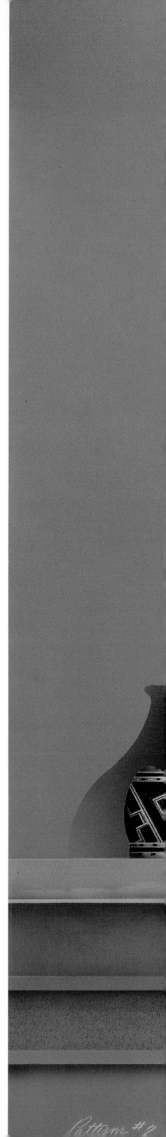

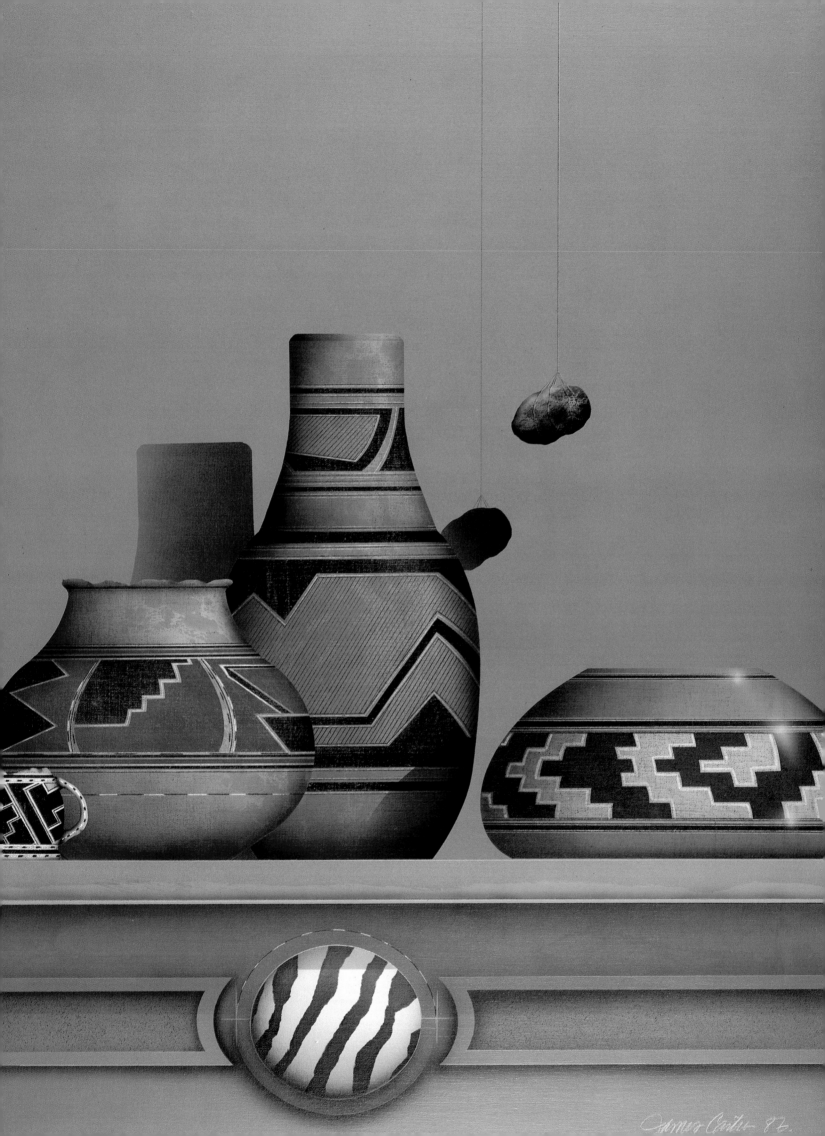

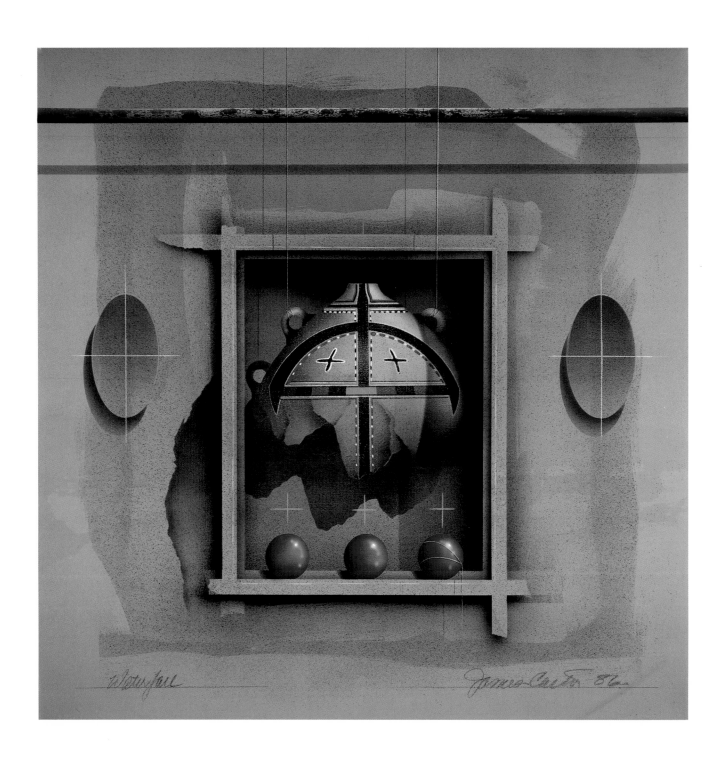

Waterfall

James Carter 86

WATERFALL ABOVE
INDIAN SUMMER OPPOSITE
SIREN'S SONG PAGE 136

134

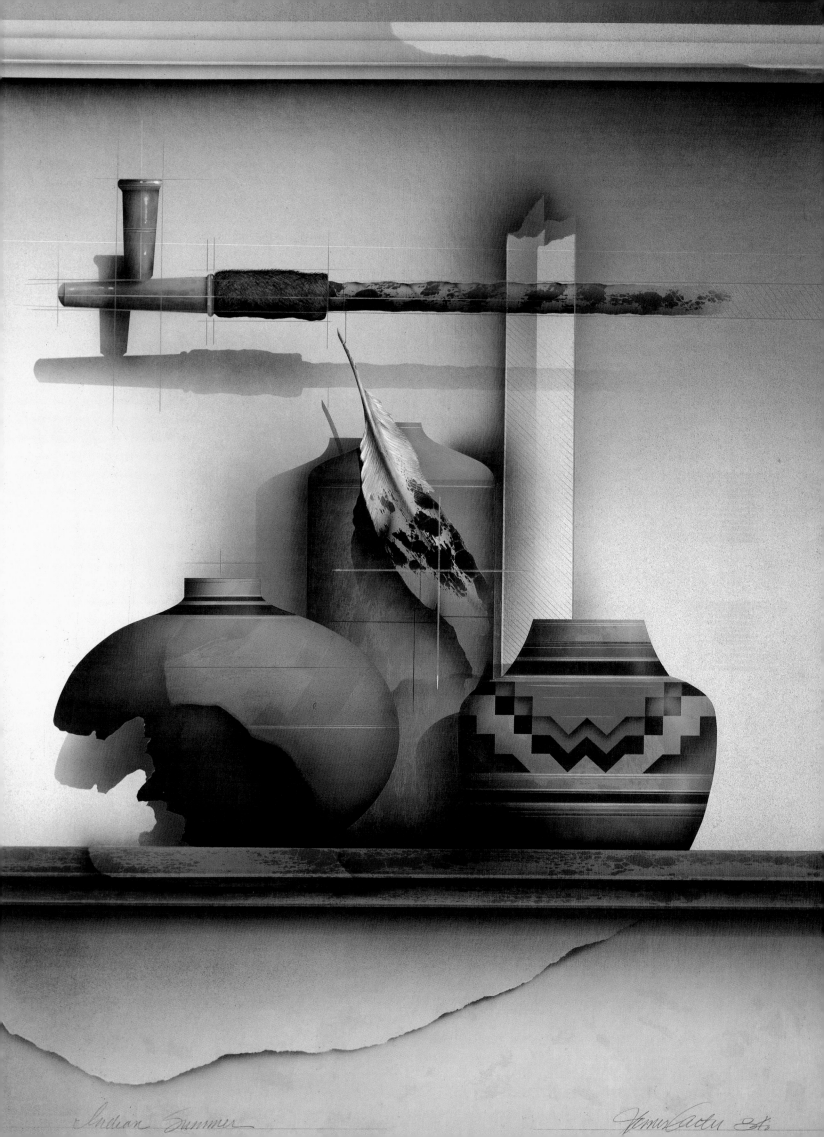

Indian Summer

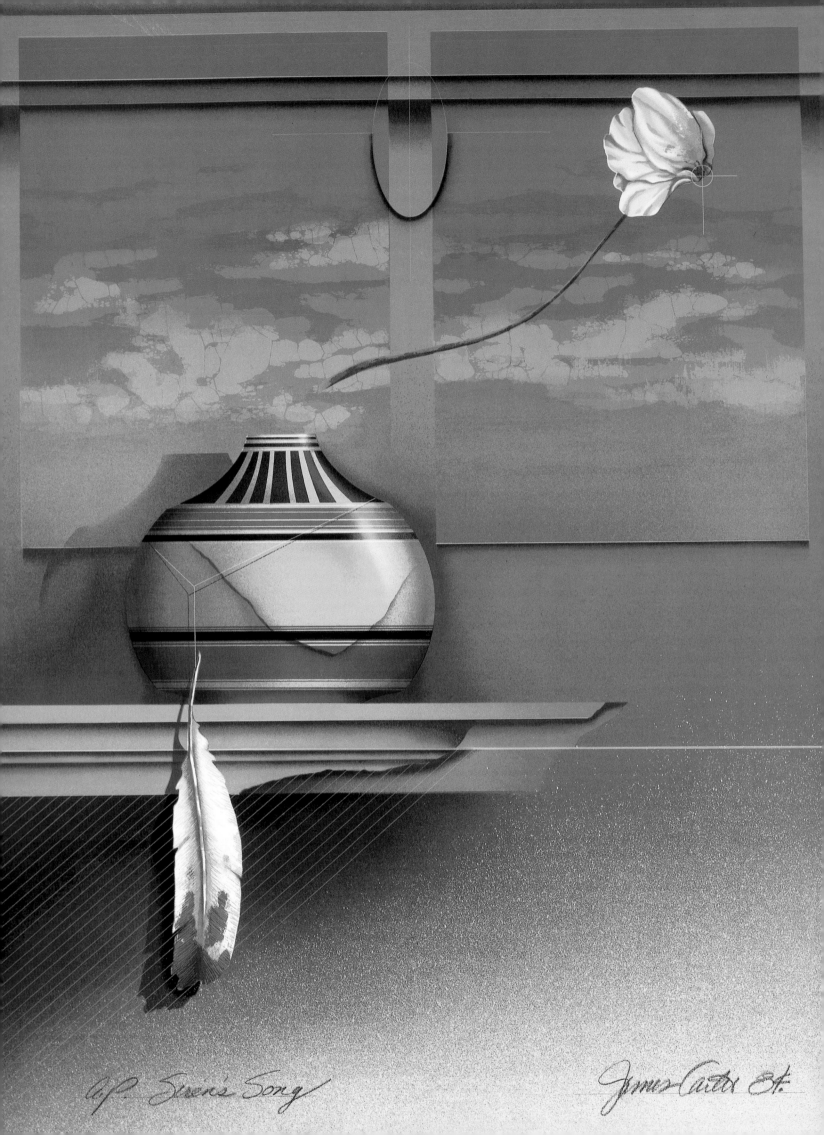

A/P Siren's Song James Carter 84.

PORTFOLIO

Study of Brush

① ② ④

③

Sky Colors

T. Background
#7
#17

Dark Blue

① ② #8

WHT WHT
⑤ ⑥

③ Blk.
③ WHT + grey
⑱.

① Blue ⑩ Blk
② Blue ⑪ Blk + grey
③ grey (Sky) ⑫ flower
④ WHT. ⑬ green + green #8 (glass plant pot.)
⑤ WHT. ⑭ WHT.
⑥ Red/Pink (Sky X flower)
⑦ Shadow Blue/Blk.
⑧ #2 + green mix for Bot. Box
 ⑮ yellow (flower/pot?)
 ⑯.
⑨ ⑰ Frame color + WHT.

htn top on rail

Brush E Brush
Brush
Letter

Zebra
Red Rose
Can & Brush

Calendar O#

Aug 6. 86

L m E
Toy Blks

EXAMPLES OF THE ARTIST'S PRELIMINARY SKETCHES AND PLANS

139

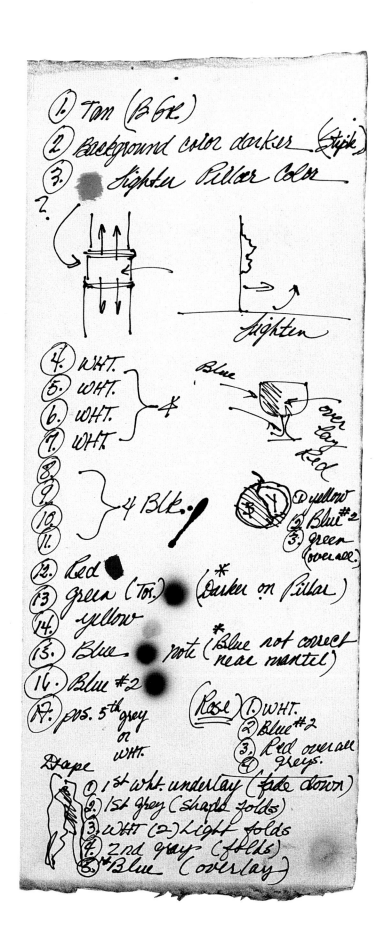

1. Tan (BGE)
2. Background color darker ____ (style)
3. Lighter Pillar Color ____

?

Lighten

4. WHT.
5. WHT.
6. WHT.
7. WHT.

Blue → over lay Red

8.
9.
10.
11. } 4 Blk.

① yellow
② Blue #2
③ green (over all)

12. Red
13. green (Tor.) * (Darker on Pillar)
14. yellow
15. Blue ____ note (* Blue not correct near mantel)
16. Blue #2
17. pos. 5th grey or WHT.

(Rose) ① WHT.
② Blue #2
③ Red over all
④ greys.

Drape
① 1st wht. underlay (fade down)
② 1st grey (shape folds)
③ WHT (2) light folds
④ 2nd gray (folds)
⑤ * Blue (overlay)

Notes on Prints:
① Press numbers for p
② On Still Life with
the shadow on th
with leaves read

one shadow

140

3

2

12

Red-Blk
11

4

8 9

13.

{ 3 > Browns
4 > wht.
4 > greys

11 yellow
12 red
13 red
14. pink
15. green
16. Blue
17. B.ground

6

7

10

5

16.

11

B. ground

15.

17.

green apple : (ochre + wht) under
fog green (1 wht.)

apple : ochre + pk red + 2 white

※ 13? yellow

※ decoy

※

4 straws
1 half full (Red.)

Bowl ?

(Music piece)

brown

large pot

one shadow.

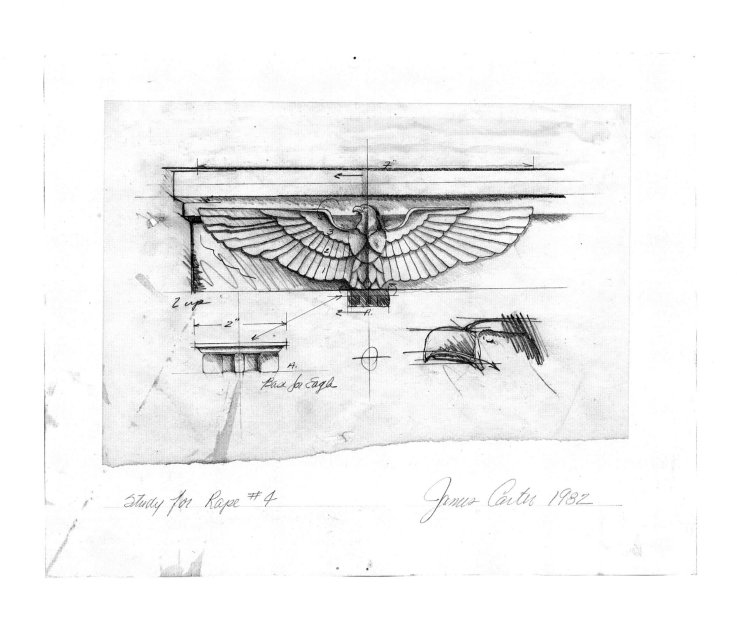

Study for Rape #4 James Carter 1982

THE FINISHED DRAWINGS ILLUSTRATE THE ARTIST'S ACCOMPLISHED TECHNIQUE,
HIS FASCINATION WITH ARCHITECTURAL DETAILS AND DRAFTSMANSHIP

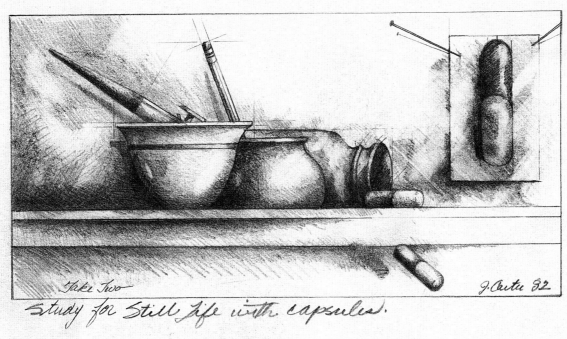

Take Two

Study for Still life with capsules.

J. Carter 82

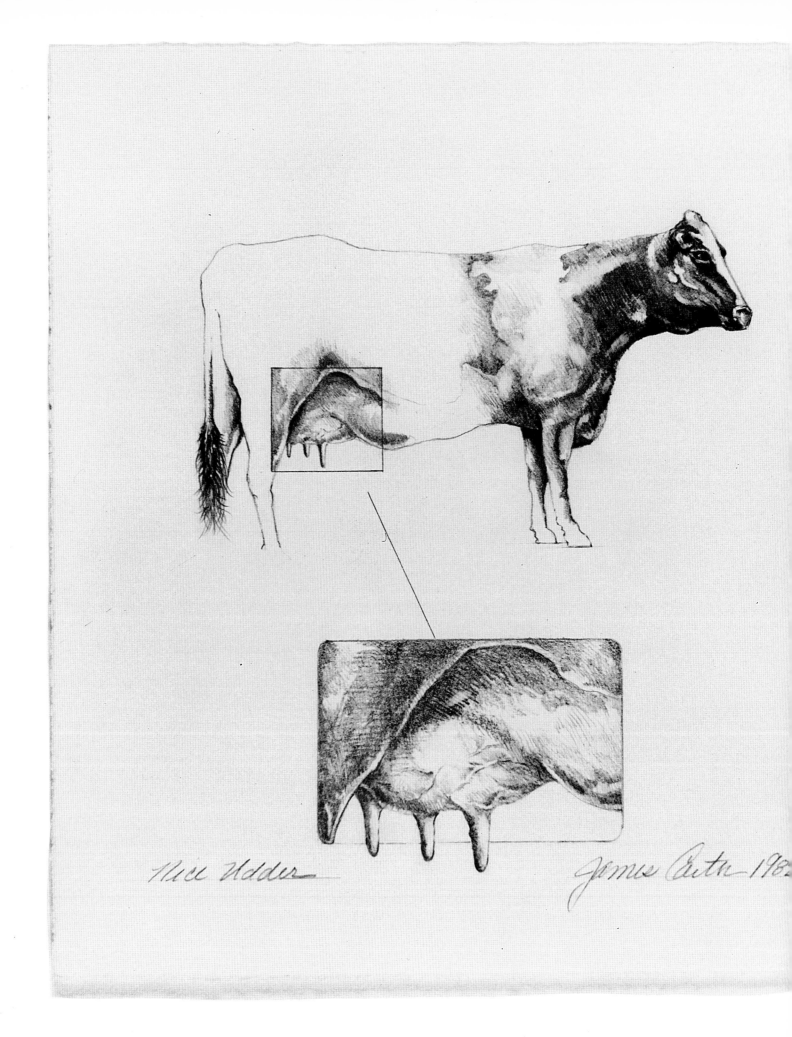

Nice Udder

James Arth 198_

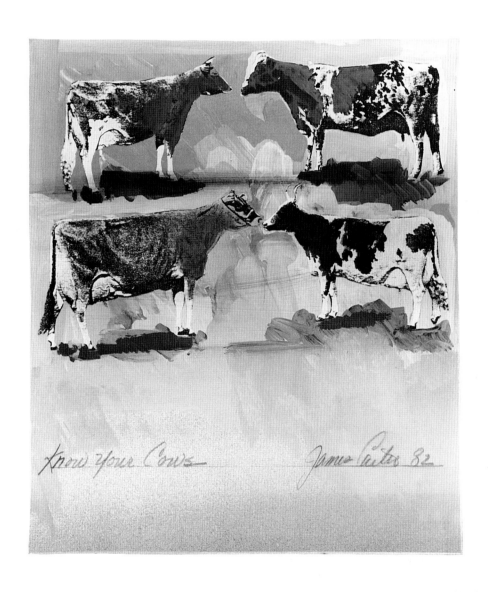

Know Your Cows James Carter 82

CONTINUED FROM PAGE 8

where a large floating fish casts its shadow on a luminous nocturnal sky above a sensual seashell, balanced on one of the manteltops that Carter employs as "stages" for many of his still life dramas. Yet, while Magritte's painterly shortcomings often weaken the impact of his poetic incongruities, Carter's seamlessly airbrushed surface and consummate draftsmanship lend a startling verisimilitude to even his most unlikely visions.

It seems part and parcel of Carter's aesthetic complexity, however, that he will often sabotage his illusionism and contradict the sense of deep space in his paintings and prints with sketchy crosshatches and other architectural symbols, drawn from a time during his college years when he briefly considered becoming a designer of buildings rather than of dreams. In this sense, he is a thoroughly contemporary theoretician, as concerned as any abstractionist with the two-dimensional integrity of the picture plane and the autonomy of the painting as an object in its own right.

James Carter goes even further in a recent series centering on art materials and other objects in his studio. Characteristically, he finds in these studio still lifes a perfect context for bringing together diverse aesthetic tendencies with a unique visual logic.

In "Wet Paint," for example, the familiar red and white design of a Folger's coffee can is partially covered by colorful spatters of pigment, as it stands beside a similarly splashed larger can and a plastic jar of blue acrylic paint. The almost Flemish austerity of the composition would seem quite traditional, if not for the wide housepainter's brush mysteriously suspended on a string above a brilliant explosion of drips and splashes that suggest a detail of one of Jackson Pollack's vast painterly vortexes.

On closer scrutiny, subtler incongruities reveal themselves to further discourage a naturalistic reading of the picture. Particularly striking is the fact that each splashed surface contains a spectrum of colors unlikely to occur accidentally, hinting at the magical alchemy of the painting process itself.

Another masterful work from the same series is "Still Life with Glue Can," which shows a more complex arrangement of cans and jars against a bright blue wall. Here, the white drips partially obscuring the label of the Liquitex gesso jar, set slightly to the right of center in the composition, refer to the white primer coat on which Carter works, putting yet another wry contemporary twist on his trompe l'oeil pyrotechnics.

In order to fully appreciate the intellectual complexity of Carter's work it is also important to know that he actually takes the trouble to painstakingly duplicate the labels on his paint jars in exacting detail, before partially burying them under seemingly random splashes and drips. Although the viewer will never be able to admire his handiwork, it is philosophically relevant to Carter's multilayered metaphysics that yet another level of illusionistic "reality" exists beneath the visible artifice of the painted image.

In terms of dense metaphysical layering, perhaps one of James Carter's most magnificent large canvases is "Of Cabbages and Kings," with its classically balanced composition pivoting on a tall marble column, rising majestically from a marble manteltop. Also arranged on the mantel are a black ball, a large green cabbage, and a sculptural letter "C" that casts its shadow on the wall behind it. Atop the tall column is a diagramatic silhouette of the super-realistic cabbage below, within which a capital letter "K" opens magically on a brilliant blue sky. But even this fragment of reality is startlingly subverted by green splashes of "action painting." Here, as in

other recent works, Carter has purposely defaced the image with gestural flourishes that assert the primacy of his painterly intentions. Yet, the image will not be so easily dismissed, for a strong figurative symbolism asserts itself (almost against the artist's wishes, it might seem) in the candy-striped parade barrier placed horizontally behind the vertical column, forming a cross-like configuration. Now the silhouetted cabbage at the top of the column suggests the head of a crucified figure, opening up the complex array of symbolic associations that Carter himself refers to as a "Pandora's box."

One of the most remarkable aspects of James Carter's work is that such striking visual metaphors come about as a result of the artist's formal concerns, rather than through a self-conscious striving for symbols or significance. Their power is further enhanced by Carter's freshness of vision, which transcends all the timeworn tricks, props, and theatrics of traditional surrealism. Instead, he invents a unique private language to reveal the secret life of objects, revitalizing the still life tradition in the process.

In surveying James Carter's enormous power and productivity as a painter, it is important not to overlook his equally considerable accomplishments as a printmaker. After all, Carter began working with lithography in college and has since stated that printmaking was "perhaps my first love."

Carter established his initial reputation as a printmaker with his serigraphs, which are technically innovative for their application of painting techniques, including airbrush, directly to the screens, to produce tonal and textural qualities previously unseen in the medium. His command of subtle tonalities in serigraphy is especially impressive in the delicate shadow play behind the miniature zebra, strolling between the panels of the trompe l'oeil cabinet in the aptly titled print "Simple Magic."

More recently, Carter has returned to lithography with equally stunning success, beginning with his landmark triptych of prints, "The Music Box," executed in 1988.

At first, the artisans in the Paris atelier where the prints were proofed on presses nearly a century old were somewhat taken aback when the American artist began to experiment with his airbrush directly on the lithographic plates, as he had done on the screens for his serigraphs. But their initial skepticism soon turned to admiration when the final prints were pulled, with their complex arrangements of musical instruments, clocks, goblets, and other objects within subtly shadowed compartments.

In contrast to the darker, denser mysteries of "The Music Box," an even more recent lithograph, "Weather Vane," explores broader spatial relationships in a lighter, more lyrical vein. In this print, the half-rusted swan decorating an antique weather vane appears to be coming to life, as it presides over a single speckled egg in a straw nest, positioned on an ornate mantel, between two large ceramic pots. Here, again, Carter returns to his poetic preoccupation with the relics and romance of the American past.

In both his paintings and prints, James Carter presents the beautifully crafted products of his fertile imagination in images that are memorable and provocative. Meanings are clearly present, but never tritely clear. Just as the artist himself discovers his themes through the creative process, the viewer is invited to interpret his private world of signs and symbols in terms of his or her own experience. Thus we can all participate and rejoice in the metaphysical quest at the core of James Carter's art.

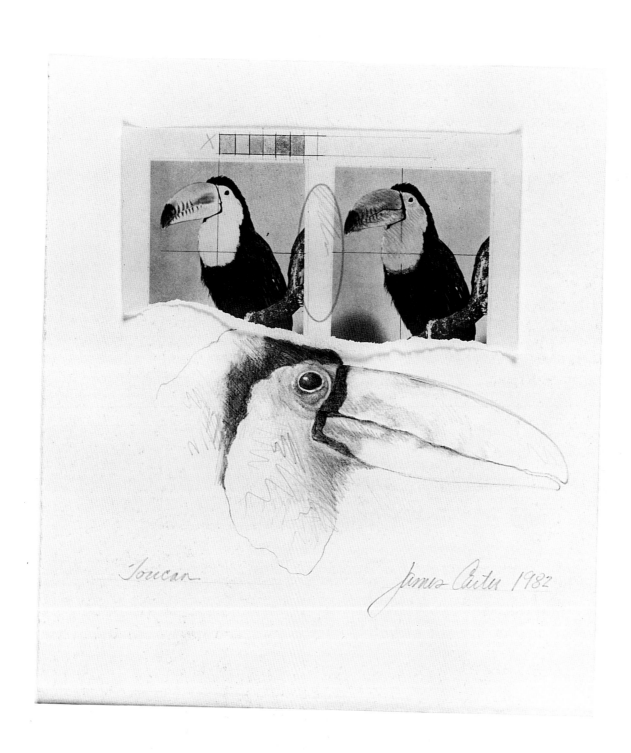

Toucan

James Cutu 1982

A L B U M

J A M E S C A R T E R

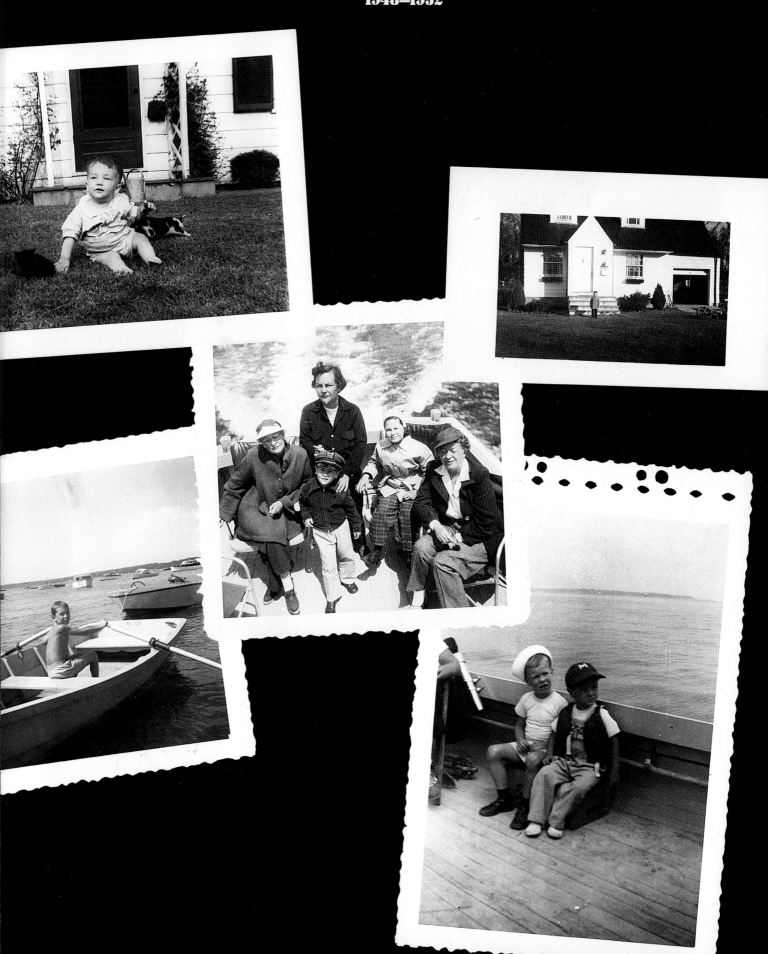

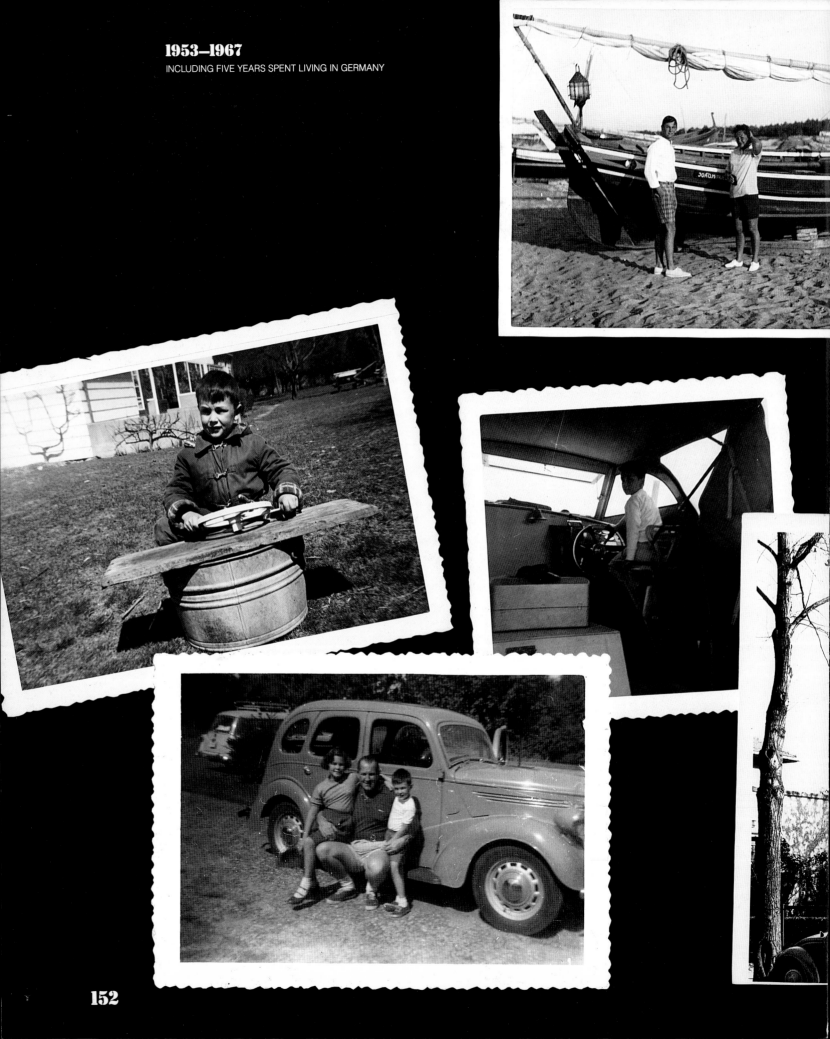

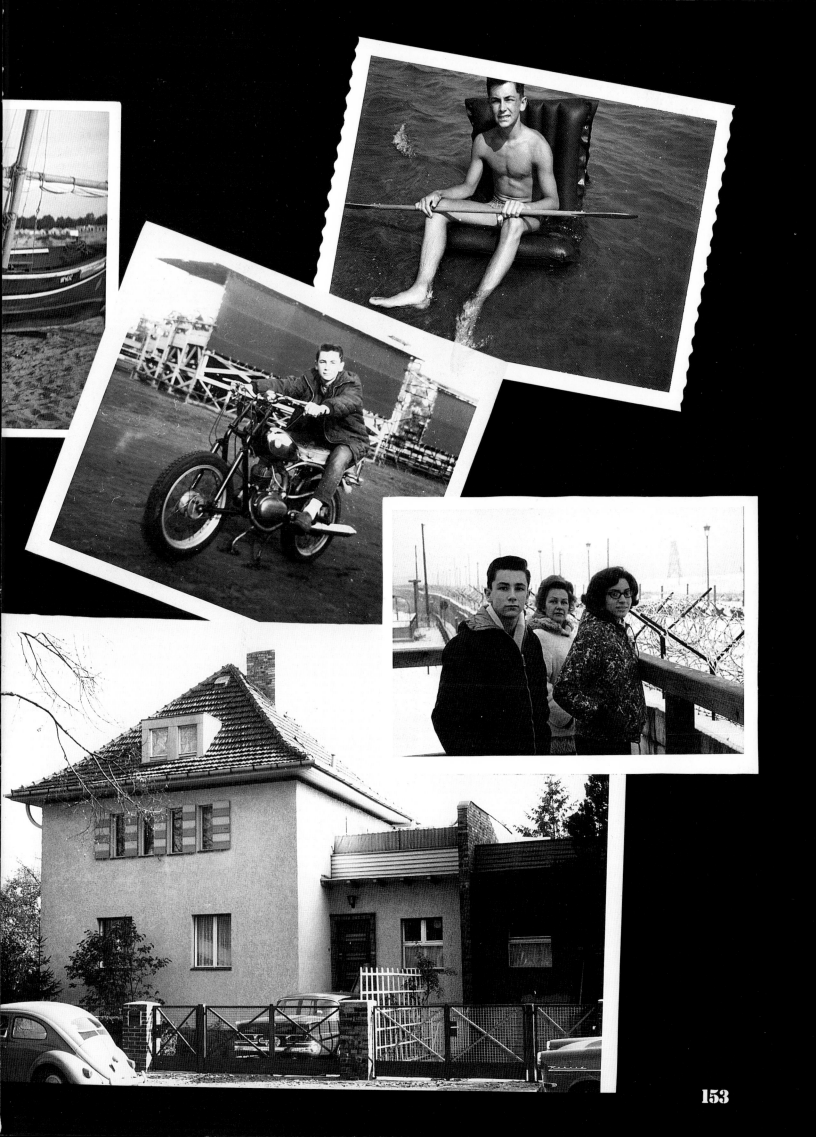

1987

CARTER WORKING ON THE "MUSIC BOX" LITHOGRAPHS IN THE STUDIO AND AT THE ARTS-LITHO ATELIER, PARIS

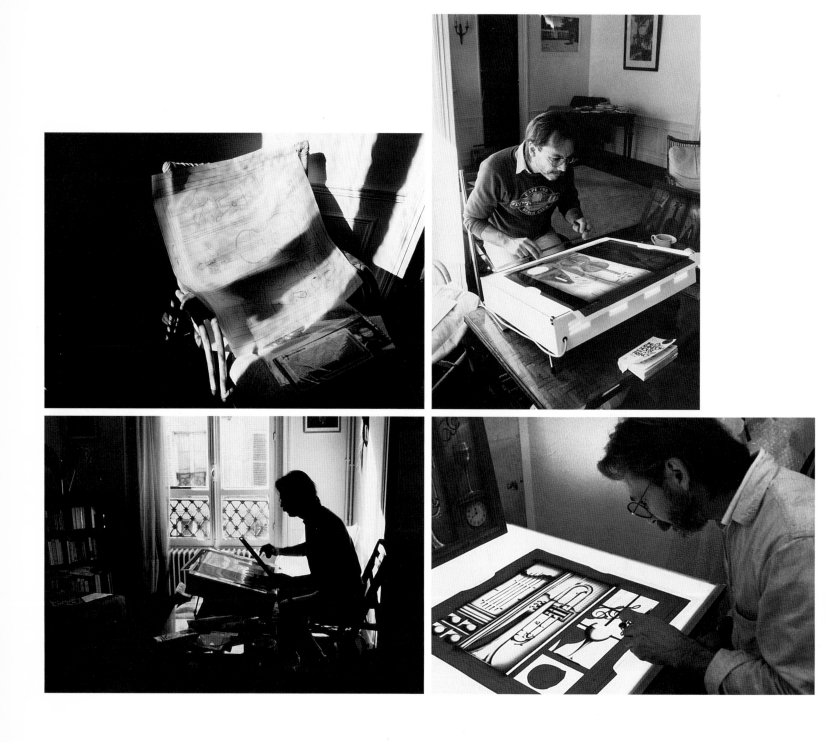

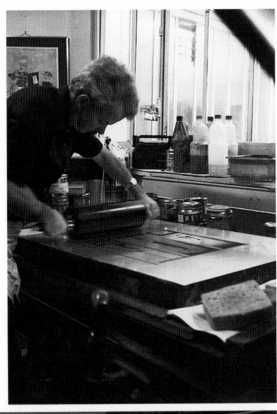

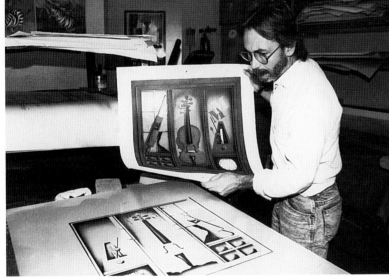

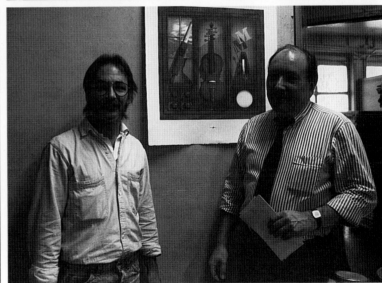

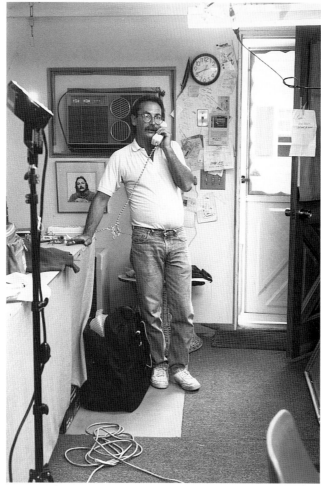

1989

THE ARTIST IN HIS CONNECTICUT STUDIO AND AT A NEIGHBORHOOD LUNCHEONETTE

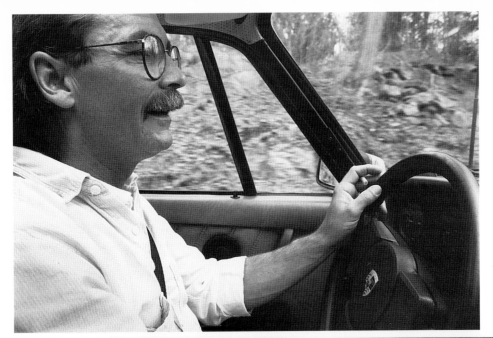

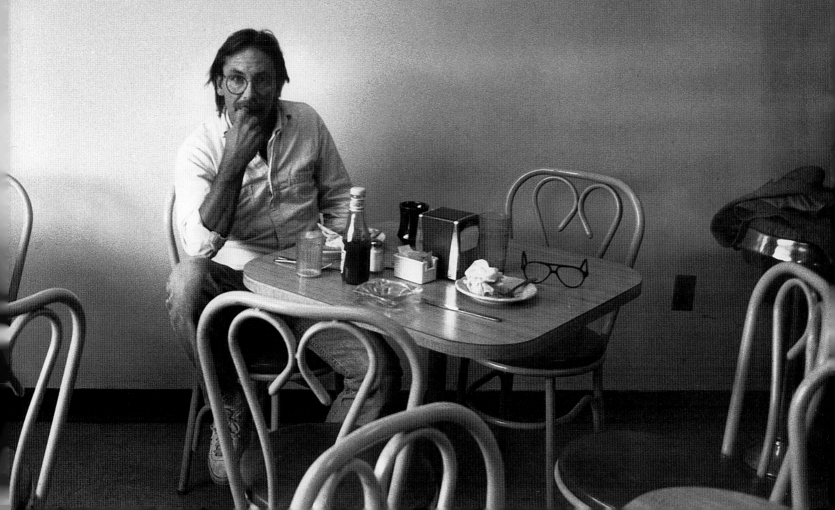

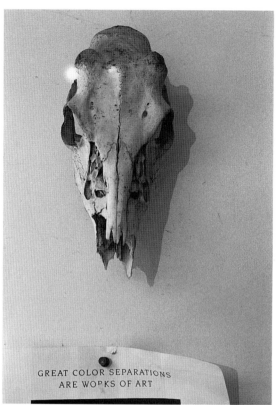

GREAT COLOR SEPARATIONS
ARE WORKS OF ART

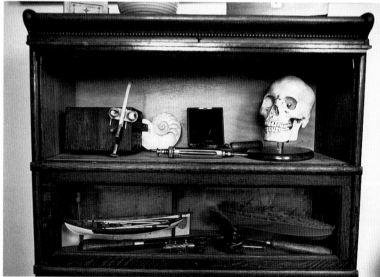

THE DIVERSE COLLECTION OF OBJECTS AT CARTER'S HOME IN CONNECTICUT

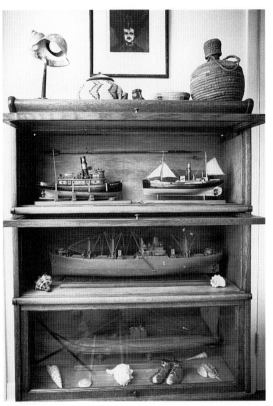

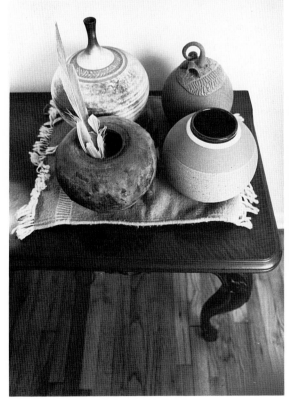

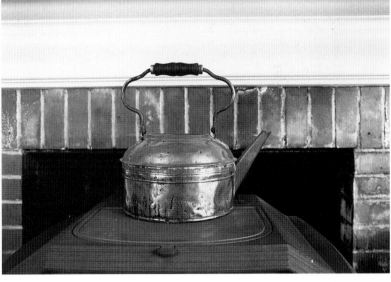

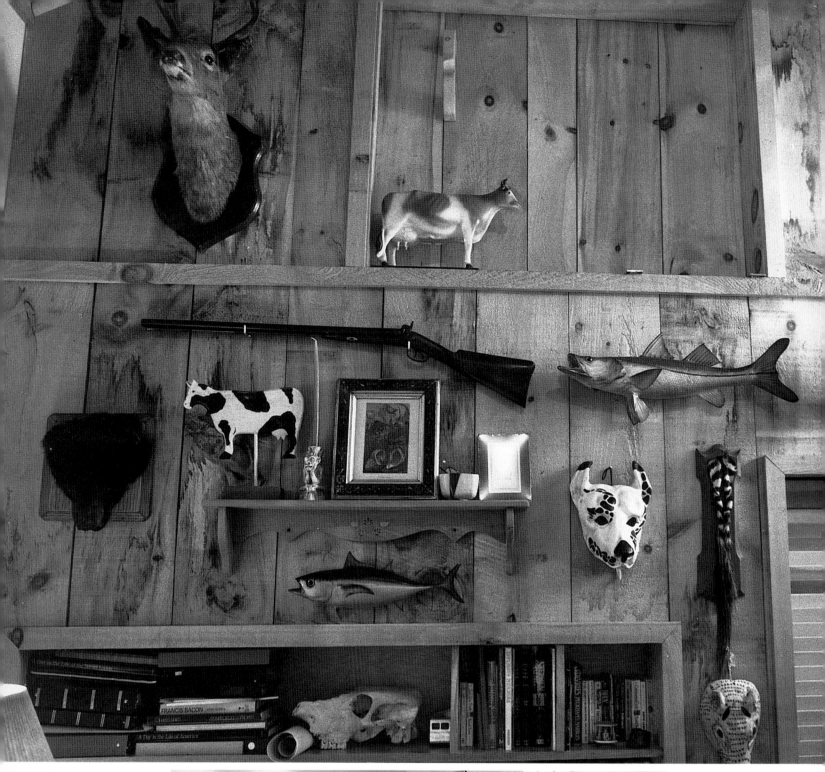

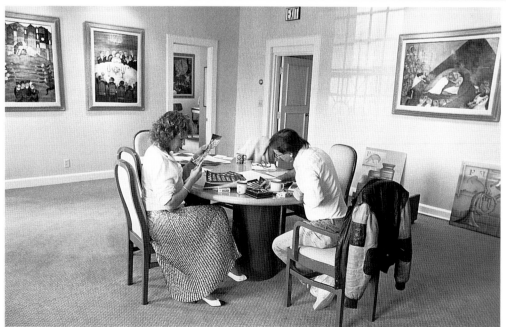

162

(BOTTOM LEFT) THE ARTIST WITH PUBLISHER, MICHELLE LUBLIN CASSANETTI

(BELOW) CARTER AT HOME, AND WITH ARTIST, TRACY HAMBLEY

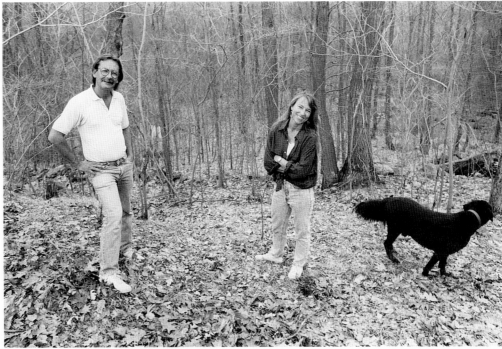

I N D E X